Whatever is contained

. . . must be released.

WHATEVER IS
Contained

My Jewish Orthodox Girlhood,

HELÈNE AYLON

MUST BE Released

My Life as a Feminist Artist

THE FEMINIST PRESS
AT THE CITY UNIVERSITY OF NEW YORK
NEW YORK CITY

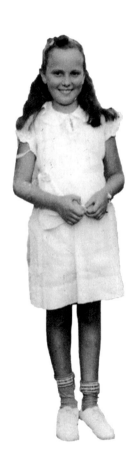

For Nat and Renée,
Mendy, Benjy, and Adam,
and Gavi and Meléa

After three days and nights of labor my mother gave birth to me at the Israel Zion Hospital in Boro Park, Brooklyn. I'm spelling it "b-o-r-o" instead of "borough" because that's closer to the Hebrew word *borei* in the prayer *Borei Pri Ha'etz* (creator of the fruit of the tree) and the members of my family would never take a bite out of an apple without mumbling that prayer first.

The Israel Zion Hospital was later renamed Maimonides Hospital, which is a good thing because its former name laid a message on my subconscious while I was trying to get out in 1931. Israel! Zion! I hadn't even been born yet, enough already. My two sisters were born in this same hospital five and eleven years later, but they never mentioned what they thought of coming into the world with the ideas of Israel and Zion looming, and they glided out without the long struggle my poor mother endured to have me.

From the hospital, I, the firstborn—if the oldest happens to be a girl, she's never referred to as the "firstborn," but never mind—was brought from Israel Zion on Forty-Ninth

Street and Tenth Avenue to our house on Forty-Seventh Street between Twelfth and Thirteenth Avenues, which remained my home until I got married.

Judging by its name you'd think Boro Park was the Central Park of Brooklyn. However, you won't find a semblance of a park in the whole neighborhood. There was just one tree on our block. A man named Mr. Behrman convinced the city to plant it in front of his house next door. We never saw him, but my mother would sing his praises each spring when she looked out the window of our enclosed porch to see the tree's first light green foliage. The last time I was in Boro Park, it was still flourishing, a memorial to a man I never met.

Since Boro Park had very few trees, and Prospect Park was almost near "The City," as we called Manhattan, on Sunday mornings Daddy used to take me all the way to Ditmas Avenue near the Belt Parkway so I could soar on the swings that overlooked a bunch of trees in the distance. Younger children had to stay put in Boro Park and make do with rocking on the mechanical horses lining Thirteenth Avenue that galloped as soon as a quarter was put in a slot. Once the children turned five years old, learning the *Aleph Beit* (the Hebrew ABCs) was deemed playtime enough. At the age of ten, tag at recess in the yeshiva was exercise

enough. In adolescence, the walk to shul, in all one's finery, was enough.

Having trees in our neighborhood was not important, but donating trees to Israel? That was pounded into our heads. Every girl in my class had a blue and white *pushka* (a tin box for collecting charity donations) to collect money for trees in Israel. Trees were planted to honor a person who had died. Sometimes I was honored even though I was not dead: my aunts and uncles occasionally gave me a "meaningful" birthday present, a certificate that read, "Happy Birthday! A tree has been planted in your honor in Israel." And then I had to write a flowery thank you note befitting such an uplifting gift.

NATURALLY, my father, Anshel, had hoped for a boy each time my mother gave birth. Who could blame him? Daddy was well prepared as to what to expect from daughters, thanks to the Talmud's forewarning:

> A daughter is a deceptive treasure to her father because of anxiety on her account: he cannot sleep at night when she is young, lest she be seduced; when she reaches puberty, lest she play the harlot;

after she is grown, lest she fail to marry; after she is wed, lest she have no children; when she is old, lest she practice witchcraft.

Yet after my auspicious nine-pound arrival as the first of the Greenfield girls, I was wheeled in a baby carriage with sterling silver blanket clamps, dressed in little ruffled pinafores, and shown off in the Young Israel shul every *Shabbos*. My smiley, moon-shaped face earned me the nickname "Bupsie." There's a photo of me at four years old in which I'm curtseying in my "Shirley Temple dress," a polka-dot frock. In those days, modern Orthodox girls were mad for Shirley Temple dolls. Chesty Barbie with boyfriend Ken, had she been conceived in my time, would never have been the choice for any Boro Park girl. Of course, Chassidic girls were responsible for mothering their real life siblings every day, so they actually had no need to play with dolls of any kind.

THE HOUSE WE RENTED for eighty years was on the same block where the annual *Simchat Torah* (Joy of Torah) holiday dancing took place. Our street, Forty-Seventh Street, was the Times Square of Boro Park. The police barriers

that were erected during the holiday to block traffic from entering the street were completely unnecessary because the streets were automatically emptied of cars on *Shabbos* and Jewish holidays. After all, the entire neighborhood was Orthodox.

My mother, Etta, had an easy comradeship with every storekeeper in the neighborhood. From an early age, she had been known as *Itte, de'gitte*—Etta, the good one. Whenever I was in a stalemate with my pesty younger sister or sulking about one thing or another, Mother would say, "You be the good one." But ask anyone who knew my mother: Who could be as good as *Itte, de'gitte*?

"The main thing, you should be with nice people," she always said.

"Mom," I told her in 1971, "I am in the Whitney Museum. It's a show called Lyrical Abstraction."

"The main thing, you should be with nice people."

The nice *haimeshe* storekeepers sent their nice Jewish daughters to Shulamith School for Girls on Forty-Ninth Street. Shulamith was named for the comely princess in King Solomon's Song of Songs. They sent their nice Jewish boys to Eitz Chayim Yeshiva, named for the Tree of Life, which was around the corner on Thirteenth Avenue and Fiftieth Street. The Young Israel shul was down

the block on Fiftieth, and the tiny, homey shul called a *shteibel*, where Baba, my grandmother, would pray, was on Fifty-Second Street. The fish store was on Fiftieth Street, the bakery where I was sent to pick out "well-baked" challahs and *Bilkelach* (small challahs) was on Fifty-First Street. Mother used to tell us that on the passenger boat to America, she, her brother Morris, and her sister Molly were given raw dough instead of rolls. "It was not Jewish bread." Until her death at almost 101, she asked for only "well baked" rolls and challahs and considered white bread to be gentile.

Sometimes I accompanied my mother on her expeditions to buy fish for gefilte fish. The fish eyes stared at me, and the smell made me dash outside to wait for my mother until she'd emerge looking immensely satisfied with her accomplishment. Then we'd go down the block to the hardware store to buy aluminum containers so that guests who came to the house could take food home with them. "Make a *bracha* (blessing) in my house" Mother would plead, asking visitors to taste some mouth-watering treat while she sneakily filled containers with more delicacies for them to take with them. "Here, have another *shtikel*, just a little piece."

My friends, my relatives, my school, my shul, my doctor, my dentist, and the Indian Walk shoe store where my

flat feet were routinely examined and fitted with orthopedics—all were located between Forty-Fifth Street and Fifty-Fifth Street. My best friend, Hindy, lived on Forty-Eighth Street; my second best friend, Hadassah, lived around the corner from us on Forty-Sixth Street with her uncommunicative rabbi father and her very old grandmother who pronounced each word slowly and carefully. Mother's oldest brother, Uncle Morris, otherwise known as Moishe Mendel, and his wife, Aunt Molly, lived on Forty-Ninth Street, and Daddy's brother Ben and his wife, Sarah, were diagonally across the street from them. (And when Aunt Sarah died, Baba imported a young bride from Europe to be Uncle Ben's second wife and care for his seven motherless children. So we got a new aunt, and after a few years, three new cousins). Our other cousins, Mutzi, Miriam, and Shaulie were on Forty-Sixth Street. Cousin Shloimie, another Shaulie, and Yankel were on Forty-Eighth Street; Aunt Yetta and Uncle Nuchum on Fifty-Second Street. Aunt Helen and fat Uncle Abie were on Forty-Sixth Street, and Aunt Tybee, who was not a real aunt but the best friend of my mother, and Uncle Abe, who was not a real uncle but the best friend of my father—lived on Fiftieth Street. Aunt Tybee and Uncle Abe had three sons who, according to the parents' plan, were supposed to marry us three Greenfield girls. The oldest boy was a crybaby, so luckily this idea was eventually dropped.

Even my Sunday elocution teacher—the exquisitely beautiful Miss Lewis, whom mother found from out of nowhere, and who made me weak in the knees with her otherworldly, powdery complexion and pastel aqua eyes— lived on ordinary Forty-Ninth Street on the ordinary second floor of an ordinary house. None of the other girls' mothers thought of giving their daughters elocution lessons, and I have no idea where Mother got the idea or how she met Miss Lewis. I can still recite a poem Miss Lewis taught me, about an old woman led across the street by a young boy. It is a long, maudlin ballad that ends:

> Somebody's mother bowed low her head
> In her home that night,
> And the prayer she said was,
> "God, be kind to that noble boy,
> He is somebody's son, and pride and joy."
> Faint were her words and wan and weak,
> But the Father hears when his children speak.
> Angels caught the faltering word,
> And somebody's mother's prayer was heard.

I never recited this Hallmark poem in public. I was already developing an aesthetic during my preadolescence and I knew the poem was pure schmaltz. Plus, it didn't quite sound like Jewish schmaltz. The author was unknown, but I

intuited a bit of Boy Scout Christianity in it. Yet mother loved to have me recite this poem to her, and she always got tears in her eyes at the mere mention of prayers, frail elders, off-spring who bring *naches* (pride) and the notion that the Father hears. It could have been Holocaust Memorial Day the way her eyes filled up. The imagery was Jewish enough for Mother, so I never mentioned my suspicion that the poem was Christian—and worse, that the divine Miss Lewis with her blond halo and perfumed aroma might be Christian too.

It certainly was rare to see a Christian in the neighborhood, or even a secular Jew, which amounted to the same thing in Boro Park.

I could always spot the difference between Orthodox and secular Jews. I call this talent "J-dar." With the ultra-Orthodox it's obvious because of their in-your-face getups. But in a glance I can tell whether someone who is dressed normally is a shul-going Jew or a wash-the-car-on-*shabbos* Jew. If the person is shul going, I can tell you if the shul is modern Orthodox, Conservadox, Conservative, Reform, Reconstructionist or Post-Denominational. I can even intuit a convert or a *baal tshuva*, that is, one who returns from a secular background. Not to boast, but I can tell whether a person is ardent or indifferent or agnostic or just plain hostile about being Jewish—or a crazed mixture of all. In fact, I

can tell whether someone is connected or disconnected to Israel, and I can calculate their degree of heated passion or cold indifference as if I had a thermometer.

The modern-Orthodox Jews are very content. Their contentment borders on smugness. They are known as the FFB—*frum* (religious) from birth. They have a sense of entitlement. The *baal tshuva* are abbreviated as BT. They try to be more *frum* than the FFBs, which causes the FFBs to marvel patronizingly at such a phenomenon. And get this: there's a new "sexy" Judaism. The twenty-something girls think being Jewish is hot stuff; I blink when I read slogans like "Juicy Jewess" on their T-shirts. Their serious parents read *Tikkun* but the kids subscribe to *Heeb* magazine.

Still, when I look in the mirror, I cannot for the life of me surmise my own category. It took my rabbi professor nephew, Adam Ferziger, whose research at Bar Ilan University in Israel is on the subject of assimilation, to tell me that I am "post-Orthodox." It's close enough. And I can sniff out other post-Orthodox types: they have my same angst. They see-saw between blown up pride and burning shame. They love to tell inside jokes and use "in" expressions that only those born to "the life" can detect. They barely cover up a perverse disdain for the polite Conservative and Reform Jews who pray in English, who don't "know" as much, and who seem overly respectful to their rabbis and

terribly good-humored about the psychopathic character of the Torah G d. And the post Orthodox feel a disguised superiority to the FFBs who struggle to be "in" the way the post-Orthodox struggle to be "out." The post-Orthodox are as intense about leaving Orthodoxy as deceived, disenchanted, divorcing spouses are about leaving their marriages. When the post-Orthodox manage to move out of Boro Park, they don't return, but Boro Park is always in them.

MY MATERNAL GRANDMOTHER'S name was Hinda Stern Scheinberg. Her deep-set eyes with their penetrating expression conveyed a pioneer's independence. She had a long chin that she would thrust forward. Her maiden name, Stern, befitted her. Still wearing her *shaitel*, wig, Hinda came through Ellis Island soon after Emma Lazarus, the author of the words on the Statue of Liberty, "Give me your tired, your poor, your huddled masses yearning to breathe free." Hinda came to gigantic America from the tiny village of Shwenzany, Poland. There she had chopped ice to make her own *mikveh*, a ritual bath, even in the dead of winter right there in the back of the inn. No tiled spa and hair dryer in that *mikveh!* Henoch, her husband, had come from the city of Babov. A renowned scholar, he was plucked

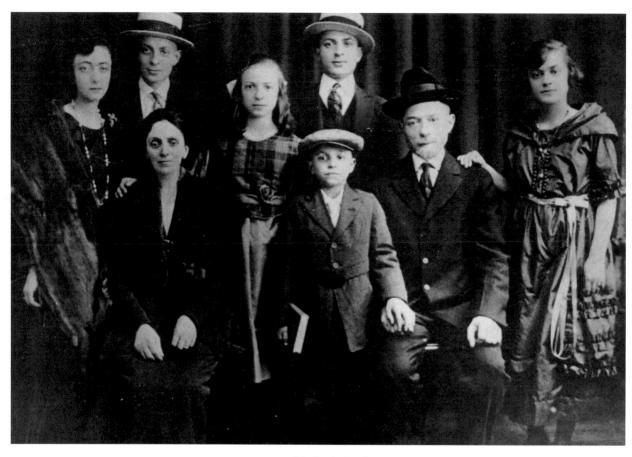

Mother's family, 1920. Front: Hinda, Louie, and Henoch.
Back: sister-in-law Molly, Morris, Etta, Izzie, and Molly.

from that city's yeshiva to be a groom for Hinda, who saw Henoch only once before marrying him. They went on to have five children. Henoch and their second son, Izzie, took a boat to America and worked until they had the money to send for Baba Hinda and Laibish, the baby. Hinda took the next boat with Laibish, but she had to leave three children behind. Her eldest, twelve-year-old Moishe Mendel, that is Morris, took care of eight-year-old Molly and three-year-old Etta until two and a half tickets could be sent for their trip to America.

Finally the time came for Morris, Molly, and Etta to make the crossing to America. Mother dramatically recounted the moment when one day in the midst of their five-week journey Moishe Mendel noticed that his baby sister Etta was lost. The poor boy was distraught. What if she fell overboard? After frantically searching, he found her fast asleep in a corner of the captain's cabin, where no steerage passenger had gone before. This story has been told and retold to Etta's children, grandchildren, and great grandchildren.

The children reunited with their parents in America and the family moved to an apartment above a store on the corner of South Third Street and Marcy Avenue in Williamsburg. The next move was to an apartment behind another store at 11 Eldridge Street on the Lower East Side. Zaida

Henoch made garters for the older children to sell on the street in front of the house; the younger children finished off the garters. "Laibish fastened the raw edge of the elastic into the metal clip, banging it in with a hammer," my mother told me admiringly. Her job was to put the elastic through the metal slides. "The work time was like our play time," she said ruefully.

The store on the ground floor was set back from the crowded sidewalk so there was also room to bring some *shmatas*, rags, to sell outside. Across the teeming street was the magnificent Eldridge Street Synagogue. Who could care about the squalor of sleeping three in a bed when you woke up to look out onto such grandeur?

Next they moved to 75 Eldridge Street, to the fifth floor of a tenement building that had a tub in the middle of the kitchen and a toilet down the hall. There were four tenants on each floor, two in front and two in back, all sharing one toilet. They would sleep out on the fire escape on hot summer nights.

"And we were happy," Mother said. "We never felt poor."

In winter, they carried heavy coal in two pails from the basement bin. In summer, they would sometimes get up very early to travel to Coney Island because there was a special rate of ten cents for lockers and just a nickel a train

ride before 8 a.m. My mother held back tears when she told the story of the one time that Hinda played ball with her on the beach of Coney Island, "She looked young at that moment. She was smiling. She always worked so hard, she was always so weary, but at that moment on the beach, she looked young."

Mom, tell me more about Hinda, even if I've heard it a hundred times before. Tell me again how her honesty shone because she was a *tsadeikista* (righteous woman). Tell me how her no-nonsense attitude ruled. Hinda, who I'm named after!

After Hinda died, Henoch married Rivka Greenfield, who came to the marriage with her own nine children. And so the nine Greenfield children and the five Scheinberg children became one family.

Soon after Baba Rivka married Henoch, on Etta's eighteenth birthday, Rivka took my mother aside and said, "I bought you nothing for your birthday, but I have a present for you! A *chassan*: my Anshel." Anshel was Rivka's youngest son. And that is how Etta, my mother, came to meet and marry her new stepbrother, Anshel, my father.

My grandfather, *zichrono l'vracha*, may his memory be blessed, was very pious, like my Baba. I was told that when his sons, my Uncle Izzie and Uncle Louie, would leave the house for the evening when they were young men, Henoch

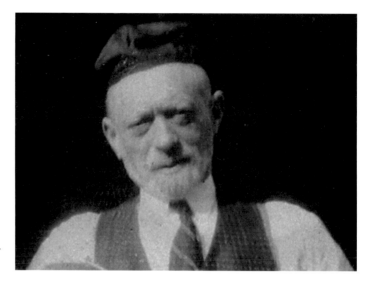

Zaida Henoch, 1931.

would say, *Gedenkt vehr du bist* (remember who you are) and not another word needed to be spoken. I suppose saintly Uncle Morris never had to be reminded, or maybe he never left the house.

HENOCH WAS ON his neighborhood's *chevra kadisha* committee, the group that washed the dead. This, of all the *mitzvot*, was what he had volunteered to do when they lived on the Lower East Side, and when they moved to Boro Park, he would take the train to Manhattan to continue this labor. (I have heard that female volunteers used to prepare dead women for the afterlife by putting sand from Israel into

their eyes and sometimes even in their vaginas. Oh Lord. At the end of my time on earth, will someone continue to be laying all this on and in me?)

Zaida Henoch died when I was two, and Baba Rivka came to live with us. Baba was my roommate until I was sixteen. All day long, Baba would sit by the porch window and *davin* (pray), unless she was cooking and baking in the kitchen with her devoted daughter-in-law/step-daughter, Etta. They'd wait together by the window of the indoor front porch for my meandering arrival from school. Then we'd all wait until Daddy's precise arrival at ten minutes to six from "The Place," his tie factory.

At six o'clock every weekday evening, Daddy would sit down to a sumptuous meal, and after dinner he'd slump in his easy chair with the *New York Times*, a brightly lit lamp overhead. I would wait for that moment to approach him with my *Rashi* homework. *Rashi* was the Torah commentator we had to study, who wrote his comments in Aramaic. I always hesitated to inflict Aramaic on my exhausted dad, but he would manage to groggily wake up to explain the *pasuk* (passage), the lamp never beaming quite enough light for the indecipherable, infinitesimal Aramaic font. I'd thank my smart Dad profusely, then hastily tiptoe right back to Mother, while he returned to his snooze. Daddy really knew a lot. He graduated from Yeshiva Yitzchak Elchanan.

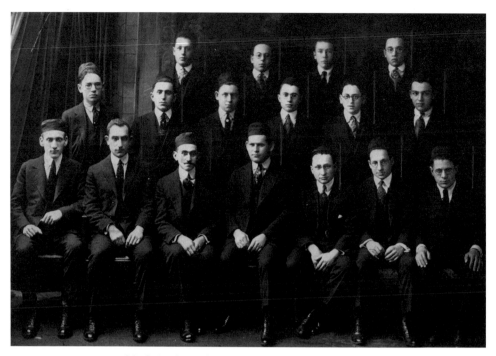

My father's graduating class at Rabbi Yitzchak Elchanan Yeshiva, 1924. He is in the middle row, first person on the right.

A picture of my father with his yeshiva graduating class hung over Baba's bed in the bedroom we shared, and I used to study it closely. Everyone in the picture had good posture, sitting and standing tall. From what I could see, everyone's shoes were polished. For sure, everyone was circumcised. Everyone had a yarmulke and everyone looked seriously sad.

It wasn't until long after I grew out of the neighborhood that it hit me—like pink streaks of lightning—what was missing from that picture.

EVERY YEAR before Yom Kippur, Baba brought a chicken to the basement for *kaporot*, atonement, a ritual that gave me the creeps. She would whirl the chicken around her head several times, supposedly transferring her sins to it. I was sure the chicken was terrified as it flapped its wings without pause. I was terrified when Baba whipped the bird around my head three times in a witchy way, singing *zot kaparati*, this is my sacrifice. I was to repeat after her: "This is my exchange, this is my substitute, this is my atonement. This rooster/hen will go to its death while I will enter and proceed to a good long life and to peace." Then she slaughtered the unfortunate bird. Believe it or not, there was even a gender differentiation in this custom: a rooster was used for a male's blessing, a hen for a female's.

I feel for Isaac, Abraham's son, the protagonist of the Biblical epic, *akeidat Yitzchak* (the binding of Isaac). How that youth must have quivered when his hundred-year-old father bound him up as a sacrifice to gain credit with a scary G–d. Even though the unlucky ram ended up as a substitute, Isaac must have been haunted by this trauma for the rest of his life. Every time I pass the sculpture of Abraham and Isaac when I visit my son and grandsons in Princeton where they live, I get an urge to stand at that statue there of the towering form of Abraham and the cowering form of Isaac, to let it be known that Abraham was hideously mur-

derous, undeserving of our admiration. Isaac was about the
same age as my third grandson, Adam. How beautiful to
behold are boys of that age, on the verge of manhood, but
still boyish, strong-boned and lanky. Could not G–d have
found another way to test Abraham's loyalty?

BABA ALWAYS KEPT a *shisel* of water under her bed in
our room so when she awoke every morning she could
immediately bend to dip her fingers into the dish to say
the morning prayer upon wakening from sleep, *Modeh
Ani. . . shehechezarta bi nishmati* (I acknowledge. . . thee,
for thou restored my soul to me). All this before she went
to the bathroom. Then she'd wash her hands again and
say the prayer we always recited when we came out of the
bathroom:

> *Asher yatzar et he'adahm b'chachma u'varah vo
> nkavim nkavim, chalulim, chalulim . . . sheh'im
> yepateiach echad meyhem o yesaseim echad mei-
> hem ee efshar lhitkayaim v'laamod lifnei keesay
> malchutcha.* (Who created the human with wisdom
> and created in him apertures, apertures, cracks,
> cracks, that if one would be opened when it should

have been closed, or closed when it should have been opened, it would not be possible to exist and to stand in front of the throne of your kingdom.)

I said this prayer many times a day, sometimes in the middle of the night, and certainly first thing in the morning. It was not a lofty prayer that one would sing in the temple in a clear voice. This prayer I mumbled very quickly to myself.

I NEVER WONDERED in my girlhood whether either my Baba Hinda or my Baba Rivka had ever been aware of the problematic passages as they peered into the *Tsena Renna Teich Chumash* (Yiddish Torah) they cherished. But in 1997, I dedicated an art piece entitled *The Women's Section* to my Babas with this statement: "If they knew, they did not say." Positioned in front of the long *shteibel tish* (the table in the women's section of a small shul) my proclamation, called "Table of Contents," contained a query: Would my Babas have been perturbed by all my probing, or would they have secretly welcomed it at long last?

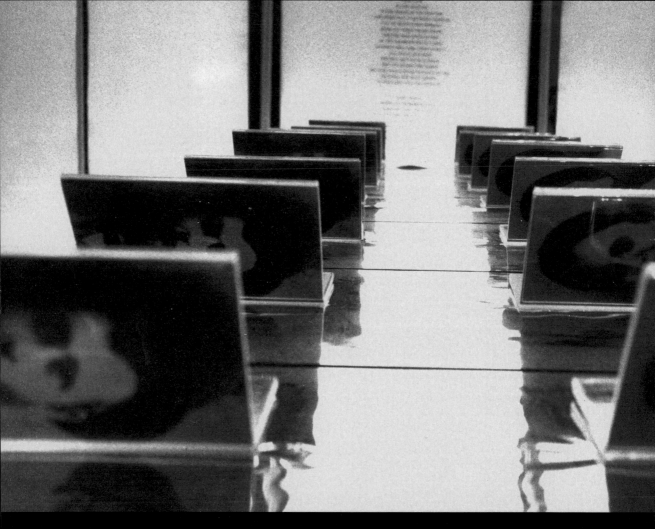

The Women's Section, 1997. Framed text with photos reflected on mirrored Mylar.

I BEGIN THE WOMEN'S SECTION
ILLUMINATING THOSE TEXTS
WHICH MY GRANDMOTHERS
—Zichronan l'vracha—
(May their memory be blessed)
KEPT IN THE DARK:
THAT MAN
SHALL RULE OVER
WOMAN;
THAT PRIESTS WHO SPRINKLE THE BLOOD
OF SLAUGHTERED ANIMALS IN THE TEMPLE
MUST FORBID A WOMAN WHO IS BLEEDING
TO APPEAR BEFORE THE LORD;
THAT IT IS MAN WHO IS SAID TO
BEGET
WHILE SUPPOSEDLY
TO THE WOMAN HE SAID
IN PAIN SHALL YOU BRING FORTH CHILDREN.
I WONDER
HOW BABA RIVKA,
PIOUS AS WIND,
COULD HAVE SAID TO ME
FROM THE TIME I WAS FOURTEEN
"Hindele velt nemen a talmid chacham."
(Helène shall take a Talmudic scholar in marriage.)
DID SHE KNOW—DID SHE KNOW
THAT THE TALMID CHACHAM OF ALL TIME,
THE GREAT RAMBAM, MAIMONIDES
POSED THIS QUESTION
ABOUT A THREE YEAR OLD GIRL:
IF THE GIRL WOULD BE CONSIDERED A VIRGIN
HAD THERE BEEN PENETRATION.
AND SO I WONDER IF BABA HINDA,
TRUTHFUL AS TIME,
EVER READ THE PASUK,
IF A DAUGHTER OF ANY PRIEST
PROFANES HERSELF BY COMMITTING INCEST,
HER FATHER DOES SHE PROFANE,
WITH FIRE SHALL SHE BE BURNT
AND THEN DID SHE, MY NAMESAKE,
SNEAK A LOOK OVER THE MECHITZA
TO SEE IF ZAIDA ALSO
GOT A SHTUCH ABOUT THE GIRL
OR DID SHE HOLD BACK, SAYING
"Oy, i don't need to know too much."
I REMEMBER
WHEN I WAS YOUNG AND SHE WAS OLD
I SLEPT IN THE SAME ROOM
AS BABA RIVKA, WHO LIVED WITH US.

EVERY MORNING
I SAW HER
DIP HER HANDS IN THE NAGEL VASSER
KEPT UNDER HER HIGH BED
FOR WHEN SHE AWOKE
TO ANOTHER DAY OF DAVENING.
"heiliche gut"
(holy G–D)
SHE SAID WHEN THE SUN ROSE
AND HER SOUL WAS RESTORED.
"inzera Tate. de eibishte."
(our Father the only one)
NOW I ASK
IN THE NINETIES
IN THE TERMS OF THE NINETIES
I ASK EVERY RAV,
I ASK EVERY LAMDAN,
CAN WE RESCUE HER EIBISHTE
FROM ALL THESE PROJECTIONS
FOR THE SAKE OF EACH GIRL
IN THE GENERATIONS TO COME
SO WHEN THAT GIRL GOES TO SHUL
ALL CLEAN AND OPEN
SHE WILL NOT HAVE TO HEAR
SHE CAN MARRY HER RAPIST
BECAUSE HE HAS DONE VIOLENCE TO HER
HE SHALL NOT BE AT LIBERTY
TO SEND HER AWAY ALL OF HIS DAYS.
NOW I PLACE
WHITE CLOTH BEHIND TEXTS
MARKING ONLY ON CLOTH
WHICH SHOWS THROUGH THE TEXTS
IN THE FRONT
AND BLEEDS THROUGH IN THE BACK.
THESE ARE THE PASSAGES OF MISOGYNY;
THESE ARE THE EMPTY SPACES WHERE
A FEMALE PRESENCE HAS BEEN OMITTED.
AND IF I COULD ASK
TO YOU I WOULD ASK
IS IT ALL RIGHT TO ASK
OH MY BABAS
WOULD YOU HAVE SAID TO MY FACE
HOLDING MY CHEEKS IN YOUR PALMS
"Hindele, meturnisht"
(Helène, you mustn't)
OR
WOULD YOU HAVE CLASPED YOUR HANDS
"geloipt tsu gut, shoin tseit"
(thanks be to G–D, it's time)

It was on our street in Boro Park that my father, Uncle Abe, Uncle Morris, and other shul people, like Louie Cohen and Julius Bienenfeld, would ceremoniously walk with a special Torah that had been rescued from the remnants of devastated Europe in the early forties. They walked it to the Young Israel shul on Fiftieth Street. The most heavenly privilege, from the look on the faces of those in the processional, was to be the one who held the Torah. I, being an Orthodox girl, never knew what that honor felt like, but I did know that the greatest calamity was to drop it. That was like dropping a newborn on its head, and the punishment for this great *averah* (sin) was a forty-day fast. Forty days! Moses waited forty days on top of Mount Sinai to get G–d's laws, and after he finally had them in hand, he got fed up with the idolatrous party scene below with the golden calf and threw down the tablets, so he had to spend another forty days creating the commandments without G–d's help.

It's funny that Moses did not get punished for the lack of anger management he displayed when he smashed

G–d's stone tablets. That act seems more worthy of a permanent time-out from the promised land than the incident that actually caused Moses to be banished; he struck, rather than tapped, a stone with his staff when G–d commanded him to bring forth water. Moses assumed that G–d needed a little push to make water gush out of stone, but G–d, in his omnipotence, needed only a light tap. You don't slight G–d.

I HAD a dazzling Hebrew teacher, Miss Kasha, who told us in class that her great rabbi father wrote two thousand interpretations on the first word of the Torah, *bereshis* (in the beginning). I wish I had raised my hand to ask Miss Kasha if perhaps her mother, Mrs. Kasha, might have written just one comment of her own, so there would be 1,999 by her father and one by her mother. But thoughts such as this had not yet germinated in my brain.

In fact, I could hardly think at all as I stared at Miss Kasha in her dark purple wool dress that reached up to her Modigliani neck. She wound her blond hair into a tunnel on top of her forehead, held in place by a single bobby pin. I could look through this tunnel when she turned to the side. I tried to comb my own hair in a tunnel like Miss Kasha's when Anna, our housekeeper, wasn't around to tightly braid my unruly hair. Another wondrous thing about Miss

Kasha was her dark purple lipstick, so dark it was almost black. It was called "Indigo," which sounded like the foreign land of India. I wasn't allowed to wear lipstick then, but on my wedding day when I was eighteen I wore that same dark indigo lipstick.

There were always teachers the girls flocked to, rushing to hold their hands. Only two girls could do so at a time, and I usually didn't care to compete with them. But in the fourth grade, I wanted to be one of the girls who bravely held Miss Kasha's beautifully manicured hand with the blackberry nail polish covering each divine long fingernail. Alas, this was one of the opportunities I missed; I was too shy to rush to Miss Kasha's side, lest the sound of my skipping heart be detected.

At recess, the girls in my eighth grade class played jump rope outdoors. Only Marilyn Shineman, one of the more developed girls, and skinny me chose to stay upstairs together in the girl's bathroom to talk about our bodies. Marilyn wore a shirtwaist blouse with two pockets that lay over her blossoming breasts. Her shoes were those loafers that had pennies tucked into the folds of the leather. I don't remember if the loafers came with the pennies or if you had to put in your own. Marilyn put on a show for me, taking out the pennies from her loafers and placing one penny in each pocket of her blouse, so that miraculously, the pennies

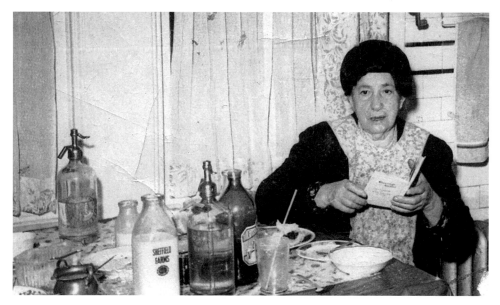

Baba at the kitchen table, 1942.

looked like nipples. We stared into the mirror until the bell rang and the other girls were climbing the four flights of stairs to the classrooms.

Lunchtime, I would come back to my mother for a *fankechen* (an omelet on a roll) or cheese blintzes, or milk soup with farfel. Baba would be eating the diabetic food that Mother lovingly prepared for her. Then Mother would inject the insulin, so lovingly. It was hard to leave to go back to English in the afternoon.

About once a week, I'd develop a cold that lasted just one day. I'd stay home sneezing and sniffling with tissues balled under propped-up pillows, my mother smoothing

out the fresh sheets, bringing me hot tea, pressing her lips onto my forehead to see if I had a fever, warning me to get more rest. I would take Coricidin—if you did not catch the cold immediately it could go into the second stage: sore throat, flu, and who knows, even pneumonia. For me it was just fine to be nursed by my mother, who was worried to death. My own greatest worry in my teenage years was that on my wedding day, I would have one of my colds and sneeze as I walked down the aisle. Curiously, these weekly colds stopped abruptly as soon as I got married.

Despite these weekly sick leaves I gave myself, the very formidable teacher, *Morah* Nechama Cohen, took note of me and invited me to her house for a special Hebrew poetry lesson. Mother was extremely proud because *Morah* Cohen was iconic. Everyone called her *Morah* in the same way that one might address the President of the United States as simply "president." She wore her black straight hair parted in the middle and tied neatly in a bun in the back. She could have been the model for the woman in *American Gothic*.

Morah Cohen had me memorize Hayim Nachman Bialik's "El Hatsipor," (To the Bird). In front of mother at home I'd dramatically ask the bird that flies to Israel to bring back news:

. . . Does dew from Hermon fall like precious pearls,
or are the dewdrops more like bitter tears?
And does the Jordan, like the eyes of girls,
still shine, before the sunlight disappears?

My repertoire also included a poem about the two spir-
its that visit the home at the outset of *Shabbos*: the good
yetzer hatov, who blesses the *Shabbos* home, and the bad
yetzer harah, who, upon seeing that all is in order, must
say amen against its will. At graduation I received the Bialik
prize. I suspect that *Morah* Cohen had this category made
especially for me.

Fifty years later it hit me that there was something
sorely missing in Morah's classes: she and my other schol-
arly Hebrew teachers never taught a commentary by a
female scholar.

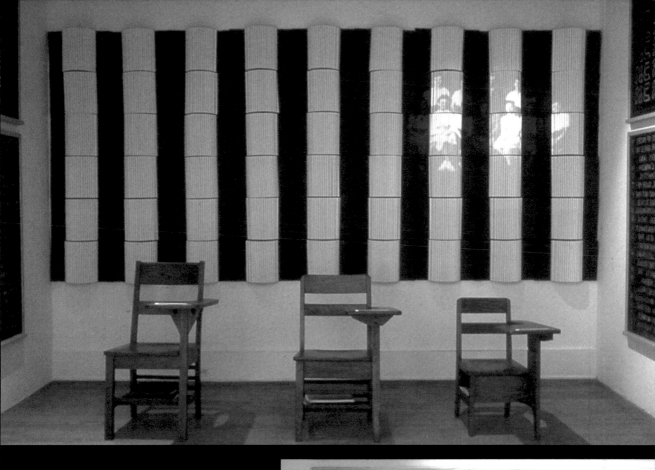

My Notebooks, 1998. Mixed media.

FOOTNOTES TO NO NOTES: DESPITE THE ABSENCE OF TEXTS BY WOMEN THE SUBJECT OF WOMEN WAS THERE FOR THE TAKING: THE BTULA-VIRGIN, THE GRUSHA-DIVORCEE, THE ALMANA-WIDOW THE ZONA-HARLOT DEFINED BY HYMENS INTACT OR PUNCTURED: THE WIFE MADE TO SWALLOW BITTER WATERS FOR THE HUSBAND TO OB- SERVE IF HER BELLY WOULD SWELL, THIGH FALL OFF. THIS IS THE LAW OF JEALOUSY: THE WIFE WITH HAND CUT OFF WITHOUT PITY BECAUSE THAT HAND HAD TOUCHED THE SECRET PARTS OF HER HUSBAND'S ASSAILANT WHEN SHE CAME NEAR TO SAVE HER HUSBAND THE SLAVE WOMAN WITH SHAVED HEAD, WEEPING FOR HER KIN ACROSS DESERTS, WHILE TAKEN AS BOOTY BY THE VICTOR; THE GIRL WHOSE INCEST WITH HER PRIESTLY FATHER RECEIVED THIS JUDG- MENT: WITH FIRE SHALL SHE BE BURNED: THE MAIDEN WHOSE TOKENS OF VIRGINITY WERE BROUGHT TO THE ELDERS OF THE CITY. I LEARNED IF HE GOES INTO HER AND HATES HER, HOW HE COULD SEND HER AWAY. I LEARNED IF HE RAPES HER HOW HE IS FORCED TO STAY WITH HER. I LEARNED BY NOT COMING NEAR HER FOR 3 DAYS HOW HE WOULD BE HOLY TO HIS GOD. I DID NOT WANT TO LEARN THE FATHERS' TEACHINGS ABOUT THE FEMALE HE TERMED NKAVA (HOLE) FILLING PAGES IN MY NOTEBOOKS. I WANTED THE MOTHERS' TEACHINGS FROM WHAT THEY COULD DISCERN FROM THEIR PLACE BENEATH THE MOUNT AND OVER THE CENTURIES WHEN THEY SAT TOGETHER IN THE WOMENS SECTION OF EVERY SHTEIBLE. I ENVISION THE MOTHERS OF YORE NODDING TO EACH OTHER "ALAS, WE ARE BAN- ISHED AS WAS HAGAR IN THE WILDERNESS" A CHORUS OF WHISPERS, "SEE, WE ARE LOATHED AS WAS LEA IN HER DARKENED BED CHAMBER" ONE FOREMOTHER POINTING BETWEEN HER LEGS, "WE ARE BEING USED AS WAS SARA, HANDED OVER," THE LAMENTATION: "OY V'AVOY WE ARE BLAMED AS WAS CHAWA, THE FIRST, WE ARE PUNISHED AS WAS MIRIAM AWAY FROM THE CAMP." I ENVISION A JOINING, LIKE FORMATION OF GEESE "RISE TO THE SKIES OH SISTERS FOR WE ARE NOT LIKE TERACH'S IDOLS WITH MOUTHS THAT DO NOT SPEAK," UNTIL ONE OF THEM TURNS BACK RECALLING "WHATS-HER-NAME, WHO TURNED INTO A PILLAR OF SALT" AND IN SILENCE THEY FOLLOW THE CURVE OF RETURN TO THEIR PLACE BEHIND THE CURTAIN. FIFTY CENTURIES HAVE PASSED AND STILL I DREAM, MAY ONE SCRAP BE FOUND BY SOME ANTHROPOLOGIST, AN ANCIENT PAGE THAT IS NOT BLANK, A PAGE FROM HER HAND AS SHE WAS...

I BEGIN
TURNING IN MY NOTEBOOKS
ON THE 54 CHAPTERS
OF THE FIVE BOOKS OF MOSES
SEARCHING FOR ANY NOTES
I COULD HAVE TAKEN
IN MY SCHOOL DAYS
AT THE SHULAMITH SCHOOL FOR GIRLS
IN BORO PARK
AND THE MIDRASHA HIGH SCHOOL
IN BORO PARK
NOTES ON THE WORDS
OF MY FOREMOTHERS
AND THEIR DAUGHTERS
AND THEIR DAUGHTERS' DAUGHTERS'
DAUGHTERS
AS IT IS WRITTEN
V'SHEENANTEM L'VANECHA
AND YOU SHALL TEACH THIS
TO YOUR CHILDREN . . .
BUT IN LESSON AFTER LESSON
ON THE FIFTY-FOUR CHAPTERS
THERE WAS NO WOMAN'S COMMENTARY
FOR ME TO WRITE DOWN
NO WOMAN'S PRINCIPLE
NOR BENEDICTION
THAT I COULD MEMORIZE
I TURN
MY HEAD FROM SIDE TO SIDE;
I TURN
THE PAGES FROM SIDE TO SIDE
MY HEAD BLANK THE PAGES BLANK
I SAY LET THERE BE WHITE!
FOR IT IS GOOD
IF ONLY TO ACKNOWLEDGE
WHAT WE WILL NEVER KNOW
FOR ME TO COPY
IN MY NOTEBOOKS.

FOOTNOTES TO NO NOTES:
DESPITE THE ABSENCE
OF TEXTS BY WOMEN
THE SUBJECT OF WOMEN
WAS THERE FOR THE TAKING
THE BTULA (VIRGIN)
THE GRUSHA (DIVORCEE)
THE ALMANA (WIDOW)
THE ZONA (HARLOT)
DEFINED BY HYMENS
INTACT OR PUNCTURED
THE WIFE
MADE TO SWALLOW
BITTER WATERS
FOR THE HUSBAND TO OBSERVE IF HER
BELLY WOULD SWELL
THIGH FALL OFF
THIS IS THE LAW OF JEALOUSY;
THE WIFE
WITH HAND CUT OFF
WITHOUT PITY
BECAUSE THAT HAND HAD TOUCHED
THE SECRET PARTS
OF HER HUSBAND'S ASSAILANT
WHEN SHE CAME NEAR TO SAVE HER HUSBAND;
THE SLAVE WOMAN
WITH SHAVED HEAD
WEEPING FOR HER KIN ACROSS DESERTS

WHILE TAKEN AS BOOTY BY THE VICTOR;
THE GIRL WHOSE INCEST
WITH HER PRIESTLY FATHER
RECEIVED THIS JUDGMENT—
WITH FIRE SHALL SHE BE BURNED;
THE MAIDEN
WHOSE TOKENS OF VIRGINITY
WERE BROUGHT TO THE ELDERS OF THE CITY.
I LEARNED
IF HE GOES INTO HER AND HATES HER,
HOW HE COULD SEND HER AWAY.
I LEARNED
IF HE RAPES HER
HOW HE IS FORCED TO STAY WITH HER.
I LEARNED
BY NOT COMING NEAR HER FOR 3 DAYS
SO THAT HE COULD BE HOLY TO HIS GOD.

I DID NOT WANT
TO LEARN THE FATHERS' TEACHINGS
ABOUT THE FEMALE
HE TERMED NKAVA (HOLE)
FILLING PAGES IN MY NOTEBOOKS;
I WANTED
THE MOTHERS' TEACHINGS
FROM WHAT THEY COULD DISCERN
FROM THEIR PLACE
BENEATH THE MOUNT
AND OVER THE CENTURIES
WHEN THEY SAT TOGETHER
IN THE WOMEN'S SECTION OF EVERY SHTEIBLE.

I ENVISION
THE MOTHERS OF YORE
NODDING TO EACH OTHER:
"ALAS, WE ARE BANISHED
AS WAS HAGAR IN THE WILDERNESS"
A CHORUS OF WHISPERS,
"SEE, WE ARE LOATHED
AS WAS LEA
IN HER DARKENED BED CHAMBER;"
ONE FOREMOTHER POINTING
BETWEEN HER LEGS
"WE ARE BEING USED
AS WAS SARA, HANDED OVER;"
THE LAMENTATION:
"OY V'AVOY, WE ARE BLAMED
AS WAS CHAVA, THE FIRST."
I ENVISION
A JOINING, LIKE FORMATIONS OF GEESE:
"RISE TO THE SKIES, OH SISTERS,
FOR WE ARE NOT LIKE TERACH'S IDOLS
WITH MOUTHS THAT DO NOT SPEAK"
UNTIL ONE OF THEM TURNS BACK
RECALLING
"WHAT'S-HER-NAME, WHO TURNED
INTO A PILLAR OF SALT"
AND IN SILENCE THEY FOLLOW THE CURVE OF
RETURN BEHIND THE CURTAIN.

FIFTY CENTURIES HAVE PASSED
AND ALL I CAN HOPE FOR IS THAT
ONE SCRAP BE FOUND
BY SOME ANTHROPOLOGIST—
AN ANCIENT PAGE THAT IS NOT BLANK,
A PAGE FROM HER HAND
THAT SHE WAS THERE.

At age thirteen, before graduation time was upon us at Shulamith School, I brazenly announced that I was going to be an artist and that I would go to the Music and Art High School in Manhattan. I got this idea from watching an older girl named Delores and her friend, Betty Grossman, draw pictures sitting on the porch two doors down. They made it seem sophisticated, even glamorous. (I wonder if Betty Grossman realizes how she influenced my life. I read that she became a recluse living in the Chelsea Hotel.) I never could summon the courage to ask if I could walk up the steps to see their drawings, but I went home and made my own drawing of a bearded Chassidic rabbi *davinning* (praying), which I copied from an oversized book on *pirke avot* (Ethics of the Fathers), the one art book in our home. I did another drawing of my Uncle Dave with his curled up Salvador Dali mustache, copied from an elaborate portrait of him set against Roman columns. I also drew my sleeping baby sister Linda, whom I used as a still model when I babysat on Saturday nights

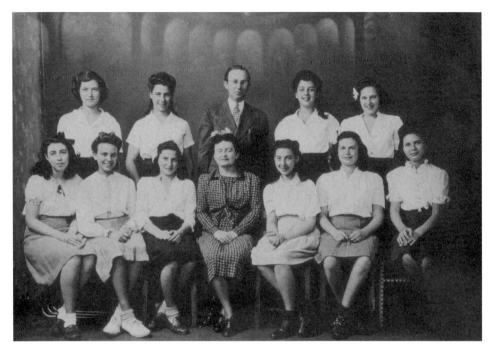

while Mother and Daddy went to visit Uncle Morris and Aunt Molly. Mother kept my drawings under glass on the bridge table so she could show them to company.

Both Dr. Leiberman, the principal of the Shulamith School for Girls, and Mrs. Jacobsen, the eighth grade English teacher, grimly set out to talk me out of applying to Music and Art. For Dr. Leiberman, the danger was that I'd come back too late in the day to attend the evening *midrasha* (Hebrew high school for girls)—and it was axiomatic that I continue my Hebrew education. For Mrs. Jacobsen,

Shulamith School for Girls graduating class, 1944. I am second from left, front row. Dr. Judith Lieberman, principal, is front row, center.

the danger was that I might bring down the school's repu-
tation; didn't I remember last year, when Anita Holtzman, a
Shulamith girl a year ahead of me, tried to get into Music
and Art and was rejected? I'd better be 100 percent positive
there was no chance of rejection before I applied.

I guess I wasn't 100 percent positive, since I didn't apply.

Instead, Mother and Daddy registered me in an art
course they saw advertised in the *Saturday Evening Post*
called Anyone Can Draw—all done by mail, no traveling
necessary. Then I could go to New Utrecht high school
by day (it was only three stops away on the BMT subway)
and attend the *midrasha* in the evenings and Sundays. I
received a "talent test" in the mail requiring me to copy a
profile of a blonde woman with an upturned face, upturned
nose and cascading hair like a Breck shampoo ad. When I
was accepted (surprise!) to the Anyone Can Draw Corre-
spondence Course, I went to the bridge table where Mother
kept my drawings under glass, tore them all up, and threw
them in the wastepaper basket. I quit Anyone Can Draw and
registered for the *midrasha,* held in the same stuffy rooms
of the daytime Shulamith School for Girls.

ANYWAY, MUSIC AND ART High School was in Manhattan,
which might as well have been a foreign country. I never

crossed the bridge to Manhattan except to go shopping with Mother at Klein's department store. We started these full-day excursions on the subway, full of promise, and came back at rush hour, as fatigued as soldiers after battle. We'd haul out our loot and model our bargains for Daddy. Then came the laborious task of choosing the perfect bargain dress and coat, after which we'd go back to Klein's to return the rejects, waiting on line for the refund. And there were accessories to be bought to go with the chosen purchases: white crisp cotton pique blouses that tied at the neck in an assertive bow for the new navy suit; a straw hat with flowing red ribbons to top off the navy spring coat with its shiny brass buttons; the Mary Jane shoes for shul, and the saddle shoes for school. And for September's back-to-school season, there was a pleated, dark green Scottish skirt, a corduroy blazer, and argyle knee socks.

OTHER THAN trips to Klein's, we hardly ever left Boro Park except in the summer, when we bypassed "The Neighborhood" and "The City" to head for "The Country," where we stayed in an Orthodox bungalow colony. Daddy would arrive on Friday afternoon, hours before *Shabbos* began, driving his Pontiac, after sweating in "The Place" manufacturing ties all week with his three brothers, Uncle Ben,

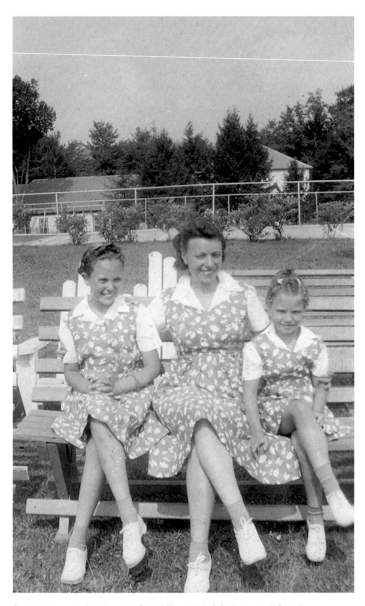

Summer vacation in the Catskills, with Mother and Sandy.

Uncle Dave, and Uncle Sam. I heard they made ties for the United States army. That must have been boring, all that drab khaki, but maybe they thought it was patriotic.

"Kiss Daddy hello," Mother would say. We'd run and show Daddy the ashtrays we made in Arts and Crafts, very useful for his three-pack a day habit.

When I was eleven years old, I was sent to *Machnayim* sleepaway camp. Mother laboriously sewed a nametag on every sock and undershirt, and every piece of the starched white resort clothes for the Sabbaths in camp. As soon as I got to camp that first year, I came down with the mumps and had the good fortune to leave before a frightening game of color war erupted. Faced with the game in subsequent camp years, I'd pitifully wait to be chosen by whichever team would reluctantly take me—the gold team or the green one—doing a good deed for a pathetic outcast. "You can have her," they'd say. "Oh, that's okay, you take her."

Thanks to color war I became a pacifist early on.

THE NEXT SUMMER, my mother ceremoniously shoved into my over-packed camp trunk a new item: sanitary napkins, in the event that I might "become a woman." Gross. Why call these things napkins? It made me feel queasy at the

dinner table wiping my mouth with the dinner napkin. Each year thereafter, at twelve, thirteen, and fourteen, I found this package in my camp trunk, ever ready—and each year the package was brought back like an unused airline ticket to a cancelled flight.

I was partially relieved I didn't have to use the napkins. My classmates and I had read and reread those sections in *Vayikra* (Leviticus)—the parts our teacher skipped over. We read that women were "unclean" when they got that bloody disease, menstruation. A husband could not even sit on a chair that his wife had sat on when she became a *niddah*, a menstruating woman. You'd think it was contagious. Even when my sisters had the measles and the mumps and the whooping cough, I could sit in the chairs in which they had sat. But according to *Vayikra*, a *niddah* is like an Untouchable in India. Maybe the thick white napkins were called sanitary napkins because they were meant to make "unclean" women "sanitary."

My cousin Dolly, who was a year younger than me, had the great idea that we should try on these grown-up accessories so we would know what they felt like. I certainly could not have asked Mother for the napkins she had stored away for when my time came. So Dolly and I snuck into her older sister Haivey's closet to find a stash. And there it was: a box of Modess in the back of the closet. Dolly pulled out

two napkins and handed one to me. She held them gingerly by the corners as though they were already soaked in blood. We took turns going into the bathroom to try them on. They were nice and soft. We only hoped they would not fall out of our underpants. We had heard that there were belts like seat belts to hold them in place but we didn't have that paraphernalia. Nevertheless, it was too late to fret, so we put on our coats and stepped out into the chaste Boro Park air, emerging with our hidden supplies intact.

We went to the bakery on Thirteenth Avenue to buy two *ruggelach* pastries. The store-bought *ruggelach* were delicious, but I remember thinking, "They taste good, but not as good as Mother's." To this day, that refrain goes through my head when I eat something Mother used to prepare.

Dolly and I had planned to replace the two napkins we took out of the Modess box with new ones once we were safely back in her bathroom. However, we were sure no drugstore in Boro Park would sell two individual sanitary napkins like the two *ruggelach* we had just bought from the bakery. And even if we had the money for a whole Modess box, someone in the street might bump into us and surmise what we were carrying. Besides, the druggist was a man—embarrassing enough—and worse, he was sure to know my mother. Even the tellers in the bank knew her; she'd always linger, despite the long line of impatient people waiting

behind her, to ask about the teller's family and vacation and whether the teller felt rested. Mother also asked the ladies who worked in Terry's Beauty Parlor on Twelfth Avenue about their health and complimented them on their bird nest hairdos. Even though Terry's Beauty Parlor catered to those ladies who did not wear *shaitels*, the shop also shampooed the *shaitels* that the *frum* ladies brought in, hanging these pageboy-styled wigs on faceless, foam rubber heads. Though many of the ladies were grandmothers and great grandmothers, I never saw a gray *shaitel*.

Dolly and I knew that to put the napkins back in Haivey's closet after we had tried them on was an abomination, biblically speaking. Better to use the paper bag that held the pastries for the disposal of the evidence. So after we had our treats, we took turns going to the bathroom to put our sanitary napkins into the empty paper bag. Then we went out once again, past the bakery, almost out of the neighborhood, to dump the evidence on Fifty-Third Street. All the while, we prayed that Haivey would never count the napkins in the Modess box she kept in the back of her closet and realize that two were missing.

When I was old enough to be a junior counselor at camp, the big moment arrived when these supplies were finally necessary. I would have been sort of glad to at last join this grown-up club if Mother hadn't immediately

announced the event to Daddy. To me, she said, "Congratu-
lations, today you are a woman," similar to the way that a
Bar Mitzvah boy is congratulated on becoming a man. After
his Bar Mitzvah, a boy is supposed to be grown-up enough
to take on *mitzvot*, good deeds, and he is showered with
gifts like *The Pictorial History of Israel Through the Ages* or
The Greatest Jewish Baseball Players that Ever Lived. But in
those days, Orthodox girls did not have Bat Mitzvahs, and
we certainly didn't receive books when we got our period.

My Marriage Bed and My Clean Days

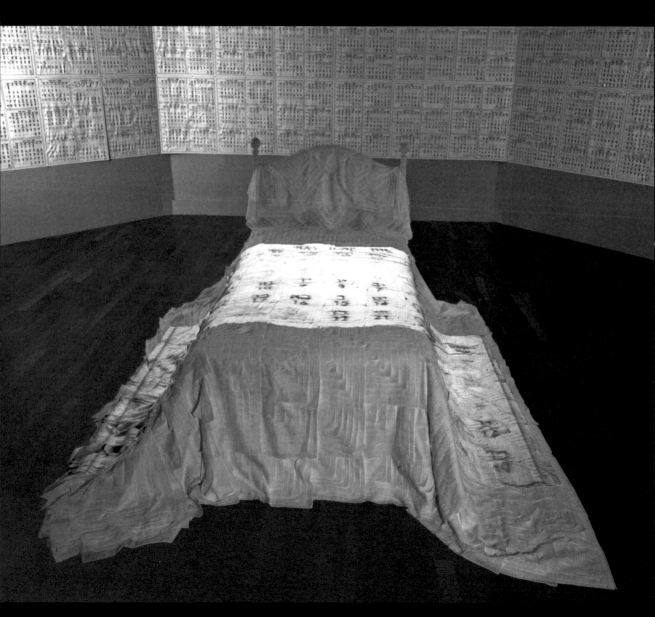

My Marriage Bed and *My Clean Days*, 2001. Mixed media.

THE BATH

YES I COUNTED IN A SYSTEM
THAT FOLLOWED THE PLANETS
NOT EVEN PASSING THE SALT AT THE TABLE
FOR FEAR THAT HANDS WOULD TOUCH
I SAY THE SYSTEM WAS DEVISED
BY AN ANCIENT WIFE
WHO LIVED IN A POLYGAMOUS HOUSEHOLD
AND IT WAS SHE IT WAS SHE
WHO WATCHED HER MONTHLY CYCLE
AND BROUGHT OTHER WOMEN
TO BATHE TOGETHER
AND WATCH THEIR OWN CYCLES
IN THE FULLNESS AND WANING OF THE MOON.
NOW IT IS WRITTEN IN LEVITICUS
THAT IT IS THE MAN WHO MUST BATHE
IF HE TOUCHES HER
OR TOUCHES WHAT SHE SLEPT ON
DURING HER IMPURITY
NOWHERE IS IT WRITTEN IN LEVITICUS
THAT IT IS THE WOMAN WHO MUST BATHE.
OF COURSE, THERE IS NO WRITTEN RECORD
TO PROVE IT WAS SHE
WHO BEGAN THE IMMERSION INTO THE BATH
LONG BEFORE THAT PRACTICE GOT CODIFIED
WITH TERMS LIKE "UNCLEAN"—
THE TERM THAT WAS USED
FOR A LEPER OR A CORPSE.
"UNCLEAN" WAS NOT THE TERM SHE WOULD USE
AS SHE COUNTED THE DAYS
BENEATH THE SUN'S RISE AND BY THE LIGHT OF ITS FALL
SO THAT SHE COULD BE THE ONE TO SAY WHEN
BY ENTERING WATERS
ON THE LAST EVE OF HER COUNTING.
THIS I KNOW: THE TERM "UNCLEAN" CAME FROM
THOSE WHO DO NOT BLEED.

THE BIRTH

NOW THE ONE WHO GIVES BIRTH
IS THE ONE WHO WOULD KNOW
HOW MUCH BLOOD SOAKED THROUGH
THE MIDWIFE'S RAGS
WHEN THE NEWBORN GIRL
STRUGGLED OUT OF THE WOMB
AND THE ONE WHO GIVES BIRTH
IS THE ONE WHO WOULD KNOW
HOW MUCH BLOOD SOAKED THROUGH
WHEN THE NEWBORN BOY STRUGGLED OUT.
DID SHE LAUGH OR DID SHE GRIEVE
WHEN SHE WAS TOLD
THAT SHE IS "UNCLEAN" FOR A LONGER TIME
AFTER HER GIRL CHILD IS BORN—
THAT SHE IS "UNCLEAN" FOR A SHORTER TIME
AFTER HER BOY CHILD IS BORN;
AND BE IT A BOY OR BE IT A GIRL
SHE IS TO TAKE A SIN OFFERING
A PIGEON OR TURTLE DOVE
TO THE PRIEST . . . TO BE CLEANSED
FROM THE SOURCE OF HER BLOOD . . .
SHE MAY HAVE ASKED AS I ASK NOW:
WHAT WAS HER "SIN" GIVING BIRTH?
AND DID SHE NOT HAVE HER VERY OWN WAY
"TO BE CLEANSED" AND BATHED
AFTER THE STRENUOUS BIRTH?
BUT CENTURIES LATER THE RABBIS PRESCRIBED
THE BATH (THAT ALREADY EXISTED)
AND DID NOT ACKNOWLEDGE THAT
IMMERSION AFTER CHILDBIRTH
(EN LIEU OF THE LEVITICUS INJUNCTION
TO SACRIFICE BIRDS IN THE TEMPLE)
WAS AN IDEA THAT HAD TO COME FROM A
WOMAN, NOT FROM
THOSE WHO DO NOT BLEED.

Growing up, I had a task to complete each Friday as part of our preparations for *Shabbos*: I tore a roll of toilet paper into individual squares, since we were forbidden to tear on *Shabbos*. I neatly tore every piece on the perforated line the way my father neatly tore along the perforated line of his telephone bills. Then I stacked the squares in a pile. My other job was polishing my Dad's big shoes. "Next size is the box," he'd quip each Friday, when he handed me his size twelve shoes with the heavy shoe-trees in them.

On Friday afternoons Daddy would leave "The Place" early and head straight to the *shvitz* (steam room) with "The Boz" (Daddy's nickname for Uncle Abe), and when he returned to us, he was high on life, eager for *Shabbos* to begin.

At candle lighting time, the dazzling white tablecloth covered the large *tish* (the dining room table) making it look like a world unblemished. Everything shone brightly. The silver candlesticks on their silver tray, the silver kiddush cup

on its silver tray, the silver *Shabbos* knife, the silver tray under the challahs—all gleaming.

My mother lit the *Shabbos* candles with a lacy hand-kerchief loosely laid on her head. I watched closely lest it fall into the flames. I loved the movements of my mother's arms bringing the *Shabbos* light toward her in broad arcs, her arms sweeping the light in toward her heart—one time, two, three, all in slow motion. When she lifted her palms from her face, her eyes beneath were invariably moist. "Good *Shabbos*!" she called out and kissed whoever was witness to the great arrival of the *Shabbos*, accompanied by the moon and the comet and the *Shabbos* queen and the angels and the *Shechina* (the divine presence of God) all arriving every week precisely at sundown when the siren was heard throughout the land of Boro Park to announce *lecht benching* time (time to light the candles). Not that we were ever in danger of being late. My mother was always ready two hours early.

After the lighting we'd leave the candles in all their glory to watch from the front porch as the men paraded to shul wearing their *tallisim* (prayer shawls). It was dusk, *bein hashmashim*, the hour "between the suns" which seemed strange to me since sunrise was hours away. My younger sisters would scurry about while Mother and I reclined on the couch, our feet sharing a hassock, as we waited for

Daddy to return. We'd keep watching as the streams of men returned from their various synagogues, the fathers walking proudly with their young sons.

Upon their return to their homes, the men would recite the weekly Friday night poem of praise, "*Eishet Chayil Mi Yimtza*" (A Woman of Valor, Who Can Find) to their wives. "She is the trading ship bringing food from afar. She gets up while it is still night to provide food for her household . . ."

After the kiddush on the wine for which we all stood around the table, we'd sit down to sing *Shalom aleichem, malachei hashalom* (Peace to you, angels of peace). Then came elaborate washing of hands with the sterling pitcher. We'd wait silently for Daddy to say the blessing over the challah and then—only then—the meal would begin.

At the end of the meal we would sing, the tune starting and restarting on a loop, as if we could not get enough of it, "*Sheishet Yamim Taaseh Mlachtecha, v'yom hashveeyeey leilohecha,*" (Six days shall you do your work; the seventh day is for your G–d.) I can hear it now, pulling me back to the *Shabbos tish.* In summer, when windows were open, the same *niggunim,* melodies, from other tables in other houses would float through the warm breeze onto the streets of Boro Park. One could taste the sounds. Uncle Dave and Aunt Lulu, Uncle Ben and Aunt Brucha, and Uncle

Sam and Aunt Ray, Uncle Nuchum and Aunt Yetta, and sometimes Uncle Moishe and Aunt Elko would stroll in with their kids without ringing the bell, since ringing the bell is forbidden on *Shabbos*.

Then Daddy would sing "*Yom ze mechubad mekal yamim ki vo shavat tsur olamim,* (This day is honored above all days because on this day the creator of worlds rested). He repeated the *niggun* like a mantra, tapping the *Shabbos tish* as the meaning behind the words intensified more and still more with each refrain.

We never turned off the lights once *Shabbos* began; a gentile named Johnny came every Friday night to do it for us. He was old, bent over, and a bit crazed. His shabby pants looked like they were about to slip down any moment. A dime was left for him on the counter, prepared before *Shabbos*. Johnny liked receiving his bag of jellyroll and apricot cookies along with his dime and Mother's praise. He came in the snow, in the rain, in heat spells and in frost, every Friday night until he died. Although Johnny performed his role in the *Shabbos* ritual with relish, I still blink with embarrassment that he was referred to as "The *Shabbos* Goy," an impolite term for someone who was so important to us. Johnny helped make it possible for us to feel the intensity of the *Shabbos*. And despite our gratitude to Johnny, we still recited: "*Ki banu bacharta V'otanu kidashta*

mikal Ha'amim" (For it is we whom you have chosen and we whom You have sanctified above all nations).

The next morning, known to the outside world as Saturday, we Greenfield girls headed out for the Young Israel shul on 50th Street. Daddy would have left two hours before. My sisters and I were always late, yet perfectly groomed, striding like royalty. We wore our small linen handkerchiefs tied around our wrists, since carrying anything was forbidden on *Shabbos*. Inside Young Israel, my mother would reintroduce me to the ladies I had known all my life, their eyes taking me in with obvious pleasure.

After services, once everybody had blessed each other again, we would walk home together—Daddy and I in front, Mother purposefully behind us, exclaiming how good Daddy and I looked together, tall people with good posture. I can't remember whether my two younger sisters were holding Mother's hand or just hanging about hoping her fixated gaze would fall on them. That gaze was reserved for the eldest. I tried to direct some of Mother's fierce beam onto my sister Sandy, who wanted it, while I could have done with a lot less. My baby sister Linda was less attuned to these disproportionate offerings of attention, and consequently she is a more happy-go-lucky person than the one who got too much and the one who got too little.

Mother commented on everything about me. My attitude—"did you greet so-and-so?" My image "why didn't you wear your pearls?" She cared about appearance as much as a *Vogue* fashion editor. And she had a thing about my hair. "Put your hair back, back! Show your face, I can't see your face," she'd say with a tormented expression. Even in later years when she was semi-blind from macular degeneration, she would nevertheless comment about my hair looking "wild." And all throughout my Shulamith years, our Polish live-in housekeeper Ana Sikora was instructed to brush my hair with one hundred strokes every morning while Mother prepared breakfast. Anna brushed as if she was pounding a rug, and she pulled the braids tightly from my scalp. I got even with her when I set the table and put her fork upside down while I set the rest of the table perfectly for everyone else's place—even my sister Sandy's.

The table was always set before we left for shul so that Daddy would not have to wait one moment upon our return to enjoy his schnapps for kiddush, and his *lecach*, sponge cake. Somehow, cake at kiddush before the meal never spoiled our appetites.

Often Daddy would gather round a whole gang of shul *menchen* for kiddush. The army of men would stampede

into the kitchen, heading for the stove that had a thirty-six-inch square *blech* (a metal plate on top of one low-heating burner so that the stove was always hot without someone having to turn any knobs on *Shabbos*). They would stand around the *blech*, holding out their plates while Baba and Mother hastily ladled out the steaming *krollas* (stuffed hot dumplings) lifted from boiling oil in the tallest of pots.

"Wear an apron in the kitchen" Mother would say to me a bit sternly. "Your beautiful dress is too fancy without an apron." The aprons were all stained with gravy, but I'd dutifully put one on. I remember once making a mental note to myself to buy Mother a new apron for Mother's Day, thinking this would score points for me. She never could accept gifts, always insisting she did not need anything, but she would have to admit that she could use an apron, at least when company came. So I presented an apron to her that she raved about as if it was made of diamonds, saying she would save it for special celebrations.

Baba and Daddy sat at the head of the table like a queen and king. Mother was the lady-in-waiting, the role she preferred. She never took on the role of queen. And she never allowed us to sit in Daddy's chair, not even after he died. It was his throne and we were his kingdom. Even now I

can hear Daddy calling out from his throne laughingly to "Toots," as he called Etta.

After an endless meal of fourteen courses, Daddy would again begin singing *zmirot* (*Shabbos* songs). Before each tune, we'd all confer over which it would be, since each one had many. Take "*Tsur mishelo, mishelo achalnu, v'savanu kidvar adoni*" (Source, from you we ate and we were satisfied, according to the word of G–d), a song of appreciation for the meal. I once counted in a Hebrew song-book seventeen melodies for this one song.

At the end of the *zmirot*, a very long *benching* (grace after meals) ensued. Mother always dragged out the *benching*, while I'd purposely rush the tempo, but she'd slow it down even more, holding the reins, singing louder than me lest I gallop away from the table too soon. She had all the time in the world to *bench* around the *Shabbos* table.

Afterward she kept me close by to deal with the uncountable "best" dishes reserved for *Shabbos* and other special occasions. She was always the one who washed the dishes and always had me do the drying. My sisters would bring the dishes from the dining room to the kitchen. After the precious sterling silver was dried, Mother made me count each fork and spoon and knife before putting it back in the frayed maroon velvet-lined chest. "One of the forks

or spoons might have fallen into the garbage, you have to count them," Mother insisted. "This is sterling, you know." Then I lugged the heavy thing to the mahogany bureau where I shoved it back in until the next week, and locked the bureau with its impressive gold key as if it was a safe in a vault. Next, all the sterling kiddush goblets and the bone china English teacups were put away on exhibit in the dining room buffet.

After sweeping the challah crumbs off the white tablecloth, the time would finally come when I could take off with my friends. I was more certain to be promptly excused when my best friend Hindy called for me. My sister Sandy always tried to prevent us from leaving by clinging to Hindy, squatting on the floor and holding on to Hindy's leg so she could not move. This would cause me to hyperventilate loudly, and Daddy would sing out to me, in his irritating sing-song style, "H-U-M-O-R."

When we finally, finally got out of the house we met up with five other girls. We called ourselves "The Seven." We'd walk from house to house in a herd, crunching on potato chips, giggling and screaming confidences at each stop. We knew another girl gang from a higher class, and there was a rumor that they once walked to a church way out of the neighborhood and one of them had spit in front

of it, encouraging the others to follow her lead because she said the preachers told lies about Jews. No one else spit; they just turned around and came back. I thought this story was disgusting and I was relieved that my group mainly concentrated on discussing whom we'd vote for as the prettiest girl in the class. Or we'd ask each other, What would you choose, if you could get your wish, a gorgeous face or a gorgeous figure?

But in the midst of all this revelry, especially when we took a long walk, there were always these two words circling in my head: Get Home.

> Get home before *Shaloshseudot* (the third meal on the *Shabbos*).
>
> Get home before *Havdala* (the prayer for the separation of the holy from the mundane).
>
> Get home before *lecht benchen* (the lighting of the candles).
>
> Get home before *B'dikat Chametz* (the search for crumbs before Passover).
>
> Get home because the Torah says so.
>
> Get home because that's our way of life.
>
> Home, where you belong.

It was hard to go far, as if I was running on a treadmill.

At the end of the *Shabbos*, I, as the eldest, was privileged to hold the *Havdala* candle. That twelve-inch candle was a remarkable object, with its intricate braiding and its four small wicks that, once lit, became an instant torch. There was danger and high drama in my fiery assignment. "Hold the *Havdala* candle up high to get a tall husband," Mother would predictably repeat each week. I'd stretch my right arm and stand on tiptoe like the Statue of Liberty, holding the torch up as high as my tall Daddy while the *b'samim* (spice box) was passed around to all those circling my torch. Each one of us would sniff the ancient aroma and pass it to the next. I would be last to hold the spice box, after Daddy had taken the candle from me. Then I could open the *b'samim's* tiny silver door and stick my nose right inside. I'd finger the four tiny silver flags above its little door, flags that swayed like the fringes of the *tallisim* on the hips of the yeshiva boys.

Now the sweet aura of the *Shabbos* would linger over the weekdays ahead, fortifying us to withstand the imminent separation from the divine. *Shavua tov, shavua tov* (a good week, a good week), we sang as the fiery torch was doused with wine poured over it, and the fragrance of wine mingled with the fragrance of cloves. We'd sway in unison singing the refrain in Yiddish, "*Gut vuch, gut vuch!*"

HOW COULD IT have happened that my tall, handsome Dad would drop dead, too young, as he and his "Tooto" held hands walking out of a movie toward the parking lot? They never ever went to the movies, but this was a benefit for Young Israel, and the entire shul crowd was going, so they joined in. The movie, *The Agony and the Ecstasy*, was not one my parents would have chosen if they'd known they'd be watching an artist painting the ceiling of the Pope's Sistine Chapel. Oy. "Who needs such ecstasy," Mom must have said to herself. And Daddy must have wondered why the Talmud did not mention that having a daughter who's an artist was an extra worry for her father. How often I've tortured myself wondering that if the movie had been *Fiddler on the Roof* or *The Sound of Music*, might my Dad have driven home that night?

One Saturday recently, I suffered through an empty *Shabbos* that felt like a *prust* Monday, an ordinary weekday. I had spent the day writing for a grant. I was to meet a friend uptown at the end of the day, and I decided to skip the bus and walk all the way. To the rhythm of my slow strides I sang "*Attah echad v'shemcha echad*" "You are one and Your name is one," Daddy's favorite. I kept humming it like a mantra, and by the time I reached my destination, I felt full.

Late that night, my sister Linda telephoned from California to apologize for forgetting to remind me that it was Daddy's *Yahrtzeit* (the anniversary of his death). I told Linda that she did not have to remind me. I knew, although I did not know that I knew.

MORAH COHEN taught me a poem by Bialik in which he writes that he can taste the salty tears in his mother's challah. I could taste the emotion in my mother's *lukshun kugel* (noodle pudding), both the apricot and the plain; her *knaidlach* (matzo balls); her *ruggelach;* her *chremslach* (Passover pancakes); her *cherein* (horseradish to serve with her gefilte fish); her latkes; her *noent* (a honey and nut candy); and her *hulupshkas* (a dish of stuffed cabbage). I could taste it in the apples and honey she set out for us to eat after the prayer "for a sweet year," and in the *glaisele tei*, tea in a glass, which she always served boiling hot and filled to the brim. One dish that puzzled me was the *zucher kichel*, literally translated as "boy pastry," which she made to celebrate the birth of a boy baby, served on the Friday night following the newborn's birth. That round, thin, bumpy pastry the size of a large pizza was somewhat sculptural, with its grooves and its sugary overlay resem-

64

bling snow on a rock-strewn landscape. There was no such astonishing pastry for celebrating a newborn girl—a cause yet to be challenged by Jewish feminists.

We never went to restaurants and when we were invited out to dinner, Mother would insist that everyone come to our house instead, as it was really easier for her to cook for ten than to go out like a guest. Then she would cook an elaborate dinner at home, careful to make sugarless recipes for those who were diabetic or for those "who had to watch their diets"—Mother's euphemism for overweight guests.

Mother continued to supervise my food intake long after I moved out. "What are you eating?" she would ask regularly. She already knew of my non-kosher proclivities, but her warnings escalated over the years:

"Look for bright lighting if you must go to one of those restaurants, so you can see what's on those plates."

"Be careful not to eat any of their sauces. Who knows what *chazarei* (pig stuff) they mix in."

"Did my *shalach manos hamantaschen* (pastries for Purim holiday) get there okay?"

"I didn't hear from you. Tell me which *hamantashen* you like better, the dairy kind or the pareve?

"Which filling, the prune or the apricot?"

"So what about Pesach?" She always asked this question right after Chanukah, although Passover was months away, in the spring.

"And will you be at the *simcha*?" A *simcha* (celebration) could refer to an *Aufruf* (when a groom is called up to the Torah) or a bris or a *chanukat habayit* (housewarming), or a party for someone's genius grandchild graduating from Harvard or from kindergarten on the road to Harvard. There was always a *simcha* that I inevitably had the chutzpah to miss.

"You know, you need a touch of home with all that strangeness you're in."

But when I left Boro Park I could not completely relish any freedom I gave myself. Instead I missed the rituals, the rules, the questions, the *simchas* for even the smallest occasions. Everyone knew it was just not a *simcha* without Mother's vast, unfailing enthusiasm as she flaunted her mazel tov cake with its icing message scrawled on top. She'd carry it out to the waiting crowd like a coronation crown. (She even supervised the baking of her own mazel tov cake for her hundredth birthday party, held under palm trees in my sister Linda's North Hollywood garden.)

MOTHER ALWAYS WROTE the Hebrew letters *Beit* (B) and *Hei* (H) on the cake in icing. Those letters stand for *Baruch Hashem* (blessed is the name)—meaning G–d. I was taught to start every correspondence with *Beit* and *Hei* written on the upper right corner of the page, no matter to whom I was writing. To this day, any document, letter, or even email feels strangely lacking without the *Beit* and the *Hei* on the upper right corner. *Baruch Hashem*—blessed be G–d, here is my rent check. Here, Guggenheim folks, *Baruch Hashem*—here is my fifth grant request for you to ignore. Here, Reader, *Baruch Hashem*—here's my life.

The other translation of the initials B and H is *B'ezrat Hashem* (with the help of G–d). No future plan could be mentioned without the prefix *B'ezrat Hashem*. *B'ezrat Hashem*—you have an appointment with the dentist; *B'ezrat Hashem*—you will go to summer camp with its color wars; *B'ezrat Hashem*—I will finish this manuscript and read the Boro Park parts to Mother.

When mother's eyesight began to fade, she asked me to read to her from the *sedra*, the Torah portion of the week. I tried to talk her into a novel, but no. It was the *sedra* of the week that she wanted. The only stories outside the Torah portions she would agree to were those of my memories of Boro Park, which is how this book originated.

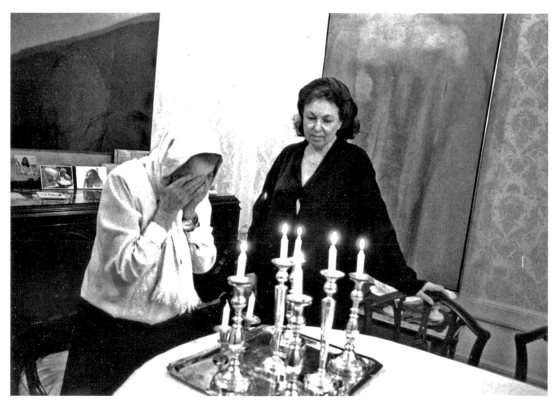

Mother and me at candle-lighting time, 1999.

Back to Mother's *simchas*. On *erev Shabbat* (each Friday after sundown) a mazel tov cake usually sat waiting on the bureau. There were almost always guests at the table with whom to celebrate. Mother specialized in gathering widows and spinsters who never got invited anywhere. "It's sad to be a fifth wheel," she told me. For years, Mother even invited the snooty landlady, Mrs. Schwartz. "You be the good one," Mother explained when I said I would never extend myself that way and asked why I had to sit with Mrs. Schwartz at the table. Mother might well have said, "turn the other cheek." She would have made the best Christian.

SOMETIMES Mother would ask me to help her on Friday afternoons by taking two cartons of care packages up to the third floor. In the cartons were all the courses of the *Shabbos* feast, one marked for ninety-seven-year-old Mrs. Baumwild, and one for ninety-eight-year-old Mr. Kratter, sister and brother hermits. Most times, Mother lugged the two cartons by herself without any fanfare. She'd place them on the threshold of their door. Behind that door, one would find the brother and sister. They hated each other and were only living together to save on rent. They never spoke to each other. Each had an unmarried daughter we felt sorry for, and these daughters also did not speak to each other. I usually

had to make two trips up the three flights, as the packages were very full. Mother gave the brother and sister sugar-free gefilte fish, assuming they were diabetic. She never inquired. Mother never waited to hear a thank you; I never waited either, but fled down the stairs like an unleashed dog, not bothering to hold on to the rickety banister.

If somebody was dying, Mother was like Florence Nightingale. She was there at the deathbeds of her three brothers, Uncle Morris, Uncle Izzie, and Uncle Louie; and her sister, Aunt Molly; and her best friend, Aunt Tybee.

"Tybele," she'd said, holding Tybee's hand, putting a cool cloth on Tybee's forehead, "Remember how we wore the same wedding gown, how we'd hang our wedding photos side by side? You with your Abe and me with my Anshel, *alav hashalom* (may peace be upon him)," she'd say after Daddy was gone. Little did my mother know then that she would marry Abe, Tybee's husband and my father's best friend, seven years after Tybee died. Uncle Abe simply moved into the house with Mother. And Mother left those wedding photos of Abe and Tybee, Etta and Anshel on the dining room wall. They were all still a foursome, even after Anshel and Tybee were gone.

When Uncle Abe developed dementia in later years, Mother wanted him to continue to think of himself as a fine

businessman. She took him on the subway every morning to a small room I found for them to rent in Manhattan, allowing him to imagine it was the business he had owned for years, Admiration Thread. Mother bought him a Saks Fifth Avenue attaché case with his initials, A.S.B., engraved on the clasp; inside the case were sandwiches she packed for lunch. In the "office," Mother would write checks for some bills and make a few phone calls, and Abe would watch her as if he were her supervisor.

There had been only one sickbed that eluded Etta: that of her own mother, who died at the age of forty-nine, when Etta was just sixteen. Etta would have climbed into Hinda's sickbed to comfort her; Etta would have kneeled on the floor alongside the bed if kneeling had been allowed for Jews. But Etta was hospitalized with scarlet fever at the time that Hinda became seriously ill with cancer. Etta did not know that her mother had died until she came home from the hospital to find out that the funeral had already happened.

But Etta did not feel sorry for herself. Even at one hundred years old, she did not bemoan the hazards of old age. When my sister Linda's sixty-year-old friends were comparing their aches and pains from getting older, Mother chimed in, "Oh, the best is yet to come!" And her answer to the query, "How are you?" was, without fail, "I'm here!"

Food was the memorial my mother created for those who were gone. She was strict about acknowledging and giving proper credit to the origins of a recipe.

"Try some of Julia's *mandelbrot* and see how good it is with hot tea." Sister-in-law Julia died, but her *mandelbrot* lives on.

"You must have some of Edith's cucumber salad." Aunt Edith died, but her cucumber salad lives on.

"There's nothing like Tybee's crumb cake." When Daddy died and Mother married Uncle Abe, Mother would make Tybee's recipes so Uncle Abe would remember his first wife.

My daughter Renée nicknamed Mother "Choo-Choo" because she hurried so, running to do this and that. Except when she answered the doorbell. When she walked from the kitchen to the porch to answer the door it felt like an eternal wait. As an adult, when I came to visit I would begin to panic in those endless moments listening for her footsteps. I'd press my ear to the door, worried sick that she might be lying on the linoleum floor in the kitchen panting, unable to rise. And what would I do if she died, how could I go on? Finally she'd look through the small slot and ask in a guarded tone, "Who's there?" Satisfied with the way I stated my name, she'd swing the door open, her

arms spread, ready to hold me, to hold on to me, to have a hold on me, to ground me, shelter me, feed me, clutch me. She never allowed us to take her presence on this earth for granted. I believe that's why she walked slowly to the door. When the door opened, life was in full bloom. She was in the world.

It was always a dreadful ride leaving Manhattan for Boro Park: I would feel like I was going backward. The passengers always looked like zombies as they returned to Brooklyn. I probably looked the same. But once inside mother's apartment, I would acclimate. The rejuvenating smell of *kuchen* (coffee cake) would cancel out the subway smells and my own exhaustion. I'd walk through the foyer with its walls of photographs—brides, brides, and more brides, and babies, babies, and more babies; I'd walk past three closets—one to hang up coats and the other two to store junk, which usually remained for years once deposited. Then there was one shallow step into the kitchen, the center of the house, the center of one's existence.

I would find myself sinking into the chrome chair by the Formica table tasting and eating and tasting and eating. It was always hard to propel myself back into the outside world, with Mother hovering.

"Here, take another piece."

"What's your rush? Stay a little longer."

"It's chilly for a spring day. I feel a draft. Here, put on Uncle Abe's sweater. It's cashmere. What can it hurt?"

"Oh you're going? Wait. Let me make you a sandwich to take along."

If the kitchen was the center of planet Earth, the dining room represented the outer reaches of the heavens. The white linen tablecloth was always fresh should some brood arrive unexpectedly, or a gang from shul trample in unannounced.

"W-e-l-c-o-m-e!" she'd sing so loudly that when I was a teenager I could hear it from the back bedroom and be forewarned to come out nicely dressed and smiling hospitably to the visitors—or, if this was my day to sulk, remain hidden until the company left.

Mother didn't have to like someone to treat them as a wedding guest. "Better to have friends than enemies," she'd advise me. The only one I can think of whom she spoke against—actually railed against—was my sister Sandy's first boyfriend. He was a playwright named Milton, of all impressive writer names. Milton wrote hostile plays about the Orthodox lifestyle inspired by our family. Mother found out when she stealthily opened Milton's mocking letters to Sandy. From then on, she referred to him as *malach hamaves* (angel of death). Sandy's relationship with Milton

did not last very long, not to my surprise. After the Milton episode, Sandy did everything according to Etta's rules. Mother hand-picked her husband, and they lived the Orthodox life in an Orthodox community. After Sandy's husband died, Sandy married Mother's trustworthy Orthodox eye doctor.

Let it be said: Etta's *mitzvot* were paid back to her. I believe it was her karma, although karma is not a Jewish term. In Etta's golden years, she received regular visits from the most *eidele* (refined), attentive girls in the neighborhood. She called them her "*Shabbos* Girls." It started when I asked the Beit Yaakov Girls' Yeshiva if there was a student who could walk Mother to Bethel Synagogue on Saturday mornings. I would have approached Shulamith School but they had moved out of Boro Park to Flatbush. Mother's eyesight was beginning to dim, and she did not want to cause me to sin by taking the subway on *Shabbos* to walk her on the days when I hadn't slept over.

Beit Yaakov forwarded my request to their class on *chesed* (loving kindness), where homework consisted of performing charitable acts. At graduation there was a prize for *chesed,* but not one for high grades.

A girl named Ruchie Gross came the next *Shabbos* morning to walk with Mother, and by the following week, she and other Beit Yaakov girls—Chayele, Surale, Rifkale,

Chanele—began to come in the late afternoon after their *Shabbos* naps to sit around the dining room *tish*. Their names reminded me of how Baba would call me Hindele. What is it about Yiddish, the *mama loshen* (mother-tongue)? When the girls came, they brought with them something of The Old Country. Those two Hebrew letters, *lamid* (L) and *ayin* (E), when suffixed to any given name, tug at my heart, especially when little children are called by their grandmothers Mamele, little Mama, or Bubbele, little Bubbe.

Chayele, Surale, Rifkale, and Chanele sang their Yiddish souls out for mother. They eagerly modeled their clothes for her, clothes meant to attract the parents of a future *chasan*, their one and only *bashert* (the groom destined for them). They candidly talked to Etta about their prospects waiting for a *shatchun* (matchmaker) who would find them the right mate—in collaboration with their parents, of course. Mother relished every detail. She had no need for me to read her romance novels.

This procedure for making a *shidduch* (match) began with the parents' extensive investigation into the background of the potential groom's family, the history and spiritual health of the ancestors—their *dvakut* (adherence), *tsedaka* (charity), and yeshiva education. Then they'd

research the longevity and stability of other marriages in the family, and *shalom bayis* (the peace of the house). A divorce in the family was a blot that could cancel the entire *shidduch*. Of course candidates had to come from *balabatish* (nicely substantial homes) in keeping with the vague standards of what a *balabatish* home should be.

Mother bowed before the notion of *balabatish*; its absence would make Mother frown and its presence would make her wax poetic. I'd say that word has something to do with Jewish classiness. All I know is that my West Village abode, lacking the supreme dining room *tish*, would not be considered *balabatish* by any standard. And the woman of a *balabatish* house was always a *balabuste*, a matriarch who could cook for hordes and bake up a storm at any given moment in her super clean kitchen with its six sets of dishes—one each for meat and dairy, another two for Passover meat and dairy—and yet another two sets for company.

Once the young groom passed the extensive examination of his family's history, and his own Orthodoxy, and after a serious conversation with him, the *kallah maidle* (potential bride) could decide whether to continue the match. If she chose to look further, the entire research process began all over again with a new yeshiva *bocher* (boy).

As far as I could see, the Beit Yaakov *Shabbos* girls were ready for marriage from the time they were twelve years old. They'd been caring for babies since they were four. They'd been cooking and baking from the time they were eight. No gossip ever escaped their mouths. For six years they came to Mother every *Shabbos*, from age twelve to eighteen, until one by one, each got married.

Once, when I was at the house for *Shabbos* and the window was open on a hot summer day, Chayele moved to shut the window when the girls began to sing, lest a boy or his father walking by hear their harmonizing voices. Men were forbidden to hear a female singing. Their voices were for Etta's ears alone. After the girls married, they called her every Friday from wherever they were— Lakewood, New Jersey, Monsey, New York, Jerusalem. They called to say, "*Gutte Shabbos*, Etta." She asked about their babies, *ken'ein a hara, kein yirbu* (with no evil eye, they should multiply).

YOU MAY HAVE surmised that I, unlike the Beit Yakov girls or the other Shulamith girls, caused anxiety from the time I was born. I validated that Talmudic statement about a daughter being a worry to her father. I did not help bring up my younger sisters. I did not cook *cholent*, the potato

and meat dish simmered on a low flame overnight, or bake challah. I challenged my parents continuously. And when the roles prescribed for me became too predictable, I'd go the other way and act more *frum* than my parents, just to overdo it.

When I was fourteen, my Dad had to contend with my self-labeled identity as a Communist. "I didn't send you to Shulamith School to hear party lines," he said. For a period of approximately a year and a half, the Communist topic would come up on every *Shabbos* as we sat around the dining room table. My father referred to Russia as "The Big Bear." I would defend the idea of sharing the wealth. "And bears should not be insulted," I'd add disdainfully. Only when we had company did I let go of the topic. My senior year at New Utrecht High School, when I served on the committee to write blurbs for the high school yearbook, I complimented my schoolmate Harold Levine by writing: "An uncommon Communist with much common sense." I was eager to read it to Daddy, but Harold asked me to take out the word Communist, since McCarthyism had overtaken the country. In fact, our favorite English teacher, Dr. Mins, had been dismissed from the school for supposedly un-American activities. So I obliged and changed the phrase to "An uncommon boy," and I never bothered to read my blurb to Daddy after all.

MOTHER'S ECHOES TRAILED me every day when I'd set out for a long day of Hebrew and English. She'd stick her head clear out the dining room window as I proceeded down the alley. Like an army lieutenant she commanded, "Head up! Chin up! Stomach in! Shoulders back! Chest out!" It didn't bother her if the neighbors heard these admonishments. I dutifully tried to stick my flat chest out as I lugged the heavy briefcase awkwardly, always a little late, always with a runny nose, always feeling too tall as I arrived at school, panting at the back of the line, relieved not to be the very tallest girl in my class, stranded at the very end. What would happen if I kept growing taller? Would I be too tall for a future husband? I might be condemned to wear those religious looking "college heels." I'm sure the Beit Yakov girls did not mind those sensible shoes. Me, I dreamed of red suede high-heeled, ankle-strapped shoes and "wedgies."

Decades later, on what should have been the most cherished day for Mother, the day of the wedding of her first grandchild, my son Nathaniel, I caused her immeasurable grief. She took one look at me and swallowed hard. I thought she could not breathe. No hug. No mazel tov. "What are you wearing?" She looked down at my sandals with the laces tied up my legs and then at my hood and layered clothes and said, "What's this bed sheet wrapped

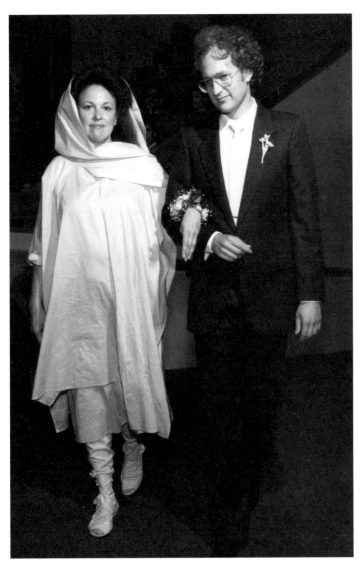

Walking my son, Nathaniel, down the aisle at his wedding, 1984.

around you? Are you afraid to look like the mother of the groom? Would you rather dress like an Arab?" How insightful she was. Indeed, I did not want to look like the mother of the groom, wearing a pastel beaded gown with a little fringe of pastel adornment perched on coiffed hair, and shiny gold wedding shoes with sensible heels. Indeed, I would rather have looked like a nomad from the sultry desert.

"Mom, I said patiently, "We're now at the wedding of your first grandson. For years we have waited for this day. We've been planning for months. Are you going to let my clothes get in the way of your happiness at such a *simcha*? " Apparently, yes. Not once during that wedding did she hug me, although she heartily embraced all the other guests.

You'd think she would have been accustomed to her problematic daughter. I can recall worse times, like when I was six years old and Mother caught me talking to the kid next door who looked like a misfit in our neighborhood. "He's not a yeshiva boy," she had previously warned me. Sure enough, the day she overheard us deep in conversation, he had spit on his finger and proceeded to draw an apple and a banana on the dusty garage door. "This" he said, "is like a girl, this is like a boy." (Really, now that I think of it, the drawing was not that far from an Ellsworth

Kelly line drawing of fruit.) As my young eyes took in the drawings, a blood-curdling *geshrai* (shout) came from the opened rusty window, a holler that could be heard all the way to the Schloss Hebrew Bookstore on the corner. "Helène, Come in this minute!"

I'm coming in. I'm coming in from the outside, the outside *muktze*, the outside *prustkeit,* the coarseness. I'm coming in from the world of the *am ha'aretz* (ignorant, uncouth, and lowly).

As if that's not enough, hear this. I was fifteen, and it was the time of Simchat Torah, the last day of *Succot* (the harvest holiday) when the streets swarmed with young "Black Hats," the super *frum* Jews who, on this occasion, deigned to mix in merriment with the more moderate Orthodox like us. I watched standing in front of my house as each yeshiva boy lined up with the next like the Rockettes in Radio City, each passionately pressing one hand on the black-clad shoulder of the yeshiva boy in front of him, keeping step with the one in front and the one in back, the labyrinth of feet taking over Forty-Seventh Street in an orgy of exhilaration. Even I inadvertently tapped my brown and white saddle shoe to the frenetic rhythms.

It is traditional to build a *succah* (a hut) on *Succot* to symbolize the temporary dwellings the Israelites built in the

desert on the way to The Promised Land. Our *succah* was built outside against the window of the ground floor bedroom I shared with Baba. We'd open the window to pass the food platters down to the outstretched arms of someone below, arms lifted for the heavenly *manna* that came out of the kitchen.

After watching the aphrodisiacal dancing in the street, I snuck into our *succah* with one of the boys from Eitz Chayim Yeshiva. His name was Lazer. We were anticipating a necking session under the grass roof prescribed for *succah* construction through which we could see the stars. I was sure the term "necking" implied upward from the neck to the top of the head and never, *chas v'chalila* (heaven forbid) beneath the neck. The word "petting" was unknown to Shulamith and *midrasha* girls. There were not even dogs to pet in Boro Park. Walk down Thirteenth Avenue and you will see streams of families with ten children walking together, but you will never see a family walking a dog.

Any activity below the neck could lead to a great *shanda*. A *shanda* is the kind of scandal that could cause a parent to sit shivah on wooden boxes and mourn for seven days. The cause of a *shanda* could be if someone's child married out of the faith, a blight on generations to come—through the third or the fourth generation for sure—or if a daughter

got pregnant outside of marriage. But I am positive that no Boro Park girl ever, ever got pregnant before marriage, and these girls were very fertile—one had only to look at the lines of baby carriages parading down the avenue to see that. Besides, no one even left home for college, and where in Boro Park could any baby-making take place, other than inside an unoccupied *succah*?

Well, Lazer and I were whispering discreetly, and as it was getting chilly that October night, he chivalrously put his arm around my shoulders. I sat straight, like I hadn't noticed this gesture, when suddenly a light was turned on in my bedroom above, illuminating our criminal activity. How could a light be turned on when it was *Shabbos*? The light had to have been turned on by my own mother! She must have deemed our about-to-neck drama such an extreme emergency, she was allowed to turn on the light on the *Shabbos*. A husband may drive a car to the hospital if his wife is giving birth. To save a soul from dying, one may call an ambulance. So when the light went on, I knew that Lazer and I were over.

EVENTUALLY, BY HER MID-NINETIES, Etta mellowed. She was a loyal listener to radio psychologist Joy Brown, from

whom she heard about life outside Boro Park. From Joy Brown, she learned the words "gay" and "masturbation"; she learned there could be sex before marriage, childbirth without marriage, and intermarriage. But her tolerance was for the next generation. In vitro fertilization without a husband? That was absolutely fine for her granddaughter who valued motherhood so much that she'd sacrifice anything to be a mother.

BY THE TIME I was sixteen, I was ready for serious rebellion. At summer camp, I flirted with the lifeguard, the only non-Jew to inexplicably land in this Jewishy camp; I headed straight for him. He was called Tex, as he came from the land of cowboys. At the summer's end, before he headed back to his Texas homeland, he asked if he could meet me in Brooklyn for a trip to the movies. Daddy found out about it from Mother, who always tattled on me, and Daddy's face became crimson. I was afraid I would give him a heart attack if I went to a movie with a non-Jew cowboy. So I did the noble thing: I wrote an eight-page letter to Tex bemoaning the narrowness of tribalism and canceling the date, like those who give up the Nobel Prize for a just cause.

After that summer, I started to daydream about leaving Boro Park and the house of too much attention. But to go

to a college out of town was unheard of. The other choice was to get married.

We did not think of the word "spinster" as politically incorrect in those days—only *nisht farinz gedacht* (not for us such a fate). I made sure that I would not be doomed: I got engaged at age seventeen. I knew that everyone would be especially relieved if I got married first, before my sisters. How would it look at my sisters' weddings if I, the oldest Greenfield girl, was not married?

AS I WROTE in my proclamation for *The Women's Section*, Baba never thought I would marry a businessman. From the time I was fourteen, she would repeat, "*Hindele velt nemen a Talmid chacham,*" and she was right. Two months after Baba died, I became engaged to a rabbinical student, Mandel Fisch. He studied with Rabbi Soleveichek, the religious genius of the century; Rabbi Belkin, the dignified president of Yeshiva University; and Rabbi Lifschitz, the pious of the pious. They were the three *geonim* (highest sages) of that era who gave him *smicha*, ordination.

When I met this young rabbi who was to become my husband, I had yet to finish my high school studies. I was full of questions; he seemed to have all the answers. We saw each other approximately six times before he went to

Montreal, where, at twenty-three years old, he already had a pulpit. I got to know him through the long, philosophical letters he wrote to me while he was there. We corresponded this way until the next time we saw each other, the day of our wedding.

Our correspondence reminded me of that old movie, *Love Letters*, with the stunning Jennifer Jones. But the love letters I received in Boro Park came straight from my Canadian prince, not a ghostwriter, as in the film's story. As I look back, the leap in our letters from a chaste discussion of philosophy to talk of marriage was thrillingly grown up. I could barely recall what my suitor looked like, and we did not speak over the phone long distance—that was a big deal in those days—so I could hardly recall his voice. Mother once told me that if everything else is right—standards, values, good family, a yeshiva background, a *balebatish* household, and a commitment to the ritual bath, then the main love comes later and stronger.

But during the months of our courtship by correspondence, I was secretly, scarily attracted in my fantasies to the *chalutzim* (the pioneers of the emerging country of Israel). Those rocky, rugged hunks were my rock stars. Let the New Utrecht High School girls swoon over Sinatra, who looked as if he barely could lift the microphone! I daydreamed of the *sabra* youths who lifted shovels, drove tractors, their

muscles bulging. Confident. They would try anything with an impudent shrug. How they scared me, impressed me, excited me, dared me to—what? I didn't know. I knew they were bent on defying the cliché of the victimized, nebbish Jew. They were ageless in the aqua Mediterranean, as different from us in Boro Park as we were different from gentiles.

I THOUGHT PERHAPS I was meant to live in Israel, far from Mother, far from the rabbinical life that was to become my destiny. But I did not speak fluent Hebrew like the tough Israelis. I knew nothing about farming. Years of summer camp never made me outdoorsy. I had to face the truth: I was a Boro Park girl with a propensity for erotic Zionism.

My suitor's letters began to take on a tone of urgency, forcing me to confront my Israeli fantasies. I was wavering, yes, no, yes. When he gave me the task of securing a date for the wedding, I simply succumbed. I didn't know yet how to imagine a truly different life than the one I'd been raised for. He had a sense of humor about it all: "Send me an invitation with the address where to go and I will be there."

Once the decision was made, I plunged into the preparations, by which I mean preparing myself mentally as well

as organizing the wedding. To signify this new vital life—
I was to be a *rebbitzen* (a rabbi's wife for G–d's sake!)—
I decided I should *do* something vital, something more
substantial than the puny weekly Jewish National Fund
donation of nickels for trees in Israel, which had been my
activism since childhood. Israel did not need more trees.
I had read somewhere how teenagers exchanged blood
to connote their commitment to a lifelong loyalty. I would
give my own blood for Israel! What could be more vital
than that?

This act was my substitute for jumping into a circle
of Israelis, dancing with the *sabras* born there, as thorny
and tough on the outside and soft on the inside as the
cactus they were named after. I had tried to imagine
myself dancing the hora and being swung by the pioneers
who farmed the land. Oh, harvest me please, to the beat
of *eretz chalav udvash* (a land filled with milk and honey),
a land as fertile as the pioneer women with their long,
thick hair loosely tied up or casually flowing—those female
chalutzot milking cows and fearlessly getting honey from
the nests of stinging bees. It was more realistic to give
blood for Israel.

I did not tell Mother about my plan to donate blood,
because she would not have allowed it. She'd have called
her brother Uncle Louie, the doctor, and he would have

sternly forbidden this plan on his sister's behalf, doctor's orders. She would have called her brother Uncle Izzie, the lawyer, who considered himself the family judge on all matters beginning from the time he was a teenager on the Lower East Side. Uncle Izzie thought Boro Park was nothing more than a shtetl, and he had the guts to move far away to Riverhead, near the glamorous Hamptons, proud that he was the only Jew admitted to Riverhead's Bath and Tennis Club. Mother both revered and disapproved of this sophisticated brother of hers. As for Mother's oldest brother, Uncle Morris, the businessman, who always brought us presents of girdles from his business, Deluxe Girdlecraft, Mother would have called him, too. He was always eager to help; he'd helped get our relatives out of Europe. How could I disobey such an uncle?

For days, I thought through the consequences of my gift of blood: even if I told Mother and made her swear not to tell all three brothers, the news would have traveled to her sister Molly and her best friend Tybee. Mother telephoned them every day to find out how they were feeling and to confide her latest worry about her eldest daughter. And even if she didn't tell anyone—even if she didn't forbid me to give blood—I pictured her tagging along, the way she used to come running to Shulamith School to bring my galoshes at the slightest drizzle.

So I went on my own to the *Magein Daveed Adom*, the Red Star of David, the Jewish Red Cross. You had to be eighteen to donate, and I'd just turned seventeen. I lied.

As I sat in the waiting room, I fervently whispered the prayer about Israel: *"Eem eshkacheich Yerushalayim, tishkach ymini"*, "If I forget thee, oh Jerusalem, let my right hand forget its cunning." I did not know what was meant by "cunning," though. Tricky smartness? All I knew was that never, ever would I, or my right hand, forget Jerusalem.

When my name was called, I woke out of my reverie and was ushered into a small room. Someone sat me down, held my arm, and stuck a needle in it; I saw bright red liquid filling up the snaky plastic tubing and I fainted.

When I came to, there was my mother's shul friend, Mrs. Charlotte Wexler, staring down at me as I lay on a narrow cot. Charlotte was a big woman, and she hovered over me like a giant. What was she doing at *Magein Daveed Adom*? Volunteering. Those ladies were always volunteering or having luncheons honoring other volunteers. She stood over me and buttoned my coat, announcing that she was taking me right back home to Etta Greenfield.

My mother never got over the shock of my heroic transgression, and every time I got the slightest cold, even years later, she said it was because I gave my blood to Israel.

AS MY MARRIAGE drew near, I pretty much dropped the fantasies and rebelliousness and made a pledge to myself: I would bring the order of *Shabbos* into my marriage. I would light the candles at sunset every Friday in Canada, where I was to live with Mandel, knowing that my mother was also lighting candles as the sun set in the US, bringing the light to her eyes, blessing me from afar. I knew that whoever was in her orbit would be in her blessing, though I was the main standby in her worries.

The place I chose for the wedding had a balcony for the hordes of guests so they could peer down at us as we walked down the aisle to the chuppah. Mother used the occasion to invite our hundreds of relatives, many of whom I met for the first time at the wedding, as well as what seemed to me like all of Young Israel and Temple Bethel.

I chose Thanksgiving Day, November 24, 1949, as our wedding date. As promised, I sent Mandel's invitation to him in Montreal. As part of our private made-up marriage ceremony, he would take the middle initial H, for Helène, and I would take M, for Mandel. The famous rabbi scholars with whom my husband had studied would stand with him under the chuppah for his marriage to a Shulamith girl from Boro Park or, as my *Ktuva* (the Jewish marriage contract) referred to me, "Helène Greenfield, virgin daughter of Anshel."

On the 5th day of the week, the 4th day of the [Hebrew] month of ..Kislev............., the year 5.7.1.0 after the creation of the world, according to the manner in which we count [dates] here in the community of ...New..York..., the bridegroom son of ..Aryel..Lewis...... said to this virgin, .Helene..Greenfield.daughter of ..Anshel..–.(Al)..., "Be my wife according to the law of Moses and Israel. I will work, honor, feed and support you in the custom of Jewish men, who work, honor, feed, and support their wives faithfully. I will give you the settlement (mohar) of virgins, two hundred silver zuzim, which is due you according to Torah law, as well as your food, clothing, necessities of life, and conjugal needs, according to the universal custom."

Miss ..Greenfield...... agreed, and became his wife. This dowry that she brought from her father's house, whether in silver, gold, jewelry, clothing, home furnishings, or bedding, Mr. .Fisch.............., our bridegroom, accepts as being worth one hundred silver pieces (zekukim).

Our bridegroom, Mr. .Mandel...Fisch. agreed, and of his own accord, added an additional one hundred silver pieces (zekukim) paralleling the above. The entire amount is then two hundred silver pieces (zekukim).

Mr. .Mandel....Fisch... our bridegroom made this declaration: "The obligation of this marriage contract (kethubah), this dowry, and this additional amount, I accept upon myself and upon my heirs after me. It can be paid from the entire best part of the property and possessions that I own under all the heavens, whether I own [this property] already, or will own it in the future. [It includes] both mortgageable property and non-mortgageable property. All of it shall be mortgaged and bound as security to pay this marriage contract, this dowry, and this additional amount. [It can be taken] from me, even from the shirt on my back, during my lifetime, and after my lifetime, from this day and forever."

The obligation of this marriage contract, this dowry, and this additional amount was accepted by Mr. .Mandel.....Fisch....., our bridegroom, according to all the strictest usage of all marriage contracts and additional amounts that are customary for daughters of Israel, according to the ordinances of our sages, of blessed memory. [It shall] not be a mere speculation or a sample document.

We have made a kinyan from Mr. .Mandel..Fisch son of ./Aryeh..Lewis. our bridegroom, to Miss ..Helene..Greenfield.daughter of ..Anshel..–.(Al). this virgin, regarding everything written and stated above, with an article that is fit for such a kinyan.

And everything is valid and confirmed.

Rabbi Samuel Minsky son of _David Minsky_........ Witness

Rabbi David White son of _Nathan_.............. Witness

My *Ktuva*, translated into English.

I look back at the pictures taken while the enthusiastic, cheering guests sang, "The Brido Cuts the Cake." I'm raising my eyes to the ceiling with disdain. The knife is ready to drop out of my hands. Was this the silly tune that would reverberate in my head as my new life of serious idealism was beginning?

Anyway, at least I would not be a Long Island matron in a split-level house, pleased with a Westinghouse washing machine and an accountant husband. My man would be a leader, and that filled me with vicarious pride because I could not yet imagine myself (or any female) leading. Baba's prophesy about my future husband had come true. He was a Talmudic scholar who could answer all the perplexing questions. Back then I still thought there were answers.

But as I walked down the aisle at the wedding, it hit me: I was marrying a rabbi. What if he knew what I was really like? And could I trust myself to be 100 percent his?

As though in answer to this question, my husband made an assertive announcement after the ceremony when the band was about to play: "No one is to dance with the bride."

Actually, it was a relief. I was glad for the law and his possessiveness. Exuberant singing began to take over the crowd. "*Od Yeshama b'aray Yehuda u'vichutzot Yerushalayim, kol sasone v'kol simcha . . . kol chasan v'kol kala,*"

"Soon it will be heard in the cities of Yehuda and the streets of Jerusalem, the voice of gladness and the voice of celebration, the voice of the groom and the voice of the bride." The thumping sound of the feet of the men, their loud voices . . . then a group of the women revelers lifted my chair above the frolicking reception. I stretched out my hand and held out a handkerchief toward my new husband, lifted up on his chair by a crowd of celebrating men. He took the other end of the handkerchief. And from that moment, I felt the bond of marriage. My marriage would be elevated above the norm, and also isolated from the norm.

MOTHER CALLED our hotel room the day after the wedding, telling us to come say goodbye before leaving for Canada. Now I sat before her as another woman, not only as her eldest daughter. What is she wondering? I thought. Is she imagining me spending the previous night and the nights ahead with my new husband? Does she wonder which nightgown I will wear from the trousseau she chose for me?

When we left my mother, Mandel and I spent all the money we received as wedding gifts on a complete Hebrew and Yiddish library. We had the library shipped straight to Montreal. Our living room would be converted into a study.

Into the car we packed my engagement trousseau with the white linen tablecloths for our *Shabbus tish,* the countless kiddush cups and the large silver pitcher for pouring three cups of water over one's fingers before meals, as well as the small silver pitcher for pouring water over one's fingers after the meal. We packed my long-sleeved blouses, high-necked dresses, and housecoats and lingerie wrapped up with sachets. We packed Mandel's three-piece black suits and black homburg. He would wear his black winter coat on the drive up. I would wear a new Persian lamb coat my parents bought me so I could "be a lady"—that's what Daddy said.

Before setting out on the honeymoon trip from New York City to Montreal, my new husband asked me to tie my long hair inside a boy's cap, so that no stranger on a dark road in some isolated gas station would be tempted to start up with me. How reminiscent of the biblical Abraham worrying that Pharoah would kill him and steal his alluring wife Sarah. Abraham asked Sarah to say she was his sister, not his wife.

My husband also told me not to extend my hand for a handshake. If, as might happen, some well-intentioned male put his hand affectionately on my shoulder, I was to demurely and tactfully circle to the side, so as not to allow

this man's hand to stay put. All this fastidious guarding is considered a *syag,* a metaphoric fence to keep potential sins at bay.

We drove through the winter night to Montreal. The next day, I was asked to give the invocation in Mandel's shul. The word "invocation" was not used in Boro Park. All I knew about invocations was that they were given at graduations and United Nations sort of events by eighty-year-old male dignitaries who cleared their throats many times before they started to invoke and kept their heads bowed until they finished.

For the invocation I pulled my hair back in a chignon to appear older. I wore a hat with a veil. I thought of mother's constant refrain: Belong, belong. You'll be happier. And so I prayed at my first invocation, *V'taher libeinu l'avdicha b'emet*, purify our hearts to serve you in truth.

I prayed to believe.

I HAD MY FIRST baby at age nineteen in a Catholic Hospital in Montreal.

There were crosses all over the place. The name of the hospital was Saint Anne's. I usually liked people with that name: Ann Lindbergh; Ann Bancroft, who played Ann

Seeing Crosses Everywhere, Montreal.

Sullivan, the teacher of Helen Keller; Anne Frank, the most remarkable Jewish Anne who ever lived. But now I was in the bosom of Saint Anne, mother of the Virgin Mary and patron saint of Quebec, as well as the patron saint of women in labor. This was far, far away from Israel Zion Hospital. Mother did not even know I was in labor, as it was Friday night and we could not telephone on *Shabbos*. Besides, Mother could not fly there, even on a weekday and leave my eight-year-old sister Linda, my Baba, who needed her insulin, and Daddy, who had never once opened the refrigerator by himself. So I went through labor without her, just my husband on the other side of the curtain in the Catholic hospital in the very cold December of 1950. "She's not my patron saint," I said to Mandel in Hebrew from my side of the curtain. I pushed harder, and Dr. Barren, an odd name for an obstetrician, kept muttering, "good girl."

When I gave birth to a boy, I believed this was the ultimate gift to my husband, who had dreamed of a firstborn son. Mandel and I named our baby boy *Nesaneil*, Hebrew for Nathaniel, meaning gift of G–d.

I WAS 100 PERCENT loyal to my husband except for one summer when he took a job as a rabbi at The Flagler,

one of the Catskill hotels. I was wheeling our infant son on the bumpy lawn when I sprained my ankle. The lifeguard at the hotel took me into his first aid cubicle and sat me on a chair as he crouched down to wrap my ankle. The baby slept in the carriage at my side. As the lifeguard bent over I noticed his broad shoulders and long back—and plaid bathing suit. I tried my best to remember that he was just like a doctor treating my painful sprained ankle. But he wasn't wearing a doctor's white jacket. Here I was, a Jewish mama wearing a long skirt and long sleeves and a scarf on my head on this summer day while he was half-naked. Our scene was the reverse of Manet's *Le déjeuner sur l'herbe* in which the woman is unclothed and the men are dressed.

"Do you need a Tylenol?" the lifeguard asked. "No, I'm fine, thank you," I whispered, because the eroticism eclipsed the pain. I made a mental note to myself to add my invisible trespass to the list of sins for Rosh Hashanah, when the congregants hit their chests and repeat *al cheit*, for the sin, as they recite every possible sin enumerated in the *Machzor*, the special prayer book for Rosh Hashanah and Yom Kippur. Here are a few of the sins that made me swallow hard when I came back from that summer in the Catskills:

For the sin we committed in Thy sight unintentionally
And for the sin we committed against Thee publicly or
privately.
For the sin we committed in Thy sight by lewd
association

At least my sinful fantasy did not fit into these scarier categories:

For the sins requiring a burnt offering
And for the sins requiring guilt-offerings
For the sins requiring corporal punishment
And for the sins requiring forty lashes.
For the sins requiring premature death,
And for the sins requiring excision and childlessness.

MANDEL WAS NOT averse to occasionally going with me to the movies, but the rule was to leave right before the ending so as not to be seen should there be a congregant in the theater. It never occurred to me to go to a movie on my own. Nor did I go out with casual acquaintances, as we were to keep our lives private. Mandel once said he did not even want anyone to know the color of the chairs in our house.

We were like movie stars avoiding the paparazzi. Mandel never wheeled the baby carriage. Perhaps he thought it undignified to wheel a carriage in his top hat and black vest. He laughed as he said he'd wait to have a conversation with the baby without the carriage when they could sit side by side and talk. He seemed older than his years, while I knew I seemed younger, too young.

Our congregation in Canada was the oldest and largest in Montreal. I felt energized when I observed the crowds waiting to get into the synagogue before the doors closed, intent on catching my husband's riveting sermons, full of *musar*, moralizing. Here I was, a *rebbitzen* in Canada in a shul called *Chevra Kadisha*, the Congregation of the Holy, the same phrase used for the committee that cleanses the dead for burial. I'm not sure which phrase made me twitch more: *rebbitzen*, *Chevra Kadisha*, or the name of our next congregation in Brooklyn after we moved from Montreal, *Nachlat Zion*, the Inheritors of Zion. Though I hardly acknowledged it to myself, I did not want to be called *rebbitzen*; I did not want to be reminded of cleaning the dead or inheriting Zion.

We went on a tour of Israel expressly for rabbis and their wives sponsored by the Rabbinical Council of America. The RCA is an Orthodox group and there were no female

rabbis in those days anyway, but the "rabbis' wives" category made me feel lonely. I still did not think of myself that way. Every day the bus brought us to the portals of another synagogue, the same way tourists in Italy go from cathedral to cathedral. I unthinkingly wore a sundress on one hot Jerusalem July afternoon. The rabbi sitting across from me at lunch handed a note to my husband asking him to kindly have his wife cover her shoulders. That rabbi did not hand me the note, even though I was sitting right next to Mandel. I said nothing, but hastily tied two linen napkins together for an emergency shawl.

That's the thing about Orthodox Judaism: with the slightest suggestion of a need to cover up, any frumpy Orthodox housewife, married thirty years, can feel alluring. This is especially true when she returns from the *mikveh*. A wife and her husband know that there can be no "relations" until she informs him that she has been *toveil*, submerged. For *tsniut*, modesty, a woman wears a special ribbon after immersion in the *mikveh* to indicate that she is "permitted" to her husband, a Talmudic term. In this way the Orthodox woman is constantly reminded of how seductive she is. What a formidable power, that volcanic force that can sweep a man straight into *gehenum*, hell, as the *pirke aavot* states, just for talking at length to a woman. He must wear

fringes surrounding his groin to the north, south, east, and west, lest a temptress corrupt him. I bet the ones we would least suspect, like the women guardians in the *mikveh* or the men who *shuckle*, rocking back and forth while praying, are the very ones who have the most volcanic "relations."

Our apartment had a balcony overlooking Van Horne Avenue in Montreal with all its trolleys, and I would sit there with the baby in a carriage by my side. Maternity in Montreal was not like maternity in Boro Park, where mothers got to show off their babies. I rarely went down to a park; I just sat and breathed balcony air. This new place, this country, this life was very far from "The Neighborhood"—that is, very far from Mother. My husband once remarked that our mother/daughter umbilical cord extended all the way to Canada.

After a few years, I was half relieved when Mandel decided to leave this faraway country to return to the homeland, to Brooklyn. His new position was in Sheepshead Bay.

Before our move to the new congregation, which was to happen right before Rosh Hashanah, there was an interim period during which we temporarily lived with our toddler at my parents' home. I was pregnant with my second child. I secretly hoped for a girl. If I had a girl I would fulfill the commandment, *pru u'rivu*, be fruitful and multi-

ply, which was understood as a requirement to produce at least one offspring of each gender. Otherwise, I might have to continue the pregnancies until that commandment was fulfilled.

Our second child was indeed a daughter. We named her Rifka after Baba and called her Renée in English. I made up a middle name for her, *Emunah*, Faith. At that time, to imagine a life without faith was to imagine a life without breath. The holidays and festivals were ethereal bookmarks, refrains of the seasons, connecting me to the long panorama of the Jewish past, ensuring my link to its future. The liturgical murmurings streamed through my veins. Known and unknown potential relatives from every part of the world could appear at our door, kissing the mezuza on our threshold. Belong, belong! I'd hear my mother's words again in my thoughts. See Mom, I said to myself, I'm belonging.

When I look back at this part of my life, it's like viewing myself as a statue on a pedestal from the front, sides, and back. Sometimes I daydreamed about being an actress, imagining myself as the lead in Jewish playwright S. Ansky's *The Dybbuk*. I would also dream about becoming an artist, but I had to make do with illustrating the shul newsletters, painting still lifes of challahs and wine decanters. Still, I was spiritually alive: I often felt as though I was flying overhead like a bird, especially on *erev Shabbos*.

In the many years since, I have noticed that if I ever get depressed, it invariably occurs on a Friday night. The light from the computer doesn't equal the *Shabbos* candles. Minimal concerts in trendy lofts are not *shalom aleichem*, a welcome to the angels. The Kitchen, an avant-garde performance space in New York City, is not Mother's intimate kitchen. And when the phone rings now on *Shabbos* I think of those days, when no one would pick up; no call could be important enough to pierce the *menucha*, the profound restfulness of the *Shabbos* day. There was a sense of purpose that carried me aloft. And there were *sodot*, secrets, yet to discover in the ancient texts.

WHEN I WAS twenty-five years old, Mandel became ill with cancer. I nursed him through his illness for five years, never letting him know how sick he was, and living in a daze myself. When he was hospitalized, I visited him every day, always dressed nicely to cheer him up, but my life was shattered. I would hold his hand and embrace him (that is, when I was not *niddah*). I wanted to break these rules, but thank G–d his very last days were my "clean" days. He'd go back to the hospital for a stretch, then return home. During that time I hardly slept. Often I stood with him in the middle of the night at the bathroom sink, pulling the ribbons

of saliva out from his mouth as he retched, bent over his own shadow. Mandel died the week of my thirtieth birthday, when the children were ten and eight. I find it hard to go into that memory channel. My insides feel like cement, deadened.

Once, I timidly tried to broach the subject of his dying, in case he wanted to know. I had been waiting for him to ask Uncle Louie the doctor if he was getting better; if he'd asked Uncle Louie or asked me, he would have been told the truth about his fate. But he did not ask. Mother spoke too optimistically to me, never facing the reality nor encouraging me to face it. The day I got a call from the hospital to come quickly (he had already died), I could not get a cab and could not trust myself to drive. I impulsively stopped a car on Ocean Avenue, crazily asking a stranger to take me to Maimonides Hospital. When I arrived I saw that his bed had been removed and I stared into the empty space that had held my husband, my life.

I had never known anyone my age to die. He was too young to die. I came back home to lie on my twin bed. The other bed was empty, asymmetrical, off balance. Should I let that bed stay there with its night table piled high with books not yet read, its lamp that would never be lit again, so far from me on the other side?

When Mandel was lowered into the ground, I dropped one of his white handkerchiefs into his dark, damp grave. I had never been to a burial before. I wrote a eulogy for the officiating rabbi to read, as it was not the custom for a woman to speak. In it, I said:

My beloved lies here . . . alone . . .

A man's life is like a scroll, a fragile parchment scroll. The center of the scroll is the core of man, and days and weeks and months wind round and round as their contents are being written. But all at once, like today, the story is ended and we unwind the scroll—we unravel it—we straighten it out flat and hold it up—we tack it against the wall to see what is written therein.

And so today, I hold up my beloved's poor, delicate, frayed, worn-out scroll for all to see. . . . It is a good story, a wise and deep story though it is too short and too abruptly ended . . .

My Marriage Contract

My Marriage Contract, 2001. Mixed media.

1949

I LOOK AT MY WEDDING ALBUM
OF HALF A CENTURY AGO;
I SEE MY EIGHTEEN YEAR OLD SELF
WALKING TO THE CHUPA,
THE CANOPY WHERE THREE RABBIS
TELL ME THE MARRIAGE CONTRACT
MUST BE KEPT
FOR THE REST OF MY LIFE
WHILE I CIRCLED
AROUND THE GROOM
SEVEN TIMES
NOT STOPPING TO READ
THAT CONTRACT, THE KTUVA.

1984

BEFORE THE WEDDING OF MY SON
IN NINETEEN EIGHTY-FOUR,
I TOOK HIM TO VISIT
HIS FATHER'S GRAVE
AS IS THE CUSTOM
BEFORE WEDDINGS;
HIS FATHER DIED IN SIXTY-ONE
THE WEEK OF
MY THIRTIETH BIRTHDAY.
I REMEMBERED HOW I STOOD
IN THAT SAME GRASS
AT THAT TIME;
I BARELY NOTICED THE HEADSTONE.
BUT ON THIS DAY
I READ THE WORDS ENGRAVED:
I READ
THE NAME OF THE DECEASED,
SON OF ARYEH LEIV, HIS FATHER—

BUT THOUGH SHE HAD WALKED
DOWN THE AISLE
WITH HER YOUNGEST OF NINE,
NO MENTION OF CELIA HIS MOTHER.
"LET'S GO" I SAID,
BUT MY SON SAID, "WAIT.
THERE'S ONE MORE THING
FOR THE WEDDING:
PLEASE DESIGN THE KTUVA,
WITH TRADITIONAL WORDS."
(I DON'T DO THIS, I THOUGHT
BUT COULD I REFUSE?)
SO I FOUND MY KTUVA
KEPT ALL THESE YEARS
TO COPY THE TRADITIONAL WORDS:
I READ THE NAME OF THE GROOM
SON OF ARYEH LEIV, HIS FATHER,
NO MENTION OF CELIA HIS MOTHER.
I READ MY NAME—
"VIRGIN DAUGHTER" OF ANSHEL MY FATHER
NO MENTION OF ETTA MY MOTHER.

2000

IT'S ALREADY TWO THOUSAND
SO NOW I'LL COMPARE
THESE TEXTS
OF MOMENTOUS OCCASIONS:
THE MARRIAGE CONTRACT
WHEN TWO ARE JOINED
OMITS THE NAMES
OF TWO MOTHERS;
THE TEXT ON THE HEADSTONE
WHEN ONE DEPARTS
OMITS THE NAME
OF ONE MOTHER.

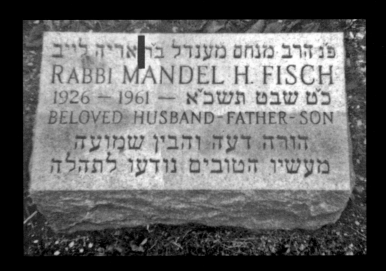

All during the *shloshim* (first thirty days of mourning) I received calls in the middle of the night and in the wee hours of the morning from Shlomo Carlebach, a popular rabbi and musician, who would sing to me over the telephone after his concerts all over the world. Before he became famous he had played his guitar for my youngest sister in our living room in Boro Park. When he called, he would sometimes ask if I was cold. I always said yes. Sometimes he would ask what I was wearing. I'd say flannel pajamas. I found myself feeling very alive, as though he was singing away the sediment of death, the grayness that receded when I heard his voice. Often in the morning I would find the phone receiver on the floor. I never remembered when the phone had dropped from my hands, but when I stepped outside my door, I hummed *"hashmeeayni es kolech, ki kolech nava"* (let me hear your voice, for your voice is pleasant). I believed Shlomo sang to me for *tchiyat hamaytim* (for bringing the dead to life).

To be thrust into single status in those days was a jolt. Without a husband, I was viewed differently in the Jewish world. When I was married, someone from the congregation once apologized for thoughtlessly using the word "damn" in my presence; but when I joined the category of single womanhood, I was no longer a princess. After my husband's death, a married male congregant confessed his fantasies about me, and I saw how unprotected I was without the barrier created by marriage and being a rabbi's wife. Indeed, the dais from which my husband preached had been my burka and now I was suspect, as described in the *Shulchan Aruch* (Code of Jewish Law): "A woman should not remain single lest she be liable to suspicion."

Being a widow made me self-conscious for all kinds of other reasons, too. It was normal in the larger world to be a divorcee at age thirty and to be thought of as still young, but a widow was old, old. No matter what I did, it would be a subject of discussion, heightened because I was a *rebbitzen*. "Was that you I saw in the shoe store buying red suede high-heeled shoes?" Um, Uh.

I had been raised to believe utterly and unquestioningly in the father above, the past forefathers, and the husband as *baal habayit* (head of the house). After Mandel died, I tried very hard to continue the tradition, but when I stood up to recite the kiddush, I felt like I was cross-dressing. The

practice of Judaism in those days was meant for a nuclear family: a husband, a wife and (at least) two children.

Hank, my secular, cool cousin, played Pygmalion in an effort to teach me how to become a new woman. He was Uncle Izzie's son and he knew about "guys and gals." Hank told me I was "a good-looking gal," which instantly got me depressed. He took me to my first uppity Upper East-side restaurant. I ordered a Patrician Salad, a royal name for cottage cheese. Hank had good intentions. He encouraged me to say, "I'm out of here." He could not know that though I was dying to be out, I was longing to be in at the same time.

And there were holier-than-thou types who would sprinkle a little hostility into their unsolicited advice. Perhaps I ought to be thankful to those who jumpstarted my burgeoning feminism. For example, when I sold my husband's esoteric Yiddish books to buy an encyclopedia set for my genius boy, I was berated by a certain sanctimonious, self-proclaimed "advisor." You'd think I had burned those books that were gathering dust on a top shelf near the ceiling. I had to explain that I wasn't a bad widow, but that this kid of mine would like to browse the *World Book Encyclopedia* when he returned from the yeshiva. It so happened that my son received his PhD from MIT and went on to become the director of the program on plasma physics

and professor of astrophysical sciences at Princeton University. So maybe my shatteringly iconoclastic decision to sell some unreadable, Yiddish books was not such a bad idea.

In the synagogue, I could no longer reach out to kiss the Torah when it was carried around. It suddenly seemed like idolatry to me. I'd back off when I saw the scroll coming my way, dressed in its velvet slipcover. I tried to hide my "disease" so none of the earnest congregants would notice. I would turn around, looking in another direction or glance at my watch with a sleepy absentmindedness, as though I happened to miss my chance when the Torah went by because I was not quite alert enough. Sometimes I'd drop my glasses and bend down to retrieve them.

The Torah assumes that a widow will want to marry her husband's brother in order to preserve her husband's name. I had no plans to marry anyone else from Mandel's family, and went in the opposite direction when I took the outrageous step of dropping Mandel's last name. The epiphany that came to me was very simple: I was no longer a Greenfield girl, and no longer the carrier of my husband's name. I was no longer "Mrs. Fisch." I was someone else now. And there it was, my new name would also be my old name: Helène Aylon. Aylonna is Hebrew for Helène. I shortened it to Aylon, and so my name would become Helène Helène.

NOW THAT MY children were growing up without an *abba* (father), I made sure we spent holidays in Boro Park. I wanted them to be part of a traditional extended family. Since my celebration of *Shabbos* in Sheepshead Bay could never be 100 percent *k'halacha* (to the law), it was better to go to Boro Park and please Mother at the same time. That was the *frum* part of me; every deviation from Orthodoxy seemed blemished, and every improvement on Orthodoxy seemed cosmetic.

In private moments I had often pretended to be an actress playing the part of the bride in *The Dybbuk*—I could only imagine myself in a Jewish play. I'd be playacting before the mirror. In my new single status I had the freedom to experiment. I'd study my face in the mirror and try out different personas. Now I could imagine myself as an actress playing Anastasia, the Russian princess who was said to have survived the killing of the Czar's family in 1917. Moving into headier territory, I acted out a scene from *Cat on a Hot Tin Roof*. Remembering all this, I'm embarrassed even now, but there in my lonely house, I was a surreptitious Cindy Sherman, trying on new identities—a glamorous Latina, a pin-up, an actress. Of course, I did not know Sherman's work in those days, but I can understand what propels her.

Playacting at the mirror, 1965.

My sessions in front of the mirror helped me begin thinking more seriously about art. If I looked closely I could imagine myself as an artist.

WHILE MANDEL was still alive, my daughter Renée began kindergarten in the Rambam Yeshiva on the same day I began classes at Brooklyn College. I secretly enrolled in an acting class, but my major was art. Better late than never.

My degree in art would be a degree in freedom. I used my maiden name when I enrolled; I had yet to start using

Aylon, and it was important to me not to "soil" the distinguished name of Rabbi Mandel H. Fisch by exposing it to my secular, collegiate world. I cringe even now as I think about this. By the time I graduated Mendel had died, but I had a long way to go before I would truly no longer be Mrs. Mandel Fisch. My feelings were deeply conflicted. I did not take a picture for the yearbook, lest someone from home recognize me and reveal my identity to my professors and classmates. I did not want that old world to be part of my new one. It was only at the age of sixty that I dared to "come out" as a formerly Orthodox Jew.

At Brooklyn College, I took a class with Ad Reinhardt, the abstract expressionist known for his all-black paintings. He gave us an assignment to paint a realistic self-portrait, and I worked with a mirror in front of me for weeks on end, studying my face as I painted. I got the feeling that Reinhardt was studying my face, too. At the end of the term he surmised something about me in that uncanny way he had about him. He said the portrait looked like me, except it was a much older, depressed version of myself. Like Dorian Gray reversed. I threw this early work into the incinerator when I moved out of Brooklyn.

I also made still life paintings of the *Shabbos* table with the wine and challah, and hung these paintings in our

Brooklyn house. My son was very attached to them. Even now, he bemoans my impulsive act of getting rid of those early works when we moved several years later. I had taken the paintings off the wall and stacked them at the curb for a garbage pickup. I might have had time to reconsider but I heard the sound of gongs coming down the street and a creaky voice belting out, "I cash clothes! I cash clothes!" An old horse was laconically pulling a wagon with an ancient man at the reins. He stopped the horse in front of our house, picked up all the paintings, dumped them on top of the *shmatas* in back of the wagon, and slowly the horse trotted away. There went my early work.

But Reinhardt encouraged my new elusive work, and pushed me to go beyond traditional painting. He spoke to the artist Mark Rothko about me, and Rothko invited me to his studio in a carriage house on East Sixty-Sixth Street. Reinhardt told our class that art is the most serious thing in the world, but it is also a game. When I saw Rothko's paintings, I agreed that art indeed could be the most serious thing in the world, but that it was not a game for Rothko.

Rothko's huge studio was bare and immaculate, with a large bouquet of white chrysanthemums flowering in a huge bowl in the center. Rothko told me of his early days at *cheder*, as the small yeshivas in Russia were

called. *Cheder* literally means "room." He told me Barnett Newman had also gone to *cheder*. We talked about Newman's sculpture *Tsim Tsum* (a Kabbalistic term for the contraction of the infinite light of G–d to make room for the finite universe) and his *Onement* paintings of a single line. I said, "These paintings go higher and won't come down, like he's making aliyah, ascending to Israel, staying on high." Reinhardt and Rothko and Barnett Newman had all shown in the Betty Parsons Gallery. I had read that after Newman's first exhibition at Parsons, he remarked, "We are in the process of making the world, to a certain extent, in our own image." How Jewish is that? I felt free to share my Orthodox background with Rothko, even though I never spoke about it to Reinhardt or my fellow students. Rothko talked about Martin Buber's "I and Thou," how a true relationship with G–d cannot be actively sought; we may ready our souls to have an encounter with G–d, but it will not happen unless we patiently allow G–d to manifest.

Rothko's judgment of his work and himself was harsh. He questioned his early work, wondering if he was the kind of artist who pandered to the taste of the masses, worrying that his colors were too appealing, too gratifying, too ingratiating. I told Rothko his paintings reminded me of the sensation of squinting into the *Havdala* flame with eyes nearly

shut, and seeing the fading and blending of the ethereal color of fire, I wondered if ho had done this, squinting while looking into the holy candlelight and seeing beneath his nearly closed eyelids the smoldering reds, the golds that he painted.

Rothko brought out his latest works on paper, done only in black and brown, and differentiated only by the varying proportions of the two colors. He asked what I thought of these somber works. I should have wondered why someone of his stature would ask the opinion of an insignificant student like me, but mesmerized by our lofty conversation, I rose to the occasion: "Your black and brown works are the *tohu va'vohu* in *Brashis* (the void in the beginning) in Genesis. And the line that separates the black from the brown or the brown from the black is the firmament, dissecting the void."

The day was waning and Rothko did not bother to put a lamp on. The dimness contributed to the drama. I left feeling as though I knew Rothko, and knew his works as never before. Three weeks later, he committed suicide.

Recently the art historian, Irving Sandler, sitting next to me at a dinner party, asked me if there was such a thing as Jewish art. I said I knew it surely was not the souvenir kitsch of menorahs and six point stars, but yes, I think that Rothko and Newman created Jewish art.

I SPENT THE YEARS after I graduated from Brooklyn College tentatively adopting my emerging artist identity and looking for ways to make money. There was absolutely nothing I was qualified to do—not even washing floors. Uncle Izzie, the sophisticated uncle, recommended that I meet a legal client of his, a wallpaper designer who happened to be gay. It all sounded utterly hip to this Boro Park kid, as I had never met anyone openly gay before, but wallpaper was not what I wanted to create as an artist. I turned him down.

Uncle Morris, the businessman, said he might find a job for me in his girdle factory. He had me draw a feather balanced on an index finger to indicate that the new line at Deluxe Girdlecraft was featherlight. Mother loved girdles as much as she loved her brother Morris. She'd sometimes brag, "the very first thing I do in the morning is put myself together in my girdle." I wanted to tell Mother I too was putting myself together, but not with a girdle. I looked in the *New York Times* want ads and found a job at an ad agency. I got fired because I was a slow typist, much to the relief of my kids, who had the insight at their young age to know that this job was not for their mom. I actually applied for a job as a guard at the Metropolitan Museum of Art, but the agent took one look at me in my flowing cape and knew this wasn't a fit either. After that I took short-term teach-

ing gigs in which I taught students everything I knew about using one's neurosis to find one's signature as an artist (my own neurosis being indecisiveness, which brought about my paintings that actually change). To carry on, I constantly applied for grants, a beggar speaking in the obscure language of grantsmanship.

My earliest job as an artist was in 1963 when I volunteered to paint a mural in a community center in Brooklyn's Bedford Stuyvesant neighborhood. The aim of the center was to assist high school dropouts. It was called JOIN, which stood for Job Orientation In Neighborhoods. My mural had three elongated "paths" converging at the top. As I painted, it reminded me of those primordial tales of a prince having to find a treasure at the end of a long journey, but he had better choose the right path or else. (That's my Rorschach test response; the kids had their own reactions.)

When a reporter from the now-defunct New York Journal American newspaper interviewed me about this mural, I gave my made-up name, Aylon, for the first time. Sure enough, when the article came out accompanied by the photo of me at JOIN, my mother received telephone calls asking if I had remarried. Why else would my name be changed? Mother was in shock that I dared to make up my own name. For years she continued addressing her birth-

day cards to me as Mrs. Helène Greenfield Fisch. I had to alert the mail carriers that the letters were meant for me.

I knew the psychologist who worked at JOIN only by his first name, Pavel. He looked like Jack Nicholson, with that same sardonic, crooked grin. Pavel had survived the Holocaust as a teen and had become a brazen critic of the God who was not around to protect him or the millions who died. Pavel had an outrageous approach with the high school dropouts and staff as well as his private clients. Most of his behavior would be considered illegal today. More than once, when conducting an interview with candidates applying for a counseling job, who was nervously trying to impress him, Pavel would ask out of the blue, "Do you like to fuck?"

I feigned deafness. Mainly, I was captivated by the way he could get the kids to open up. When I told Pavel about my Orthodox girlhood, he scathingly predicted that I would soon have a "religious change of life" that would be "an upheaval akin to the loss of virginity." I was appalled by this pronouncement, dripping with innuendo, but I guess I was curious to hear more.

One day Pavel offered to drive me to pick up some supplies for the mural. He said this would be a good time to have a serious talk. The roof of his sports car was down, it

was a balmy day, and I relaxed in his attentiveness. But as soon as we got onto the Bell Parkway, he began to speed at seventy miles an hour, leering up at the heavens, as the wind hit our faces, "You Lordy Lord up there, you fuck-up! Why did you let the babies die?"

"What are you saying?" I screeched. "Is this the talk we're about to have?" He put his foot down harder on the gas pedal pointing his middle finger up to the clouds, "Oh, Lord: Do you have pubic hair to match your flowing beard?"

"Stop it, for G–d's sake!" I yelled.

"Then what should I do 'for G–d's sake?'" he laughed wickedly.

"You'll get a speeding ticket—you'll see!" I said, as though he cared. My fright only escalated his craze. He honked his horn and raced on.

I screamed to be let out while he shouted, "Lordy Lord, I dare you to crash this car. You who teach vengeance and violence, I dare you to show me your omnipotent strength right now. Go on, You the Smiter, smite me! Where are your balls, your mighty outstretched arms?" And he pushed down even harder on the gas pedal.

I started to laugh a bit hysterically, because despite my terror, there was something funny about the way he elongated his word "a-a-a-r-m-s." That's when he finally slowed

down and drove to an exit to park the car. Then, with utter calm, he turned to me and declared that my nervous laughter was the release he was waiting for, that I was cured of what he called my "religious paralysis," and now I could get on with changing my life.

THAT SUMMER I was the art counselor at my kids' summer camp, my way of paying camp fees. I took a few days off to go to a cabin in the woods nearby where I could work quietly, illustrating Shlomo Carlebach's ethereal religious melodies. At the time, I was "divesting," emptying myself of a whole bunch of laws, yet there I was filling my soul with the holy songs set to Shlomo's beseeching melodies, which I played on my tape recorder as I illustrated these yearning chants. As I listened, hearkening, I felt a gentle spirit soaring through me, becoming part of my heartbeat.

Rocky, our English springer spaniel, accompanied me to Woodstock, where the cabin was located. He was a part of a grand plan I had developed to experiment with letting go and finding out what was out there besides Orthodox Judaism. The idea was that I would head to an outdoor café every day, and Rocky would sit on the pavement beside me. I would boldly order something *traif* (non-Kosher) like a

ham sandwich. Every day, I dutifully conducted my experiment. I'd look at what I'd ordered, sniff it, and challenge myself to eat it. *Feh!* I couldn't manage even one bite, and I'd drop the horrid sandwich down to Rocky, who dutifully helped me get rid of it. I tried bacon. Then pork. I never ate any of it, but had a small nauseating triumph in taking one bite of a tuna fish sandwich that I was sure had been sliced by a knife used for ham.

Mandel once told me of a psychology class at Yeshiva University in which a popular professor known as Doc Horowitz tried a *kashrut* (kosher) experiment with the students. He hypnotized a student in front of the class and told him to chew notebook paper. "It's not bad tasting, it will relax you like chewing gum," he told the student once the trance took effect. The student chewed calmly on the paper until the professor told him that a classmate who was a good friend was in truth an enemy. The student, still chewing the paper, became agitated and tried to stick this "enemy" with his pen. Then the professor calmed the student down by telling him that it was a mistake; there was no actual enemy, and the student could resume chewing the paper to relax. The student began chewing again, completely at ease, until the professor said, "That nice paper you are chewing was used to wrap a ham sandwich." The

student abruptly came out of the hypnosis, spitting out the paper, coughing uncontrollably. Nearly stabbing a class-mate did not catapult that student out of his hypnosis, but the thought of eating *traif* was enough to make him jump as though he had caught fire.

Difficult as it was, I gradually managed to loosen some holy ropes of my Orthodox observance. I think Pavel's crazy challenge to a G–d he did not fear had something to do with it. I had stepped off the dais, to totteringly stand alongside the rest of the world.

IN 1967, when my son Nathaniel graduated from the yeshiva of Flatbush High School, Renée still had two more years to go. I faced the daunting decision as to whether this would be the time to send her to public school or keep her in the yeshiva. Her brother was now enrolled at MIT. She'd be on her own, traveling by bus to Flatbush Yeshiva although there was a fine public high school just two blocks from our house. It was hard to make the decision on my own. Grappling with the yeshiva vs. public school question for my daughter awoke in me my own post-Shulamith choice all over again: Music and Art High School vs. the *midrasha*. Finally, in exasperation and desperation I let Rocky decide:

if he gave his left paw, Renée would go to a public school. If he gave his right one, Renee would stay in the yeshiva. Rocky gave his left paw and that was it. Renée went off to public high school and I rented a studio on St. Marks Place in the East Village, my first official declaration of myself as an artist.

You can't imagine all the phone calls I got from Mother warning me that my sweet girl could become a drug addict now that I was letting her go to public school. Mother called me daily to remind me that if Renée had been attending yeshiva, she would come back at 6:00 p.m. to a mother who was home to greet her, whereas since public school let out at 3:00 p.m., "the orphan" was coming home to an empty house because "The Mother," as she called me, would not be finished "shmearing" in the East Village so early in the day.

Believe me, I was not like Louise Nevelson or Grace Hartigan, two artists who ran from mothering; or Lee Krasner who emphatically let it be known that she had no desire to be a mother; or Georgia O'Keeffe and Agnes Martin who had no children, and were just fine about it. Unlike these artists, I loved being a mother.

And yet, as usual, I was down on myself, both for my incomplete dedication to mothering, Etta-style, and for my

incomplete dedication to art, Soho style, because indeed, I was a mother first. All through those anxiety-provoking years when I worked at becoming an artist, I feared my children would judge me for my iconoclastic choices. I was sure that if they could not have a mom like their homebound grandma or their friends' mothers, they would rather have their mother be a nurse or a teacher or a librarian. A mother was supposed to be practical. A religious mother did not take a studio across from the Electric Circus where Tina Turner sang "What's Love Got To Do With It." How well I remember hearing the click of my daughter's bedroom door shutting when I came back late for dinner from this den of iniquity, announcing shakily, "Hi, I'm home!"

I thought maybe I could divide my guilt equally: 50 percent of the time I would go to pieces for not being with my children as much as I thought I should, and the other 50 percent I would fall apart for not being in the studio as much as I needed to be. Of course that meant I felt guilty all the time. Stuck between two worlds, I did not have any women friends to talk to about this dilemma. Nor did I have the money to hire someone to be there when Renée came home alone and lonely without her brother.

My salvation arrived in the form of feminism. It was a birth, a rebirth that dazzled my imagination like a sunrise,

and plucked me out of the guilt that was caving in on me. The feminist movement was impossible to miss in 1970 in Manhattan. Ten years later, it would have been too late for me. But I was rescued just in time. I was inspired by women like Maya Angelou, Andrea Dworkin, Adrienne Rich, and Mary Daly. I realized that these role models did not tremble in their lives the way I did in my splattered smock. They moved, but they did not shake. As feminists, they inhabited the world in a new way. They threatened to turn it upside down and inside out. To me, this meant that feminist art was not some tiny creek running off the great river of real art, it was not some crack in an otherwise flawless stone. I learned it was okay to give myself the trip over the Brooklyn Bridge into Manhattan, thank you very much. And the trip back home—a huge thank you for that, too.

MY FIRST PROFESSIONAL commission was a mural for the Jewish chapel at Kennedy Airport, part of a plaza with Jewish, Catholic, and Protestant chapels hovering above the waters of a lagoon.

I knew that I wanted to paint one word in that chapel: *Ruach*. This word is composed of three letters, *Reisch*, *Vav*, and *Chet*, and it means spirit, breath, wind. It is the one

word in the Old Testament that I still venerate. It comes from the second verse in the Book of Genesis that I spoke about with Rothko: "In the beginning, God created heaven and earth. Now the earth was unformed and void, and darkness was upon the face of the deep and the spirit (wind/breath) of God hovered over the face of the waters." Rabbi Akiva, the great Jewish scholar, once said that the world is based on wind/breath. "Take away just breath," he is quoted in the *Midrash T'mura*, "there is no life." This word would be what I would hold on to as I exited one life and passed through the revolving door to face a new direction.

I got this commission after sending in drawings of my proposed mural to the architect and to the rabbis in charge. I showed them how I would layer the motif of the three Hebrew letters, each washing over the others, intersecting until the letters began to look like doors and archways. As I told an interviewer from *Art News*:

> I wanted to paint not blue and black and red but blueness, blackness, and redness. I wanted the colors not to look as though they came straight off the brush but more like stains coming through from the other side. But letters always seem to be going forward. I wanted to push them back, to travel backward in search of meaning . . . If I saw a shape emerging, I spread it out. If I saw a positive color coming through, I veiled it. I did not want a beginning or an end.

I also designed the synagogue doors to reflect the shapes of the tablets on the far end of the building. Alas, the donor who was funding the doors wanted his name on them. I said, "This is the entrance to G–d's temple. The name of the donor can be placed on a plaque somewhere on a wall." (I had the courage to say this because I had already been paid for the doors and they had been pictured in *Art News*.) But when my son and I stopped at the chapel one summer evening before he was to fly to Harvard for summer school, I found the doors lying on the ground like fallen angels. The *machers*, the bigshots, had showed me, this young upstart not to talk back to an "important" board member. Had it been Rauschenberg, they would have listened, and considered that the demand signified the staunch integrity of the artist. But my tablet-shaped doors with their tablet-shaped handles were cast aside. An expensive new wooden entrance was installed with the name of the donor on the new door. Two more words had been added: "push" and "pull."

I was speechless. I said nothing but the next day, I hired four construction workers to pick up the doors and haul them into my fourth floor studio on St. Marks Place.

The three chapels, which were quite beautiful, lasted only a short time before the airport authorities decided they didn't need chapels any longer. I once asked the chaplain

at Kennedy what happened to my wall, and was given the runaround. But the doors stood tall in my studio like remote giants. Once they were placed upstairs against my black wall, there was no way to move them ever again. The doors were there in the evenings when I went home to Brooklyn to give my daughter dinner and be a mother, and they greeted me upon my return the next morning, bearing witness to my life as an artist.

Painting *Ruach*
at JFK airport,
1966.

Ruach

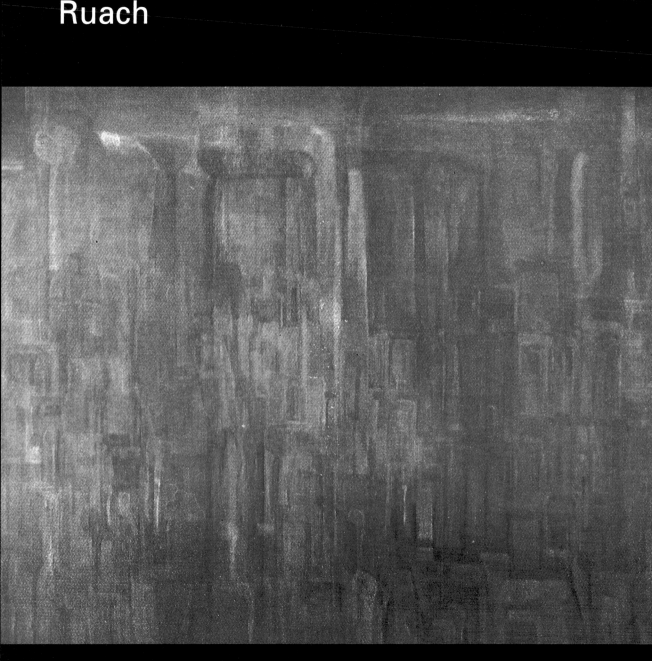

Ruach, palimpsest of letters at the JFK airport Jewish chapel, 1966.

JFK airport Jewish chapel, 1966.

Ad Reinhardt had come to see my work in the airport chapel. He remained an important influence on my way of looking at art, seeking a revelation. You look at a Reinhardt black painting, and after staring a while, you can discern a glimmer of color emerging, as confounding as the first glimmer of light in the black of night. I later would seek a revelation in my own work, painting partially on layers of glass, so that depending on the position of the viewer, an elusive shine of the metal backing might peep through. I held a Bunsen burner to ten-foot sheets of metal until the paint cracked from the heat, revealing the metal's shiny iconography beneath. I showed these works at the Max Hutchinson Gallery in Soho in 1970 and 1972. Mother brought cookies to both openings.

REINHARDT SENT me postcards, wanting to know why I never confided more about the controversy over the doors, why I never invited him to my home in Brooklyn, why I was

DEAR HELENE, HAVEN'T HEARD YOUR SOFT VOICE since when? READ ABOUT YOU VERY NICELY in ART NEWS, GOOD. HAVEN'T SEEN YOU SINCE YOU DUMPED me in FLATBUSH, MIDDLE OF NOWHERE, FLAT-FOOTED, EMPTY-HANDED, FINGER-NAIL-BIT-TEN, BEDRAGGLED, AIMLESS, FUZZY-HEADED, SYNAGOGUED, AROUSED AGAINST POWERS THAT WOULD CENSOR YOU, AIRPORT-DIZZY, SORE AG-AINST ST-JOHNS, WEARY, SWEATED, HOT, CAR-SICK, CARLESS, FORCED TO GO UNDERGROUND TO GET OUT OF BROOKLYN, UNABLE TO SAY GOODBYE, WORRIED ABOUT TIME, FACED WITH HOURS OF TUNNEL-TRAVEL, WHERE ARE YOU? Ad

HELENE, NOBODY NEVER TOLD me YOUR NAME, TWO NUMBERS GOT LOST, LARRY CALLED me ABOUT HIS LEG, YOU NEVER CHECKED BACK, NEVER REPORTED THE CONTINUING SYNAGOGUE-STORY, NEVER OUTLINED THE LATER-CONTROVERSY, NEVER DOCUMENTED OR DESCRIBED THE LATER-FATE, NEVER DISCLOSED THE FOLLOWING-FACTS, NEVER COMPLETED THE MURAL-REACTIONS, NEVER HINTED AT THE INSIDE-DOPE, NEVER CONFID-ED THE CONFIDENTIAL-INTRIGUES, NEVER AIR-ED THE AIRPORT-DECORATION-DEBATE, NEVER INCLUDED me in THE LATEST-NEWS, WHY? Ad

Postcards from Ad Reinhardt, 1966.

139

so secretive. Of course I could not get myself to invite him into my home on Avenue R and East Twenty-fourth street in Flatbush, with all those still life paintings of challah and kiddush cups. I had to keep this Jewishy life away from my avant-garde guru. Somehow, I had to hide the fact of my *frummy* origins, although the mystical leanings were apparent to him in *Ruach*.

MOTHER HAD RAVED about my art attempts when as a child of eleven I drew my youngest sister as she slept. That was sisterly, she said. In *midrasha* days, when I copied the photos of frowning rabbis that hung on the walls, Mother thought this showed nice feeling. She nearly fainted with appreciation for all the Mother's Day, birthday, and Chanuka cards I made for her. And in my adolescence, she thought my being artistic would improve my stature as a wife someday.

It was clear that she was rapturously supportive of my art as long as she saw either family or *Yiddishkeit* in the works. "You are the spirit of the house," she'd say to me when I gave her paintings to hang in the dining room, the living room, or the indoor porch. She'd introduce me to everyone she knew as "my daughter, the artist." She

140

would see what she wanted to see in the works and refer to them by her own titles. When I gave her an abstract piece titled *Oval with Diagonal Furrow*, she turned to Uncle Abe, now her new husband, and cooed, "Sweetheart, look, Helène brought us a painting of Mt. Sinai for our anniversary!"

I painted a smaller version of the *Ruach* mural for her. Mother chose to see the word *chai* (life) instead of the word *ruach*. She would walk guests toward "*Chai*," holding their hand, navigating them toward the "blessing of life." But once the art began to rock the boat, she did not know what to make of it. As I began creating installations with oil meant to drip and splatter and spill, she warned me that dripping oils make a mess. And years later when I boasted that I could teach Moses about feminist consciousness, I was not merely being an ordinary *knaka* (an obnoxious show off); in her eyes, I was trouble. What do you need this for? She'd ask. I'd explain but she'd ask the question again the next day as though it was a fresh new thought that just came into her head.

To be fair, Mother's queries partly stemmed from her worries for my security. I was earning only a little money now and then from sales of the art. The occasional grants were coming in sporadically. But her insistent questioning

propelled me to assert myself. Someone once said all decisions in life can be relegated to two choices: do you want to eat well or sleep well? I chose to sleep well in my own dream world; I'd never imagined I could make this choice as an Orthodox housewife.

From the day I finished *Ruach* and then hauled away the tablet doors, I could not find a way back to the Torah G–d, the one I was raised to love "with all my heart and all my soul and all my essence," as the prayer reiterates. I wanted to find the true original G–d who ostensibly wrote the Ten Commandments, the Commandments that Moses threw down Mt. Sinai and smashed when he caught sight of the golden calf.

I KEPT ON making art, shuttling between my two worlds, one in Brooklyn, one in Manhattan. After Renée went off to college, it was time for me to move out of Brooklyn. When I had brought up the idea of moving while she was in high school, she'd resisted—she had her life in Brooklyn, her friends there. Indeed. Why should she have to live in a fourth-floor walkup in the East Village? So I waited, wishing my sacrifice would seem remarkable to someone else beside myself.

I moved to Westbeth, the New York City artists' building on West and Bethune Streets, hence it's name. Soon after I arrived, I met someone who remains one of my dearest friends in the world. Brenda Dixon moved in shortly after I did, and we bonded immediately when she showed me the painted sky on the ceiling of her baby daughter Amel's makeshift bedroom. Brenda was African American. I hungered to balance the bland thin whiteness that I had ingested for so long with the fullness of color. In the *Machzor* there ought to be within the long list of sins, this one: "For the sin of depriving Jewish children the friendships with children of color by discouraging play dates or by general seclusion."

Soon after I moved in, I posted a sign in Westbeth's lobby offering a job for a dog-walker. I needed someone to walk Rocky late at night in the windy, empty streets by the West Side Highway, where in those early years, prostitutes stood on the corners waiting for cars to cruise by.

I got a call from someone named Jose who was interested in the job and arranged to meet him in the lobby with Rocky for a short trial walk since I was nervous about this stranger knowing the number of my apartment. He took Rocky outside for and I waited impatiently for their return. After half an hour I began to worry that he had taken off

Me with Rocky in front of *Willow*, 1971. Westbeth, New York City.

with my dog. What would I tell Renée, who had left Rocky in my care? Finally, after an hour had passed, Jose returned, a halo of glistening snowflakes surrounding his Afro, a beatific smile of sheer pleasure on his face. He had given Rocky the supreme walk of any dog's life and so he got the job.

Two weeks later, Jose came in from another freezing snowstorm after one of his midnight walks with Rocky, and I invited him to sleep over. After that we shared my bed every night, falling into a peaceful routine that lasted for the next two years. I would get up early and work on my long metal pieces, painting steel and then heating it until it cracked. Jose would sleep soundly through the morning despite my puttering around. I would cook brunch for the two of us and he'd leave soon after. I never asked exactly where he was going. I only knew he was heading for some East Village dive where he played jazz. When he came back elated, I caught his high as if it was religious exultation, a gigantic ode to being alive. I liked caring for him and never thought there needed to be a sharing of responsibility. His energy electrified me.

Renée, ever the analytical one, thought that her leaving home was a factor in this offbeat combination; I needed

someone else to mother, she thought. But I knew that I was crossing a line to find out what there was to experience in the outside world. I went to Spanish Harlem for the first time with Jose, to visit his parents. And especially daring for a Shulamith girl, I started committing petty crimes. In our own private act of transgression, Jose and I would drive to Long Island to spray white paint on the black faces of garden statues on manicured lawns—he sprayed, I drove the getaway car. On quieter days, Jose would help me with my art; he framed the only circular painting I ever did, which now hangs in my son's dining room.

I could not tell Mother about Jose and our ecstatic life, but I may have subconsciously wanted her to know. I went to the beauty parlor and got a permanent; after all she had always urged me to have my hair done—but she did not expect I would walk out sporting an Afro. She didn't say anything when I visited with my new do, but the following week, Mother suggested we go on an outing to get a new "outfit." We met at B. Altman's department store, where in her most saccharine tone of voice she suggested we stop at the wig counter first. I should have known from her suggestion of B. Altman's instead of Klein's that there was an ulterior motive. Klein's did not have a wig department.

Comparative piece,
Twice Told,
1972. Steel.

Comparative piece,
Counterpoint,
1972. Steel.

The euphoria I experienced with Jose came to an end when I discovered that his daily outings were for heroin, not jazz, something I should probably have figured out sooner. He never walked Rocky again. Instead I began waking Jose up at seven in the morning so we could go to a clinic for methadone treatments. I stayed with Jose until he recovered. Then I wanted to go as far away from New York as possible. My opportunity appeared out of the blue: some friends had gotten married and were taking a honeymoon trip in their van to California. They needed a third driver and I jumped at this chance. I'd check out California the way Moses' spies checked out the land of milk and honey before the Jews entered. As we three drove across the country I cried and cried for Jose, and my naïve fantasy about my life with him. As I listened to Roberta Flack singing "killing me softly with his song," I wondered what was wrong with me. Why had I romanticized Jose? I'd done that the whole time we were together, convincing myself he was a musician but never having the courage to ask him where he practiced every day. I started remembering that first time in the snowy, windy New York night. I wept while my friends drove on through the sienna beauty of New Mexico and over the slopes of the Sierras, until they plunked me into the hot baths of Esalen, in Big

Sur. This was a different kind of *mikveh* to be sure. California passed the test for the good life.

After three days at Esalen with my friends, on my way to the airport for my flight back to New York, fortified with all the New Age-y-ness I'd found at Esalen, I marched into San Francisco State University and jauntily asked the chairman of the art department if there was a teaching position open. It so happened that he was indeed about to advertise a position. How could I have known, he wondered. I met with the faculty that day and corresponded with them upon my return to New York. Within a month I had the job. I would move to California to teach drawing and painting at San Francisco State University.

The year was 1973, exactly twenty-three years after I had left the streets of Boro Park to get married. I liked to think that in this new phase I was following Agnes Martin and Georgia O'Keeffe, finding new inspiration out West. My son was at MIT, and my daughter was studying drama therapy in England. I was free to cross the desert with Rocky to the capital of new consciousness. I would sublet my apartment with short-term leases so that I could return often to provide Mother with any reassurances she might need (and get some reassurance myself by alighting on her doorstep).

While I was preparing for my move, I happened to meet Peter Schjeldahl, the art critic. I told him of my plans.

"You are moving to California? But why?" Peter, the quintessential New Yorker asked.

"To be happy," I said.

"That's not a reason," said Peter.

After arriving in California, I became the fifth occupant in a Victorian house on Delores Street in San Francisco. My room faced a steep hill with a line of palm trees that looked like skinny models with bouffant hairdos. It would be a decade before I would move back to New York.

DURING MY FIRST autumn in California, I met a secular couple who had a troubled son who'd turned his life around thanks to the influence of *Chabad,* the ultra-Orthodox Chassidic sect. This couple swore that their son was becoming a *tsadik* (a righteous sage) because of the home *Chabad* gave him. They invited me to join them for the Friday night service. "No, absolutely no," I said. "I've paid my dues, I *davinned* enough for two lifetimes." But they persisted.

"All right, all right, just this time."

When I entered the *Chabad* service, I saw metal tables with hundreds of candles like a robust chorus of holiness. I

lit two candles and placed them among the crowd of flames. I sat down behind the *mechitza* (the curtain separating the men and women) and almost immediately tears unexpectedly welled in my eyes. Images began to run through my mind, of the past, of my childhood, of my mother lighting the candles as she beckoned the *Shabbos*, sweeping her arms in wide arcs.

To distract myself, when the prayer called for rising, I stood on tiptoes and craned my neck to peer over the *mechitza*. There they were—the usual congregation of men under their prayer shawls, huddled together away from *de vybeh* (the wives). My tears came to a halt. Saved. Looking at their dark suits underneath the *tallisim*, their black oxford shoes worn down on the outer edges, I was on dry land again. Not one man there wore sandals or loafers, and this was Berkeley, Birkenstock country. Their shoes seemed to insinuate that the covenant had been given to them, alone; like the *balabatim* in Boro Park and in my late husband's shul, they stood firm inside their oxfords, unmindful in their exclusivity.

It would be another seventeen years before I'd begin the two decade artwork that I named the G–d Project, but on that night in 1973 in Berkeley all I knew was that I was a feminist—and more so, a Jewish feminist, born

out of the ins and outs of the religion I had known so well, the religion I loved so well, and the religion that betrayed that love.

I DIDN'T THINK then that the Paintings That Change, which I created in my large garage of a studio in the flatlands of West Berkeley, had anything to do with being Jewish. They seemed to be a continuation of my elusive metal "paintings," with a streak of light that would appear, a glow emanating from the painting's cracked metal backing.

My new paintings were different, though; their change was actual, not dependent on the position of the viewer and the light. The silvery metal works from the East Coast had been cloudlike, the way clouds sometimes block the sun. The California paintings were of the earth. The collector Flora Biddle thought my new Paintings That Change in Time should be called "plantings," not paintings. I painted from behind the surface of the paper, allowing the oils to seep through naturally, in their own time, outside of my doing. I'd wait for the image to manifest on the front surface through chance—absorption—and I would accept the outcome.

In part, the work was a test: to see if oil would eventu-

ally rot the paper or preserve it. I was recklessly gambling away a decade of work just to see if that work would last, or maybe if I would last.

I wanted the art to tell me something I did not know. I was waiting for a *mofase* (a sign from heaven), and to find it I had run from everything Jewish to the last boundary of this country to see what would be revealed—to see if *yaish mai'ayin* (if there is something from nothing).

I never analyzed it then, but now I can see that the essence of the Paintings That Change was Kabbalistic. Paradox is acceptable in the Kabbalah; the very word Kabbalah means "acceptance." That was my stance about imagery—not to produce it myself, but to receive it.

As I intermittently observed the Paintings That Change, I saw that the works got richer and more beautiful in time, and that the paper was indeed preserved by the oil. Hallelujah. I realized I could now more readily face my own aging process as a captivated observer, recognizing the wrinkles, the spotting, and the branching veins on my hands as the handwriting of the universe, its morphology on the body, on the body of the land. And if the spotting that emerged seemed unaesthetic to my minimalist sensibility, I would accept this turn of nature knowing that even this change could change again.

I looked to this new land of California to replace my dream of aliyah to Israel. The natural force of the sand and waters of the Pacific seemed to be writing messages to me—Sand Scripts I called them. I saw the handwriting of the Universe in the branched forms that were present in the veins of every leaf, the spinal column of my body, my cerebellum. When I poured liquid it dried in these configurations, appearing as a delicate crystallization. It was natural for the earth to crack in the sun's heat, and for my skin to wrinkle with time.

Tar Pouring (named *Roots* by mother),
1973. Tar and butcher paper.

Paintings That Change

Drifting Boundaries,
Paintings That Change
series, 1974–1977.

1974

1975

1976 *Receding Beige*, Paintings That Change series, 1974–1976

Formations

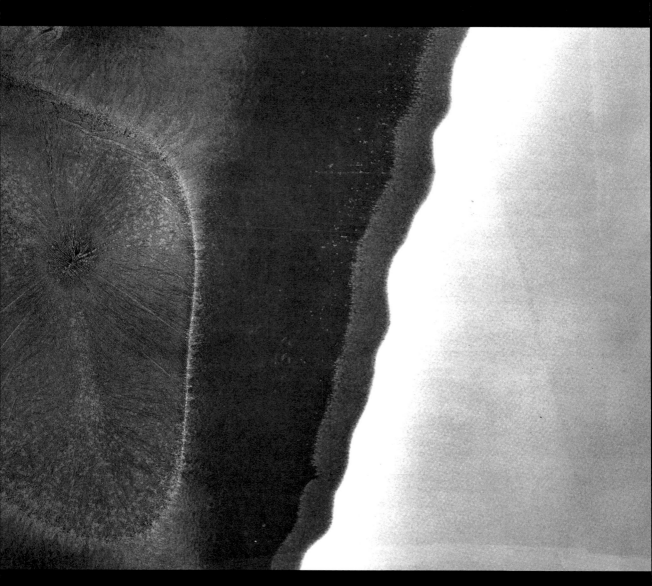

Oval on Left Edge, 1977. Oil on paper.

Opposite page, detail of transforming work, 1987.

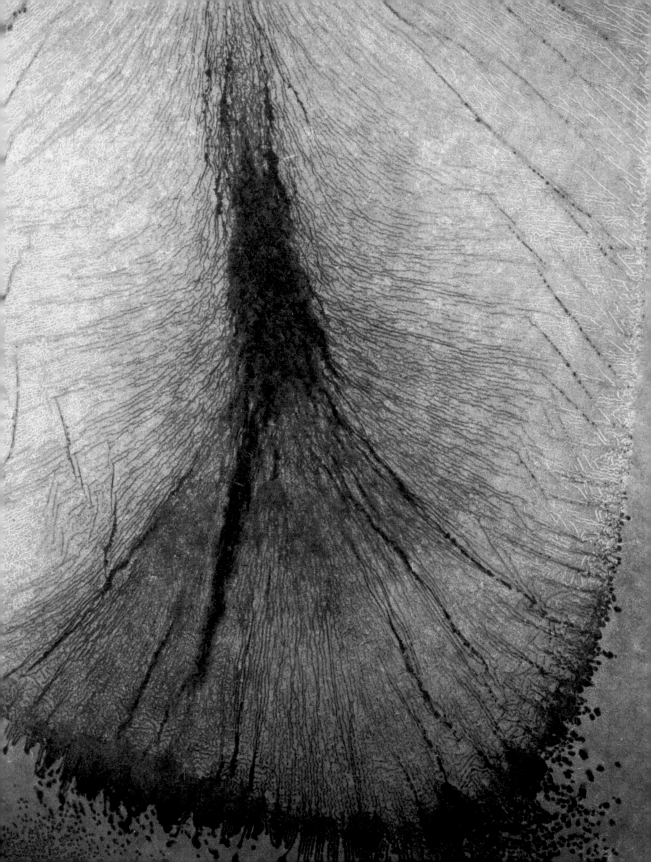

In the summer of 1973 I met with the art dealer Betty Parsons in her Bridgehampton summer home to show her my work. I came with only the very first of my Paintings That Change in Time, one of the smallest. I wasn't going to show up schlepping a big package in my usual bag lady persona. She looked at my tiny painting and without a moment's hesitation, declared, "This is very large."

Betty traveled to my Berkeley studio to see more of my work, bringing her friend, the playwright Edward Albee, who ignored the paintings on the walls and went straight for my file drawers, without permission. "I want to see what you're really about," he had the nerve to say by way of explanation. But there were no clues to the meaning of my art in the drawer—just sanitary napkins, as Albee discovered.

Betty showed Paintings That Change in Time in 1975. I could never discuss feminist theory with Betty. She thought my inspiration for the paintings came from the West Coast,

Betty Parsons at 112 Workshop viewing
Breaking with Jagged Edges, 1979.

163

but she didn't see the feminism inherent in the work, the way in which Paintings That Change in Time played with role reversals. With these works, the collector was deriving the excitement of the work in progress instead of the artist. They were about process rather than completion, which I think of as feminist.

To Betty, action painting was energetic and masculine, inseparable from the American dream. She had an imperialist attitude about American art, seeing the link between the action painting of the 50s and American expansionism. There's a strong correlation in her attraction to the "legendary " aspects of the cowboyesque Jackson Pollock and her attraction to the American Frontier mystique. "Picasso could never have done what Jackson did," she insisted. "Jackson threw down the walls!"

"America is at the crossroads," she wrote for one of her catalogs. " American artists are at the spiritual center of the world because they have the background of the American Dream."

Betty gave me a second show, Formations, in 1979, in collaboration with the alternative gallery 112 Workshop. In the late 70s I was pouring gallons of oil over panels that lay on the floor, standing over them like an ancient priest anointing a biblical king. The top layer of oil would form a

dry "skin." With the wet oil beneath, the panels lay prone for months until the outer skin was thick and set. Then I would lift the panels upright, to "midwife" the paintings with other women I invited to the studio. I called these Formations Breaking "The Breakings."

Each time a panel was ready to be lifted, I announced to the other midwives: "Whatever is contained must be released. You are to initiate the breaking, and I will accept it."

The women then raised the panel and leaned it against the wall. The wet oil would pool beneath the dry skin, forming a sac. And the sac, heavy with oil, would break before our eyes. Sometimes the liquid would gush out; sometimes it drizzled; sometimes it dripped.

It's possible that the prayer my Baba taught me in my childhood, the one I recited each time I left the bathroom influenced The Breakings, but I could not bring myself to say that to anyone in the art world. These works alluded to the visceral body that makes us live or die, as opposed to the idealized body of the dominant culture that encourages us to stare at parts of the body, never seeing the whole miracle.

The strong pull of the Kabbalah was surely in The Breakings. The too-full sac caused the skin to rupture, spill-

ing and emptying out, and a new formation arose. There cannot be a *tikkun* (repair) without a *shvira* (break). The evidence of the moment of birth was in the image of the torn skin. The crystallization forming around the break was akin to a scab that heals a wound.

I see The Breakings in my mind's eye lined up one next to the other on a huge wall. The empty spaces in between the breakings are joined, one negative space merging with another to create a new form. These spaces are like the pockets of silence the Kabbalah speaks of. There is never nothingness.

And like Georgia O'Keeffe, who insisted that the vulva imagery in her work was merely floral, I used dry conceptual terms to describe this very wet, orgasmic process art. I intentionally made paintings that change through natural means, much as a plant that grows, a face that wrinkles, a scar that heals.

The Breakings

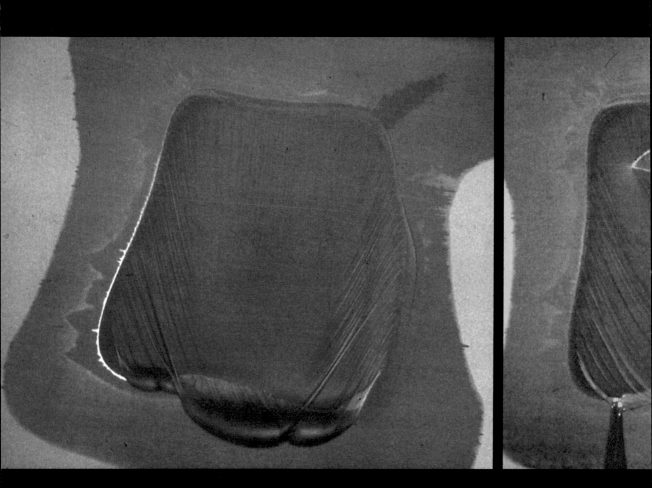

Breaking with Erratic Spread, 1978. Oil on paper.

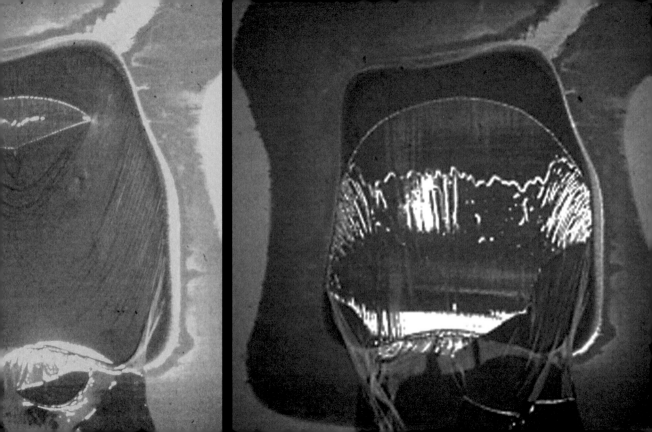

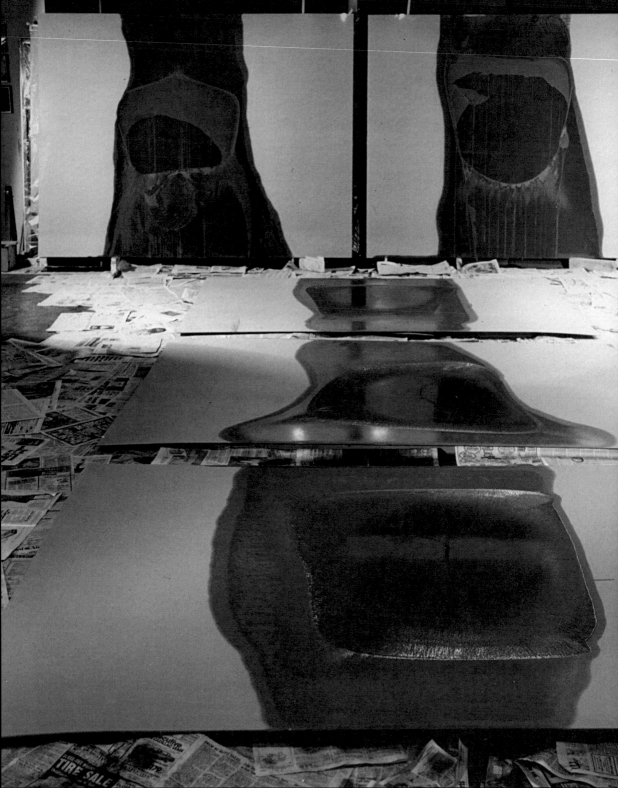

I WAS READY TO BREAK FOR YOU TODAY
JUST BREAK, TWENTY YEARS LATER
BUT I CAN ONLY SHOW YOU WHAT IT WAS
I CAN ONLY TELL YOU WHAT IT WAS
BECAUSE BREAKING IS A MESSY THING!
YOU WHO BREAK UP WITH LAUGHTER UNTIL YOU CRY
WILL KNOW WHAT I MEAN.
YOU WHO BREAK DOWN IN TEARS UNTIL YOU LAUGH
WILL KNOW WHAT I MEAN.
YOU WHO BREAK OUT IN SWEAT FROM EVERY PORE,
YOUR NOSE LEAKING AND YOUR PALMS MOIST,
YOU WHO BREAK INTO CONVULSIONS
UNTIL SALIVA RUNS DOWN YOUR CHIN
G D FORBID,
YOU WHO WOULD NEVER BREAK THE SPELL BEFORE
IT BREAKS FROM ITS OWN MOUNTING PRESSURE,
YOU WHO ALLOW THE WAVES TO BREAK WITHIN YOU
AGAIN AND YET AGAIN,
YOU WHO BREAK LOOSE,
YOU WHO BREAK AWAY,
YOU WHO COME CLOSE TO A BREAKDOWN
BUT STRAIN TO HOLD ON,
YOU WHO HOLD IT IN UNTIL YOU CAN
NO LONGER HOLD IT IN BEFORE IT LEAKS,
YOU WHO KNOW WHAT IT WAS
TO WAIT ALL THOSE MONTHS
FOR THAT SAC TO BREAK,
YOU WHO KEEP TIME WITH THE MOON
OOZING STEADILY UNTIL THE NEXT LOW TIDE,
YOU WHO THINK OF YOURSELF AS A SOFTY
WITH A VERY THIN SKIN,
YOU WHO THINK OF YOURSELF AS A TOUGH ONE
WITH A VERY THICK SKIN,
YOU WHO MEMORIZE EVERY LINE IN YOUR SKIN,
AND YOU WHO ARE SO AGITATED
YOU JUMP OUT OF YOUR SKIN—

IT IS FOR ALL OF YOU THAT I SHALL SHOW
"THE BREAKINGS."
I JUST HAVE TO FIND MY WAY BACK
AND YOU WILL KNOW WHERE I WAS
BUT NO, I WILL NOT ACTUALLY BREAK
THERE IS NO WAY I CAN BREAK
BECAUSE BREAKING IS SUCH A MESSY THING!
TWENTY YEARS AGO, I SAID,
"WHATEVER IS CONTAINED MUST BE RELEASED."
NOW I SAY,
"WHATEVER IS CONTAINED MUST BE RELEASED."
TWENTY YEARS AGO,
I DID NOT THINK OF THE FINAL RELEASE
NOW I DO THINK OF THE FINAL RELEASE.

I WAS READY TO BREAK FOR YOU TODAY TO BREAK,
TWENTY YEARS LATER
BUT I CAN ONLY SHOW YOU WHAT IT WAS
I CAN ONLY TELL YOU WHAT IT WAS
BECAUSE BREAKING IS A MESSY THING!
YEAH, BREAKING IS A MESSY THING!
IT'S A MESSY THING, ALL RIGHT.
BREAKING IS A MESSY THING.

—From *Breaking Twenty Years Later*, performance piece,
Century Show, Whitney Museum, 2000.

Berkeley studio with Breakings
in stages, 1978. Oil on paper.

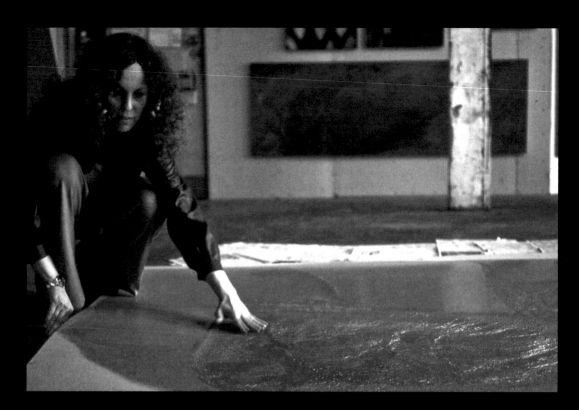
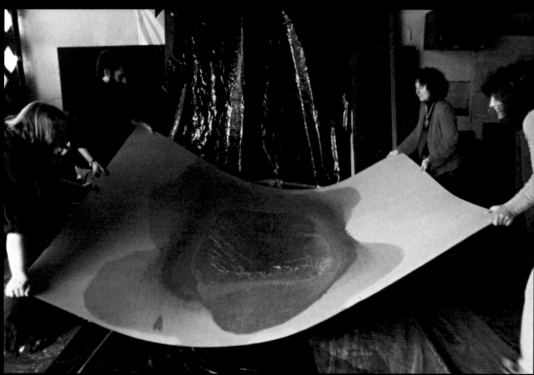

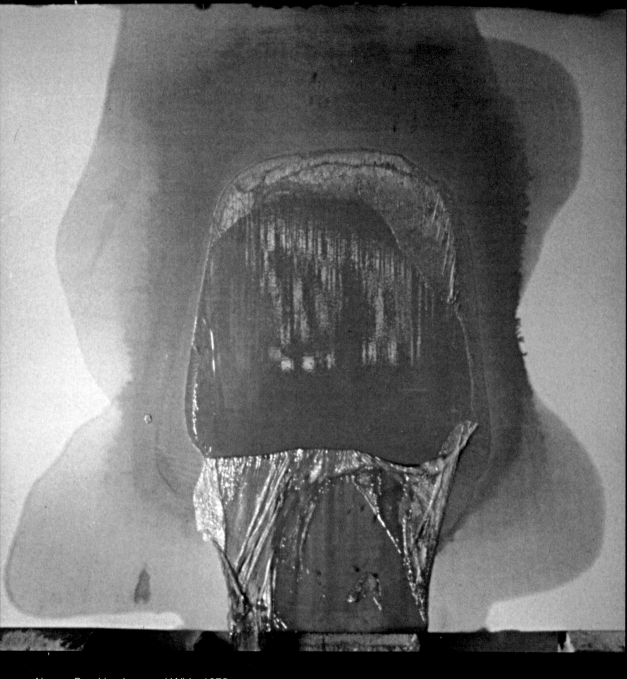

Above: *Breaking Low and Wide*, 1978.

Opposite top: testing the skin.

Opposite bottom: Mary Stofflet, David Ross, Moira Roth, and
Gloria Frym lifting the panel.

After The Breakings, I was not sure where my work would go. I wanted my focus to be less metaphoric. The Breakings were clearly about a woman's body, one that was not defined within the typical male realm of understanding. I became one of a group of Berkeley feminists who met together to discuss various issues, including the environment. We named ourselves The Feminist Institute although we had no building and met in each other's homes. Susan Griffin, the ecofeminist writer, was a member. I'd read her incisive book *Women and Nature*, which shook my feminist consciousness to the core. She constructed the book so that the male voice—one of authority, the keeper of civilization—was on one page, and facing it was the female voice—the remnant of nature. This dichotomy was essentialist, extreme, but it clarified my sense of patriarchy.

I was also deeply moved when I heard the Australian physician Dr. Helen Caldicott speak out against nuclear

weapons. She was a scholarly antinuclear activist, who challenged the psychic numbness that permeated our culture at that time. After hearing Caldicott's evidence of the dangers of nuclear warfare, I became conscious of the militarism all around us. Every park seemed to have a statue of some general on a horse or some soldier with a rifle.

Caldicott proclaimed: "Use where you are in your life to stop the arms race."

I had been isolated in my studio, pouring linseed oil onto huge panels that lay on the floor drying, until gravity ripped them open. Now I saw my gushing sacs of oil as an antidote to the explosive Strategic Air Command (SAC).

It was 1980 and the similarities between the conquering of the land and the taming of women had become obvious to many in the feminist movement. Ecofeminist artists Ana Mendieta and Mary Beth Edelson were looking to the land for answers, Mendieta tracing her Cuban roots and Edelson bringing gaia consciousness to feminism.

I would link my art to the land as well. I was not seeking the Goddess; I was not interested in substituting a female hierarchy for a male hierarchy. Instead, I left my studio in search of a mystical place that was timeless and female

without any hierarchy. The spirit of my ancient foremothers still lived in the land.

WHEN I LEFT studio work behind, I left tubes of paint, gallons of oil, metal sheets, butcher paper—they were no longer relevant to me. My material would be the earth itself. It wasn't such a leap: I'd still be my same old metaphoric self, but newly activist.

I went to the San Andreas fault line and gathered sand from the trail of the last earthquake. I planned to juxtapose this first Sand Gathering at a natural disaster site with a second Sand Gathering at a site of potential manmade disasters—the San Onofre Nuclear Power complex on the southern end of the quake line.

The plan was to bring sands from these and other gatherings to the newly opened San Francisco Women's Building for an art event sponsored by Friends of the Earth. I'd bring ocean sands to pour over the fault line sands as though the tidal force of the Pacific could stop the fault line from cracking. I'd bring salt from salt lands to cover the sands from San Onofre and earth from Livermore Weapons Design SAC in Livermore, California, as though the salt could soothe, in the way that a gargle of saltwater eases a scratched throat.

Digging at San Andreas fault line, 1980.

Private ceremonial at the Pacific Ocean, 1981.

I thought I'd better take someone along for my excursion to the San Onofre site in case there was trouble with the nuclear authorities. The perfect person was Linda Montano, a kooky, endearing artist and ex-nun who lived in San Diego at that time. When I explained to Linda that the sands near San Onofre were endangered by a potential manmade disaster and that those sands had to be rescued, she immediately understood. She met me at the power plant, and she sang into its strange gigantic open pipes after we scooped up sand, all alone in this bizarre landscape.

At Livermore Weapons Laboratory I approached one of my son's college friends who worked at Livermore to help me gain access to the land surrounding the plant. "Big Al," as his friends called him, was a young man who should never have chosen to work at Livermore. When I met him at the plant, and said that I wanted to dig some earth to put into a pillowcase, Al took it in calmly. "Anything for Nat's Mother!" he said.

I looked at Al, this young brilliant scientist, and wondered about him and all the other scientists in the grey buildings of Livermore, gobbled up from high-tech universities like MIT and Stanford. There they were, poring over graphs and charts, concentrating on equations and diagrams, conferring on esoteric data in order to come up

Rescuing earth,
Livermore Weapons
Laboratory, 1980.

with a "good" design for a weapon. Weren't they curious about the outcome of their work? Did they ever feel like the artist Jackson Pollock on the verge of his first drip, imagining an enormous breakthrough? Is pride in one's work the same for a weapons designer as for an actor at curtain call, or a gardener who anticipates the flowering, or a farmer who waits for the harvest? Can a scientist be deterred from trying out his weapons, built for deterrence? I had no answers, but thanks to Big Al, I did have "rescued" earth from Livermore.

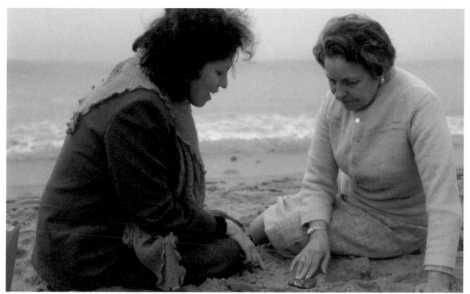

I then scheduled various Sand Gatherings at the shores of the Pacific Ocean. There was a gathering with pregnant women who swore on each other's stomachs that their unborn child would never go to war. Next, mothers with infant sons gathered sand in California and in New York City, making a simultaneous New Year's vow that their tiny male newborns would never go to war.

IN 1980 my sister Linda gave birth to her sixth child in North Hollywood, and Mother of course flew from Brook-

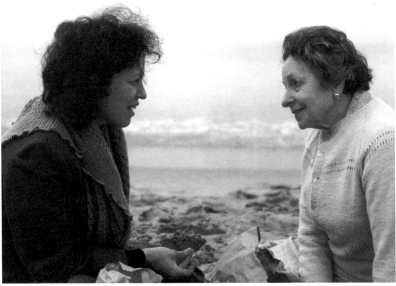

Trying to explain the Sand Gatherings to Mother at the Pacific Ocean, 1980.

lyn to celebrate the occasion, while I traveled down from Berkeley. I figured I could do an intergenerational Sand Gathering starring Mother while she was on the West Coast. When else would I be able to be at the Pacific Ocean with her?

"Please, Mom, come to the Pacific Ocean with me."

"What for?"

"To gather sand."

"But I don't like sand."

She came anyway and Renée took our picture.

FOR THE LAST Pacific Sand Gathering before the performance in San Francisco, my friend Maryel Norris and I buried ourselves in the sand on the shore of the Pacific Ocean all afternoon, a circle of women celebrating our symbolic racial merger of black and white, while we held on to each other.

I had met Maryel by chance, lucky for me, as she is my precious friend to this day. A woman from my yoga class was going through a horrible divorce and asked me to accompany her to the Bacchanal Woman's Bar on Solano Street in Berkeley. As soon as we walked in, I noticed a lone figure sitting in the back of the room. I walked over to Maryel, who said she had just moved from Ann Arbor to begin a new life in Berkeley. I, too, had moved here from New York to begin a new life, I said.

"I love you," I whispered to Maryel a few months later as we lay together under the sand, not thinking she could hear me since the circle of women were skipping and singing around us as if it were a Jewish wedding.

ON FEBRUARY 28, 1981, around five hundred and fifty women and a few men gathered at the new San Francisco Women's Center to watch as the sands were poured by four women standing on scaffolding. The sands landed

on metal roofing material. The women nearly fell forward with the heavy pull of the falling sands. The auditorium was transformed into an indoor beach.

Maryel and I were holding two poles attached to screening to sift pebbles from the sands as they fell. Listening to the sounds of the falling sands descending through the metal screens reminded me of listening to the sounds of the shofar every Yom Kippur: the *tkiyah,* a short note, the *shvarim*, a broken note, and the *tkiya gdola*, the long-held note seemingly beyond what any human breath can muster. Now the sounds of the falling sands conjured new sounds to live by.

THROUGH THE 70s and into the 80s, I was an active feminist, standing together with other women, raising consciousness together, teaching and learning together. I could not have sustained my vision without this back-up. I was a newly blooming flower child. I could no longer imagine opening the door to a husband's arrival at the end of the day, saying, "How was your day, Dear?" even if he was one of those good husbands who asked his wife about her day. How could I explain my day? "Well, today I gathered sand with pregnant women . . . tomorrow I will bury myself in sand . . ."

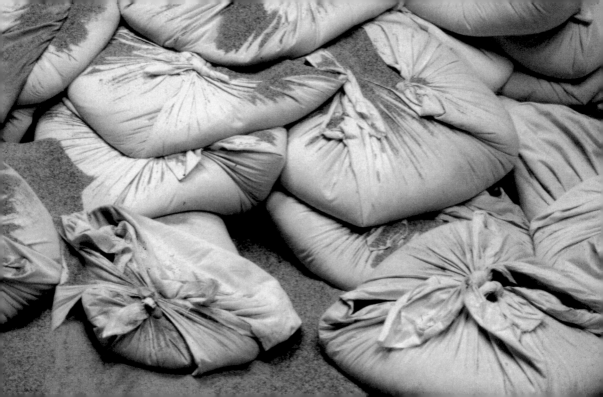

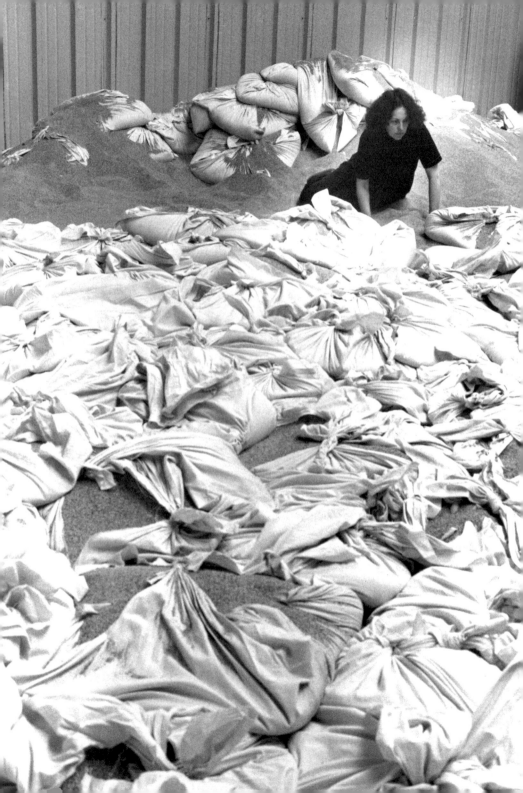

WHEN I SAW how the California women had readily participated in the Sand Carrying, I thought, what if I could bring women from warring nations together. I wanted to try this with Arab and Jewish women. Through a grant from the National Endowment for the Arts, I traveled to Israel. I visited women's centers in Haifa, Jerusalem, and Tel Aviv looking for participants. I went to a feminist conference, the *Kenes*. There were two Arab women and 498 Jewish women. I went straight to the Arab women and lured them into it. For four weeks twelve of us came together and talked. Can there be pacifism if the enemy lurks at the door? Can women stop it, STOP IT, once and for all? The women, with their lovely names, Ha'Yam, Ha'Yas, Chedva, Rena, Dena, Neely, Serena, Ofnan, Rivka, caught the mood: "I will bring my sister," "I will take my daughter." This was working.

At our second meeting I passed around photographs of my sand works. "*Ze kadosh*" (This is holy), said Ha'Yam, an Arab woman. I said that the Hebrew words *adama* (earth) and *adahm* (human being), have the same root. "We are of the earth, and to earth we return," she added.

The Arab and Jewish women gathered stones together at an Arab village, Vadi Salib, near Haifa. Two by two, Arab and Jewish women pulled stones from the dry crust of the

Stone sacs
carried by Arab
and Jewish
women. Vadi
Salib, Israel. 1981.

earth in Vadi Salib. They paired up, each picking up two corners of a cloth and laid the cloths on the ground in one gesture and placed stones upon their shared cloth. Their hands met as they tied the corners of the cloth together. Then they lifted the sacs to bring them to a row of archways, stones clanging against stones inside the sacs.

Some women had brought their daughters, who giggled at the solemnity of their mothers. "Do one yourself!" a mother suggested to her daughter. And so the daughters followed their mothers, and their little brothers joined them, handing them stones. At the end of the gathering, the village had two sacs of stones in every archway. It may have been utopian, but I was ready for utopia to supplant realism for a change.

AFTER Sand and Stone sacs, I came to Earth sacs. I had been thinking of photos of refugees—images of women fleeing with their "sacs" of precious belongings in one hand, clasping a child's hand in the other. If only we could take our most precious belonging—the earth itself, in all its variety—and carry it to safety.

The same instinct to confront the military was also motivating women in Europe; they were leaving their homes to set up tents alongside army bases in Greenham

Common, England, and in Comiso, Italy. And in the US, American women would buy land adjacent to the Seneca Army Depot in Romulus, New York, in order to camp out and watch what was going on.

I was no longer teaching painting and drawing at San Francisco State University since I had not received tenure. There were only two women on the art faculty: me and a woman who taught jewelry making. My "style" did not mesh with the rest of the department, they explained. Maybe they did not like it when I had a black model pose with her baby as the Madonna and Child in my life drawing class, and then plastered all the drawings in the halls at Christmas time. Or maybe they did not like that I got very close to the students; how could I critique their work without knowing just what it was that drove them? I would quote Agnes Martin: "Helplessness is the most important state of mind for an artist." And I listened to the advice of Louise Nevelson, who said the first thing she did when she taught art was "not to teach art." An article I wrote for the journal *Visual Dialogue* titled "Academia and the Fear of Feminism" was certainly the last straw. But not getting tenure turned out to be a blessing. Instead of some dreary art department where cronyism was the mode, I taught a course titled Performance Art as Antiwar Strategy at the Feminist Institute. Three of my students joined me when I

rented a truck, painted a large red cross on both sides over white contact paper, and slapped the words "Earth Ambulance" on the front.

I planned to find more women to travel with me across Nuclear America, based on the War Resister's League map showing the military sites across the United States. Taking turns driving a van and the ambulance, we would arrive at each site and "rescue" earth in pillowcases, both our own pillowcases and ones brought by women who lived near the site. Our destination was the United Nations' mass rally for disarmament scheduled for June 12, 1982. At each military stop along the way, we would be keeping watch, peering through fences into the eyes of the men in their camouflage uniforms on the other side, trying to persuade them to quit the military.

The Women's Party for Survival, founded by Dr. Caldicott, backed my Earth Ambulance odyssey and allowed me to make announcements at their meetings. Faye Sellin, an activist mother of two daughters, had offered to help me with the itinerary. She came to my tiny north Berkeley apartment where we knelt on the linoleum floor in the kitchen, spreading out the War Resister's League map. The map had pink spots printed all over it, like measles. These were the SAC bases. Some of the spots had little red arrows that indicated they were submarine carrier bases. There were

open stars for weapons research; colored stars for weapons stockpiles; an "R" meant military reactors; a ten-pointed star meant nuclear waste; a colored circle meant the reactor was operating; an open circle meant a reactor was being built; a green diamond meant nuclear fuel processing; an outlined diamond indicated a uranium-mining site.

My eyes began to blur.

"You might as well take the most scenic route," Faye said, and drew a straight line along the Pacific coast from Livermore SAC in the Bay Area to Vandenberg SAC in Southern California. Then she moved her pencil to the right, landing at Kirtland Air Force Base outside of Albuquerque, and on through the rest of New Mexico to the once native lands where the deadly nuclear cycle had originated.

From there we would head to Colorado Springs, the home of the Peterson SAC base and a uranium mine. Faye's pencil swung upward to the Rocky Flats plutonium trigger factory. She looked up at me. "That's scenic, all right," she said grimly.

We set out on May 2, 1982, with eleven women and two children. Many more joined along the way. From Wichita, Frieda Newman, a woman with cerebral palsy who could not speak easily, drove with us from one SAC to another to dig the earth. A Native American woman, Marie Fowler, joined us at the reservations where Utah, Colorado, Ari-

zona, and New Mexico meet. She escorted us through Navaho and Hopi lands and in the end chose to drive all the way to New York with us, burning sage every morning to symbolically purify the earth. It reminded me of the spice in the *Havdala* box, the aroma that heralds a new week.

Except for four sites—Los Alamos in New Mexico, Peterson in Colorado, Bettis Atomic Lab outside Pittsburgh, and the Picattiny Arsenal in New Jersey—the police ignored us as we carried the earth away in our pillowcases. And at the four sites where it looked like we might have trouble with the police, we managed to talk our way out of any confrontation.

We were in New York City on June 12, where we car-

Seneca Army Depot, 1983. Hostile townspeople (left) and guard (center): pillowcase hanging (right).

ried our pillowcases on old army stretchers down a curving, steep set of steps at Ralph Bunche Park across from the United Nations. We emptied the contents into transparent boxes lined up in the grass in front of the park's Isaiah Wall, engraved a passage from *Yeshayahu* (Isaiah), "They shall beat their swords into plowshares, and their spears into pruning hooks; nation shall not lift up sword against nation, neither shall they learn war any more." I can still belt out the riveting Hebrew refrain to this passage. The words stirred me as a girl in Boro Park, and they stir me now, though swords and spears seem like toys compared to nuclear missiles.

THE NEXT YEAR, in 1983, a group of women from Hol-

Earth Ambulance

SUNRISE DEPARTURE OF THE EARTH AMBULANCE
MAY 2, 1982, 5 AM

DEAR FRIENDS,
WE ARE STARTING ON A VOYAGE TO TWELVE MILITARY SITES
AS THE SUN BREAKS THROUGH THE MIST
BEHIND THE BERKELEY/LAWRENCE LABORATORIES:
WE WILL FILL PILLOWCASES WITH EARTH FROM THESE SITES
AND THE EARTH WILL BE DRIVEN TO THE UNITED NATIONS
IN THE EARTH AMBULANCE.

TO AMERICA, I SAY, OPEN YOUR WINDOWS;
THERE ARE ARSENALS IN YOUR BACKYARDS.
THAT IS WHY WE BEGIN FROM THE WEST
WITH LIVERMORE WEAPONS LABORATORY
AND THEN SOUTH, THE HOME OF THE TRIDENT, VANDENBERG S.A.C.
HEADING EAST, LOS ALAMOS WHERE IT ALL BEGAN—
ALSO IN NEW MEXICO, THERE'S THE KIRTLAND WEAPONS STORAGE.
PETERSON S.A.C. AND ROCKY FLATS PLUTONIUM TRIGGER FACTORY—
BOTH IN COLORADO—AND MCCONNELL AIR FORCE BASE
NEAR THE MISSOURI NUCLEAR WASTE BURIAL.
WHITEMAN S.A.C. IN KANSAS AND RICKENBACKER IN OHIO—
BETTIS ATOMIC WEAPONS IN PENNSYLVANIA—
AND AS WE GET CLOSER TO NEW YORK,
THIS VOYAGE WILL END WITH PICCATINY
WARHEAD DESIGN ARSENAL IN NEW JERSEY.

ON JUNE 12, THE DAY OF THE MASS RALLY FOR DISARMAMENT,
WE WILL WALK DOWN THE STEPS NEAR THE ISAIAH WALL
ACROSS THE STREET FROM THE U.N.
WE WILL EMPTY THE PILLOWCASES INTO TRANSPARENT FRAMES
TO LOOK UPON EARTHS FROM ACROSS AMERICA.
ON JULY 4TH, WE WILL HANG THE PILLOWCASES—
EMPTIED AND STAINED FROM THE EARTH—
ON A CLOTHESLINE ALONG TREES (BETWEEN FIRST AND SECOND AVENUE
AT DAG HAMMARSKJOLD PLAZA ON 49TH STREET)
AND THE DREAMS AND NIGHTMARES (WRITTEN BETWEEN TWO OCEANS)
WILL BE SCRAWLED ON THE PILLOWCASE SACS.

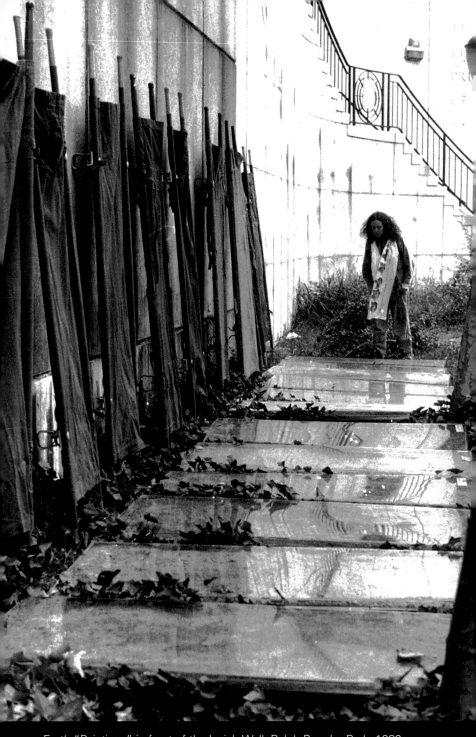

Earth "Paintings" in front of the Isaiah Wall, Ralph Bunche Park, 1982

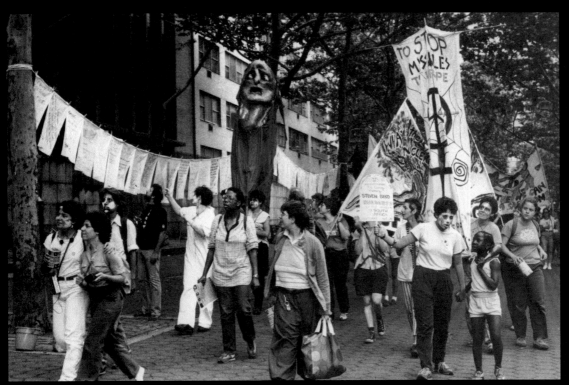

Dag Hammarskjold Plaza, Womens Pentagon Action walking past the pillowcases, 1982.

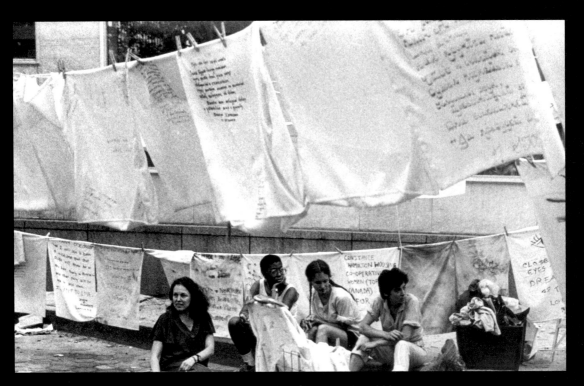

Living under the pillowcases at the New York City camp-in, 1983.

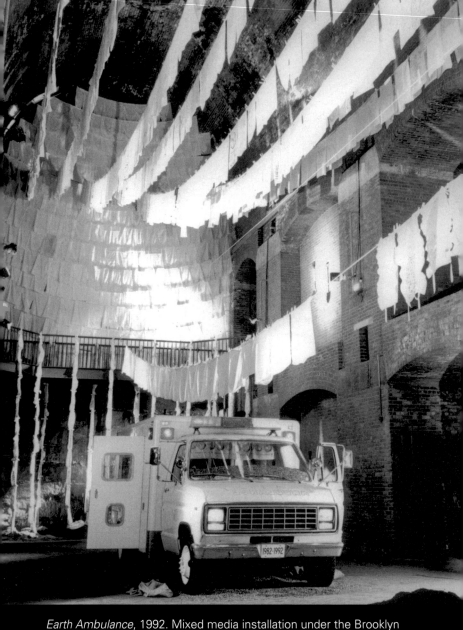

Earth Ambulance, 1992. Mixed media installation under the Brooklyn Bridge anchorage, commissioned by Creative Time.

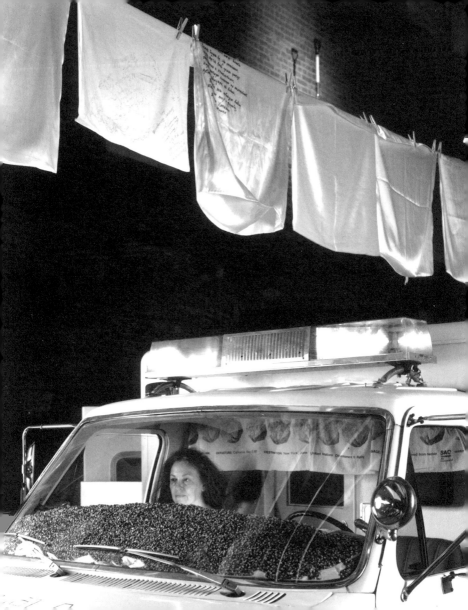

land and France joined me to camp again in Dag Hammarskjold Plaza, also across from the UN, for fourteen days and nights. Nearly one thousand pillowcases from around the world were strung up, all of us sleeping beneath this linen shelter at night. We never asked for a permit to camp out. We simply reassured the police that "it would only be six more days" every time they approached us. It seemed to work.

After the camp-in ended on July 4, 1983, we moved to the Seneca Army Depot in upstate New York to call attention to the missiles being deployed from there to the military site at Greenham Common in England. The poet/activist Grace Paley was at the site and in a brilliant moment of political theater, cut holes in her pillowcase for her arms and head so she could wear it. At first the artist in me winced, but the picture of Grace in her pillowcase became an iconic antiwar image. And when other women followed Grace, the soft shield of the pillowcase giving them the courage to climb the Army Depot fence, I was humbled.

A young guard approached me to ask if he could hang a pillowcase in the police headquarters. I said I could not remove any that were meant for the army fence, but that I'd get a few women from the peace encampment to make a new pillowcase especially for him. I like to think that guard quit his job because of this piece of cloth.

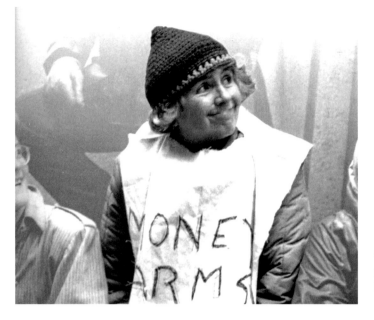

Grace Paley wearing her pillowcase, Seneca Army Depot, 1983.

IN 1985, I went to Japan to commemorate the fortieth anniversary of the Hiroshima/Nagasaki tragedies. Two sacs were filled by students with seeds, pods, bamboo shoots, and grains. I placed the sacs in the Kama River, where they floated downstream to Hiroshima and Nagasaki as a symbol of renewal.

Myriam Abramowicz supervised the Japanese crew who filmed the journey and my conversations with survivors of the atom bomb. In exchange for Myriam's accompanying me, I agreed to teach her Hebrew. We started our lessons in Japan and continued in coffee shops and cafes when we returned to the states. I liked being Myriam's *morah*, but she took my lessons so seriously that she became rather fanatical, even covering her head with a *tallis* in the synagogue.

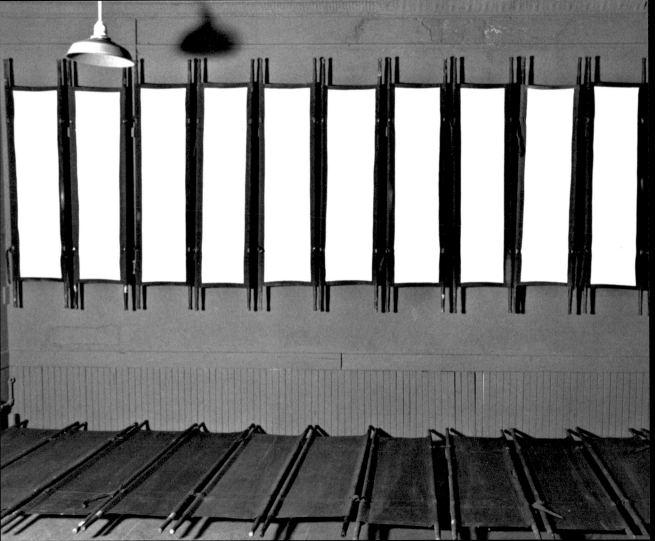

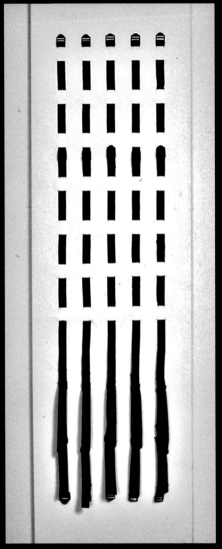

Unstretched Canvas, detail, 1988.
In my studio; later shown at Cleveland
Center of Contemporary Art in a joint
show with Christo.

Weaving, 1989. Straps from
army stretchers.

Current: two sacs en route

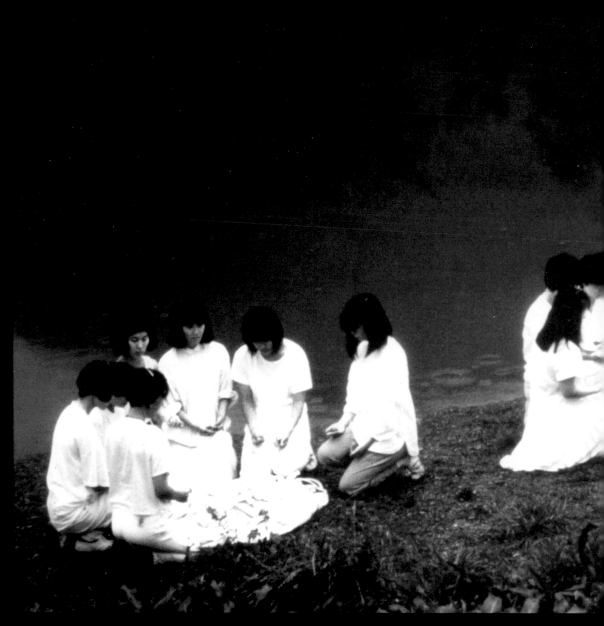

Japanese students launching the sacs, 1985.

1985: AND THE MAIDENS HEARD THE GOVERNMENTS OF NATIONS SPEECH TO THE MIDWIVES AND THE FARMERS AND THE SCHOLARS AND THE MOTHERS AND THE OLD AND THE YOUNG OF EVERYLAND:

"GIVE ME YOUR SONS TO FIGHT MY WARS AND GIVE ME YOUR WOMEN TO SMILE IN COMPLIANCE. THEN GIVE ME YOUR SKIES TO PIERCE WITH MY MISSILES AND GIVE ME YOUR ISLANDS TO TEST OUT MY BLASTS. THEN GIVE ME YOUR MOUNTAINS TO STORE MY ARSENALS AND GIVE ME YOUR LANDS TO RAPE WITH URANIUM, AND GIVE ME YOUR SEAS TO DUMP IN MY WASTE."

BUT THE MAIDENS DID NOT DO AS THE GOVERNMENTS COMMANDED. WHEN THEY COULD NO LONGER HIDE THE EARTH, THEY MADE FOR IT A SAC OF CLOTH AND PUT THE EARTH THEREIN AND LAID IT BY THE RIVER'S BRINK. AND THE MAIDENS WALKED ALONG BY THE RIVERSIDE. AND THE SISTERS STOOD FAR OFF TO KNOW WHAT WOULD BE DONE TO IT.

THEN SAID THE SISTERS TO THE DAUGHTERS OF THE GOVERNMENTS—SHALL WE GO AND CALL A NURSE THAT SHE MAY HEAL THE EARTH? AND THE DAUGHTERS OF THE GOVERNMENTS SAID "GO" AND THE MAIDENS WENT TO CALL THE MOTHER . . .

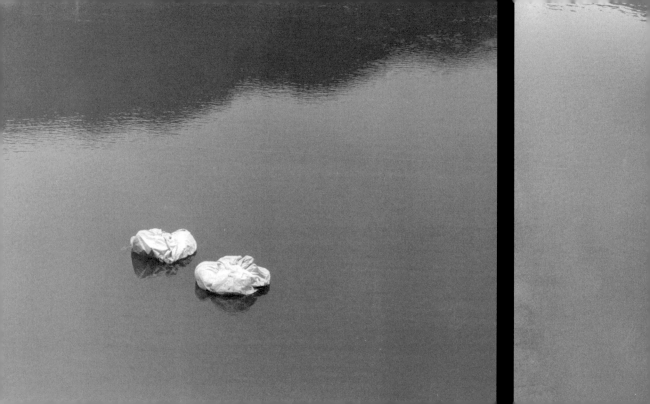

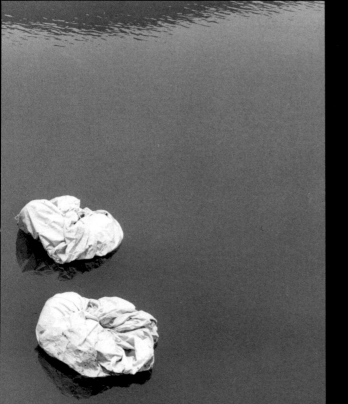

CURRENT: TWO SACS EN ROUTE

IT IS VASCULAR, THE RIVER IS.
IT CONVEYS WATER LIKE THE BODY CONVEYS FLUIDS,
ARTERIES FROM THE BAY TO THE SEA.
IT HAS A SYSTEM OF ITS OWN AND I TRUST IT.
I GO TO THE RIVER BED.
I PUT TWO CLOTH SACS ON THE RIVER.
THE SACS ARE CARRYING SEEDS.
THE YOUNG WOMEN AT THE RIVERSIDE KNEEL
WITH THE STILLNESS OF PORTRAITURE.
THERE'S A GROUP SURROUNDING THE FIRST SAC—
REIKO, HIROKO, TOMAKI, NORIKO, YUMI, KAORI . . .
THERE'S ANOTHER GROUP AROUND THE OTHER SAC—
SHIGEKO, CHIYO, KUNIKO, MIEKO, NUKUI, TORU.
SEEN FROM ABOVE THE TOPS OF THEIR HEADS
FORM A BLUE-BLACK CIRCLE AROUND EACH ROUND SAC.
ONE WOMAN DROPS A TINY KERNEL OF RICE INTO THE FIRST SAC
AND ONE DROPS IN A SEED FROM HER FINGERTIPS.
ONE OFFERS A SINGLE BLADE OF WET GREEN GRASS
FROM THE RICE FIELDS AND ONE AN INFINITESIMAL CLOVER.
THEN WITH A DANCER'S HAND GESTURE, ONE PLACES A GRAIN
NO LARGER THAN THE *NEKUDA RISHONA*, THE FIRST DOT THAT
BEGAN THE UNIVERSE.
THE BOY LIFEGUARDS WILL NOT LEAVE THE BRIDGES,
THEY MUST STAND GUARD.
FOR IF THESE TWO SMALL SACS DO NOT SINK,
NOR WILL THE PLANET.

Screening of *Current: two sacs en route* on the Times Square Jumbotron, commemorating the fiftieth anniversary of Hiroshima/Nagasaki, 1995.

Post - - - - - Script

HIBAKUSHA, YOU WHO ARE A SURVIVOR OF THE
A - T- O - M, WILL YOU SCRIPT YOUR DREAM AND NIGHTMARE
ON YOUR PILLOWCASE?

WHEN SHE WROTE ON HER PILLOWCASE, SHE SAID, "I HAVE
NO PICTURE OF HIM. THAT IS WHAT I REGRET MOST." AND
THEN FUJIE KIYOMI PURSED HER LIPS RESOLUTELY AND
WOULD SAY NO MORE.

MYOKO WROTE OF THAT DAY: "I HEARD SOMEONE CALL OUT,
ARE YOU MYOKO? BUT I COULD NOT SEE WHO WAS SPEAKING
TO ME BECAUSE HER FACE WAS COMPLETELY DESTROYED."

ABOVE THE EMBROIDERY CHIYO TAKEOCHI WROTE HER LITTLE
PUPIL'S WORDS: "I WISH I WAS BORN A FISH BECAUSE FISH
DON'T MAKE WAR" AND SHE SAID THE NEXT DAY THE BOY
WAS KILLED INSTANTLY.

ANOTHER SEVEN YEAR OLD HAD REACHED FOR A
DRAGONFLY FACING THE FIERCE LIGHT UNKNOWING IN HIS
CONCENTRATION. HE WAS VAPORIZED IN THAT SECOND.

THE SMALL-BONED SHIGEKO SAID SHE WAS FINE EXCEPT FOR
ONE KNEE THAT DOES NOT BEND; THAT IS WHY SHE COULD
NOT KNEEL ON HER TATAMI BECAUSE OF THAT DAY IN 1945
WHEN SHE WAS TWELVE.

SESHIKO ISHIMATO COUNTED FIFTEEN FROM HER FAMILY.
"NOW I CAN WRITE ABOUT HIROSHIMA, THE WAY IT
HAPPENED TO ALL FIFTEEN."

AND THERE WERE FOUR WHO WROTE FROM THE HOSPITAL,
THE FOUR LONG TERM FRIENDS WHO HAD BEEN IN THE
HOSPITAL ALL THOSE YEARS TOGETHER. "THERE ARE MANY
HAPPY THINGS BESIDES" ONE SAID AS SHE GATHERED THE
SCRIPTED PILLOWCASES.

"ARIGATO," THE WORD I KNEW. "I WILL TAKE THESE BACK
AND KEEP THEM."

Pillowcases from Hibakusha, 1985.
Berkeley Art Museum, 1995.

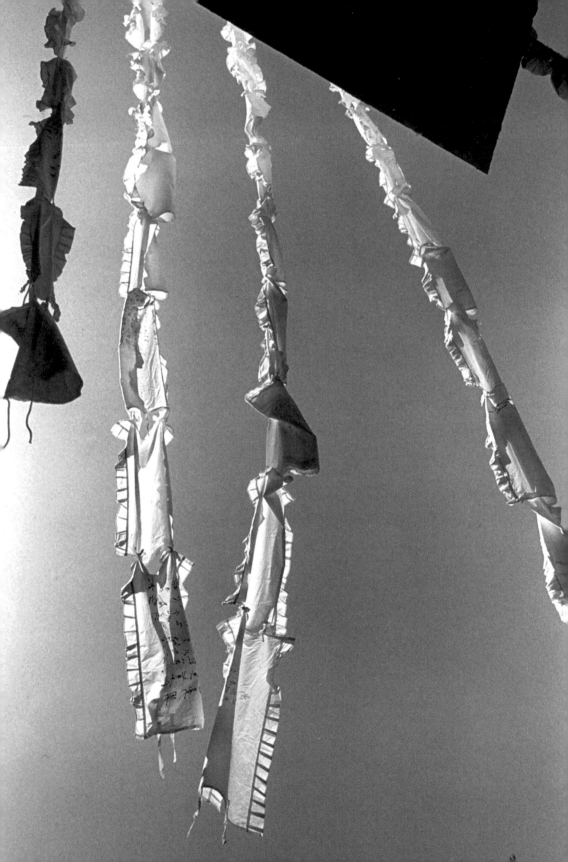

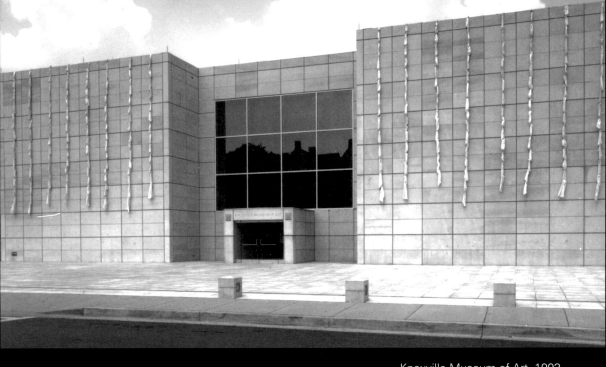
Knoxville Museum of Art, 1993.

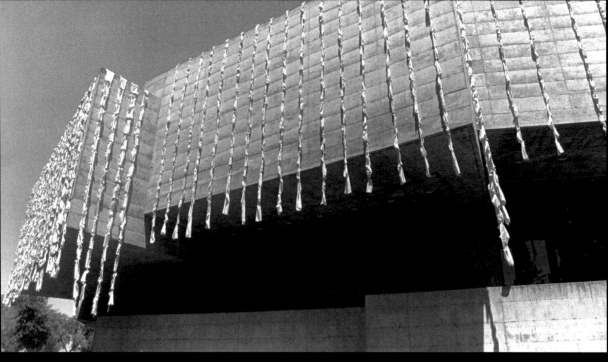

Berkeley Museum of Art, 1995.

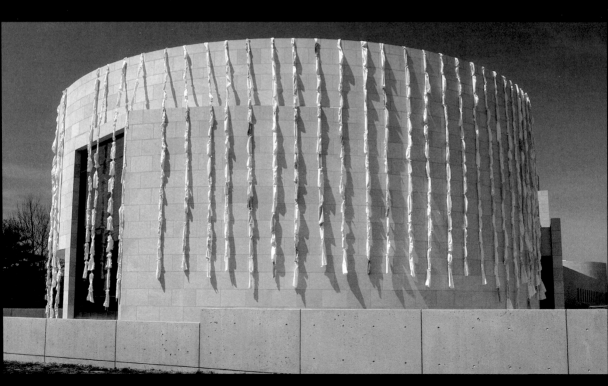

American University Museum, Washington, DC, 2006.

I used to feel that I could never reach out the way my mother did to everyone who crossed her path. Mother did good big time, capital "G." As a child I did not feel that intrinsic goodness within me. Mother never particularly demanded it, since, as *Itte, de'gitte,* it was up to her to give, to dish out to her children, her family, her community, and every passerby. Mother was the bearer of gifts while she would accept nothing in return except for a few effusive birthday poems and greeting cards made especially for her.

When I was seventeen and engaged, and my future groom was "rabbinating" in Montreal, his mother was ill. I wanted to do the good thing, to visit my future mother-in-law and help, so I took the train out of Boro Park to Williamsburg, the Jewish community that was a step lower than Boro Park, much as Boro Park was a step beneath Flatbush, and Flatbush was beneath Far Rockaway.

In those days, Williamsburg was not the hip arts

scene it is now, and I felt thrilled that I was kind of slumming by getting engaged to a man from there. I was the princess bearing flowers to this rather shabby homestead, far from my base in Boro Park and our part-time housekeeper.

When I came into the house on Bedford Avenue, Mom Fisch was about to take a nap. I encouraged her to go ahead, and I would read, sitting beside her. I felt like Greer Garson, in her role as a glamorous private nurse in some war movie I had seen. I imagined writing about this Williamsburg visit to my future husband in the next love letter from Boro Park to Montreal, and in his answer from Montreal to Boro Park he would love me even more. When I heard the even breathing of my soon to be mother-in-law, I had a strong desire to outdo myself with even more remarkable goodness: after I put my flowers in a makeshift vase I found lying around, I took out a mop and washed the floor to freshen up the room. I had never washed a floor in my life. I tiptoed out so as not to get any praise, like a fairy godmother, and headed home, satisfied, to tell Mother.

Can you imagine? I was expecting to get some credit for my altruism. I don't think I ever saw Mother that unhinged. What could possibly be wrong with washing the floor?

But mother's expectations for me didn't include a mop. As the first generation out of the shtetl, she had a dream of a beautiful debutante daughter marrying an Orthodox Prince Charming, "Washing floors is not what I wanted for you," she said with tight lips.

"But you would have done so much more," I thought to myself, perplexed and shocked to see this other side of Mother—a side she revealed only when it came to me. It took years but eventually I learned that despite Mother's desire for me to be first and foremost a housewife, I could actually do the most good in her eyes being the person she introduced as "my daughter, the artist." In a way, I had been programmed. Even when ecofeminism supplanted the Young Israel and Beth El synagogues, Mother and my religious training were directing my course. The feminist artist Mierle Ukeles, who has a similar background, once kiddingly named our work "mitzvah art."

Still, Mother continued with her refrain: "What do you need this for?" when I announced the Stone Carrying with Arab women, the Earth Ambulance at military sites, the 1982 and 1983 camp-ins at the UN, the floating sacs in Japan. And if I had been able to answer her, I would have said, "I need to do this to be more like you, Mom. To be good like you."

I DID NOT return to the West Coast after the cross-country journey to New York with the Earth Ambulance. I had given up my apartment in Berkeley and my Westbeth apartment was now available. I planned to drive the Earth Ambulance to the entrances of ten New York City hospitals to make the connection between our health and the health of the earth. But the main reason, my gut reason for staying on in the East Coast, was to be back with Mother.

I was back home taking the train to Boro Park on Friday afternoons to sit at Mother's sacred table and walk her to shul in the freshness of the Sabbath morning, feeling her gladness at having her eldest daughter back from California—it gladdened my heart as well. Sometimes we visited the sick on Saturday afternoons in the tradition of *bikur cholim*, and once we visited Morah Cohen, who sat like a sphinx in her old age. It was good to be home, even if I knew as never before that this was no longer my world.

It was my reading to Mother from the Torah's *sedra* of the week that made me realize there was now no turning back. I used to be able to shrug off Torah words like "smite," but now I found myself hyperventilating every few sentences. Mother made it worse when she raved on at how much I retained from the fine Shulamith education she and Daddy had provided for me and she drove me up

the wall with her breathless respect bestowed on the male figures of the bible, my forefathers. A crucial hunger arose in me to hear about my foremothers instead.

Art had always filtered in the beauty of Judaism—the letters of *Ruach* with the coupling of wind/breath, the temporary *succah* with its teachings on transience, the three *Havdala* stars and the glimmer of light from dark. But I was no longer looking in wonder at the celestial skies. Nor was I looking below at the drifting boundaries of the earth. I was clearly facing the G–d of the Torah that Moses claimed to have seen "face-to-face." That G–d dwelled in Boro Park.

My son Nathaniel, of course is traditional, and he was planning to get married at this time. He made just one request: that I create the *ktuva,* the ornately designed Jewish marriage contract for the wedding. "Of course," I said immediately, even though the *ktuva* was not the kind of thing I did as an artist. (What was the matter with me, worrying about how I presented myself stylistically? This was my son's wedding, right?) But when I read the words of the contract, which I never read when I was eighteen at my own wedding, it came to me what I was doing—designing a contract in which I didn't exist. My name was not there; the bride's mother was not there. I told my son I could not comply with his request unless the mothers' names were included. For this I needed the approval of the officiating

rabbi, Rabbi Herskovics, Nat's venerable teacher from the time of his Bar Mitzvah. The rabbi had recently moved to Israel, and Nat had paid the round-trip airfare for him and his wife so that his rabbi could officiate.

The rabbi agreed to meet me at Mother's house to discuss the *ktuva.* Mother busied herself putting an array of cakes on the dining room table as the rabbi and I went over the document word for word. Things started out fairly neutral: there was a promise on the groom's part to provide "silver." That meant maintenance. Okay, I could go along with that. But when we got to the omission of the mothers' names, I found myself getting testy.

"Rabbi, Jesus Christ had only one parent: Mary. But my son was not an immaculate conception. He had two parents, and as it turned out, only one parent brought him up, his mother." Mother rushed in with tall glasses of iced coffee to cool things off—in true Etta fashion, she had filled the ice cube tray with coffee so the drinks wouldn't get watered down. Rabbi Herskovics stated that he could not marry this couple if I included my name as the mother of the groom, nor could the name of the mother of the bride be added. He offered a compromise; he would announce the mothers' names aloud under the chuppah.

I went into the kitchen to call the saintly Rabbi Schorr of Beth El Synagogue. He had known me since my childhood.

But he too refused to give his rabbinic sanction to include the mothers' names, though he intimated regretfully that he might have overlooked my iconoclastic document and not stopped the wedding had he not been asked for his official *hechsher,* that grand rabbinic sanction. His stance was sort of like Clinton's "don't ask, don't tell."

I called three more Orthodox rabbis, each of whom forbade the inclusion of the mothers' names, until finally one, Rabbi Yitz Greenberg, gave the *hechsher* on the condition that the names be placed in the margin or on the back of the page. Okay, I thought, we're going to the back of the bus, but at least we're on the bus. I was sure the bride's mother couldn't care less. And I would simply put an asterisk where our names were left out and on the bottom margin I would write the word *eema* (mother), for all mothers.

I thanked Rabbi Greenberg and came back to the dining room to see if Rabbi Herskovics would concede to my fourth rabbi's solution. He agreed but it was obvious he took pride that he had not been the one to compromise. He looked at me and I looked back at him. I told him I loved Judaism, but there was no place in it for me.

We heard Mother's cheery voice as she swung open the door to the dining room with more goodies. She insisted on paying for a cab for the rabbi from Boro Park's Zion Car Service. "Rabbi, you went out of your way so much for us,

at least you should be comfortable returning." As though this solved everything.

As soon as I got home, I called my son. Nat asked me please not to make his marriage "a cause," and who could blame him two weeks before the wedding? He said, half joking, "Can you go the day after the wedding to the Rabbinical Council of America to bring this up?" How I wish I could have taken him up on this joke of an idea, for all those Orthodox mothers at their children's weddings. But I was satisfied for my son's sake that I circumvented the omissions while staying within the Halacha law.

This small act of correcting an ancient text was the beginning: putting in the asterisks meant something was left out and I was correcting the omission. It seemed to me that G–d was not as authoritarian as Moses described him, that G–d had been victimized by Moses and I stuck up for G–d, protecting him like a defense lawyer. Mother did not like the way I was thinking. Indeed, I told her I was cocksure that I knew better than Moses, because I had feminist consciousness and Moses did not. Mother shuddered. Then one day I blurted out to her, "I rescued the earth from the goddamned patriarchy; now I will rescue G–d!" Mother looked at me like I was out of my mind and said patiently that she didn't mind her place in life one bit, in fact, she was altogether happy with it. Why couldn't I let things be?

I created a performance titled *Four Questions*, which was shown in the Jewish Museum not that long after the *ktuva* was held up high by Nat's "best man" walking down the aisle at the wedding. I invited Mierle Ukeles to join me in asking these four questions and repeating them with a touch of goofiness:

1. What is bothering you about the Jewish community?
2. What do Jews owe the world?
3. What do Jews owe each other?
4. How do you fit into this?

Every word got its own turn with exaggerated emphasis, with sardonic repetition.

What is bothering *you* about the Jewish community? What *is* bothering you about the Jewish community? What? What! *What* is bothering you about the Jewish community? You!

We wore gauze veils over our eyes, so that we walked almost blindly up and down the aisles of the audience, like the men who walk up and down the aisles of the synagogue carrying the Torah. On a big screen in the background was

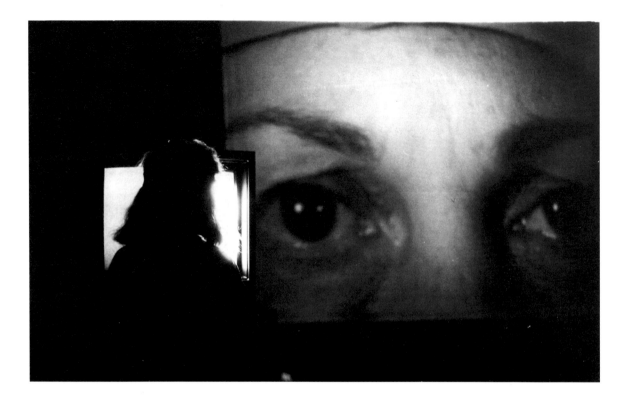

a video close-up of our eyes—first my eyes and the audio of my questioning voice, then Mierle's, and back to mine. Our four questions were directed at each other, at ourselves, and at anyone in the audience listening.

During the symposium after the performance, I found myself speaking very personally. I spoke about the depth of my emotion over the birth of my first grandson, Mendy, Nathaniel and Tobe's newborn. I predicted how thrilled I

Four Questions, performance with Mierle Ukeles, 1988.

225

would be when baby Mendy, learned to read from the *siddur* (prayer book)—until he comprehended the meaning of the morning prayer, *Shelo asani eesha* (thanks that I was not made a woman). I continued further down that road, bemoaning how anxious I would be at this young boy's Bar Mitzvah, lest his long studied *sedra* be one about the sins of past ancestors laid upon the third and fourth generations. And further down the road, at this lad's *chatuna* (future wedding), I predicted my discomfort when the words in the *ktuva* would identify him as the son of his father without mentioning his mother. And much, much further down the road, on my own tombstone, he, Mendy, would notice my name engraved as the daughter of his great grandfather Anshel only, since his Great Grandmother Etta would be left out. All this would be laid upon this pure baby's tender brow unless we did something about it now. That is when I announced my intention of pursuing *The Liberation of G–d*, though I wasn't yet sure how I would do this.

Soon after, I picked up a bunch of markers in an art supply store with the intention of highlighting words in the Torah that bothered me. I had no idea how I would use this in an art work but I sat down and began respectfully gluing transparent velum over the pages of Genesis so as not to mark the actual book. The first troubling word I came to was "dominion." Indeed, "dominion" said it all. I carefully

highlighted that word in a pale gray. My first choice was pink—how gratifying would it be to put down the hierarchy in one stroke of pink!—but I was fearful that pink would be too "kneejerk" female. It was only after highlighting an entire set of fifty-four chapters in that shadowy gray that I made myself just do it, just go ahead and highlight in pretty, feminine, baby-girl, mmm, luscious pink.

I wrote the proclamation for *The Liberation of G–d*. The last words conveyed the history that had brought me to this point: thirty years ago, I had held on to the word *Ruach*, not seeing the word smite. I saw and wanted to see only the inspired words. I looked into Kabbalah and made Paintings That Change as an act of faith that they would not rot away. I practised *tikkun olam*, healing the earth, when I sought to unite women from warring nations.

But now in the 90s, I came to realize the Five Books of Moses were the Five Books of Moses. No more than that.

After that auspicious beginning, I bought a large bible. I covered all the pages in the first five books of that Bible with a transparent overlay and spent every night highlighting a horizontal pink slash over the words of vengeance, deception, cruelty, and misogyny—words attributed to G–d. In between words where the female presence was left out, I inserted a vertical pink line. I worked by candlelight, setting up an elaborate ritual for this self-imposed, lonely,

holy and unholy task. I called this work *The Liberation of G–d*. In the title I spelled G–d with a dash, as I was taught to do many years ago at the Shulamith School, but now the dash was pink.

Thus began a six-year undertaking during which I highlighted the five books of Moses, fifty-four individual chapters, three times over. The second time was so that my hand could be filmed while highlighting for video footage, and the third time was so that I could have a set to exhibit at the Jewish Museum.

At first, I had wanted to bring *The Liberation of G–d* to a synagogue; it was a Jewish problem, and I was too ashamed to let it out of our hands to show it in a public museum. I would sit in the majestic Bnai Jeshurun Synagogue in New York, and imagine myself up high, highlighting. I would daydream about how I'd unfurl a highlighted scroll, letting it gently drop down onto the *bima* (platform) where the cantor was singing. Then I'd wait at the *bima* with my arms wide open to receive the scroll as it descended as gracefully as a bird. This would be my aerial performance, airing out the Torah, unlike Moses, who threw G–d's tablets down as if they were his own.

Roly, as Rabbi Rolando Matalon of Bnai Jeshurun was affectionately nicknamed, knew my misgivings about the Torah. He had talked with me about *The Liberation of G–d*

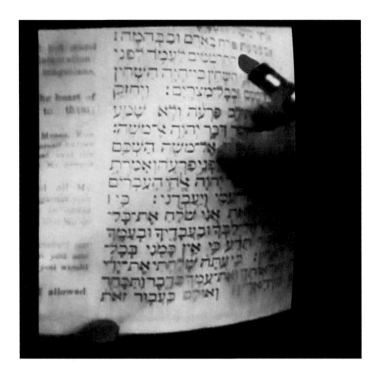

The Liberation of G–d, 1990–1996. Still from video, highlighting passages.

while it was germinating in my mind, and he understood the task I had given myself. I confessed my daydream to him. He smiled, but turned me down. It would be sacrilegious to use the Torah in the way I imagined. But Roly agreed to let me highlight the Torah scroll in its book form standing high above the synagogue in a private ceremony on a weekday. And so I ascended ten flights of rickety spiral stairs to the dome of B'nai Jeshurun. I felt like I was in *Vertigo*, the Alfred Hitchcock movie. I stood in the celestial dome and highlighted in pink that first word, "dominion," holding my breath.

The Liberation of G–d

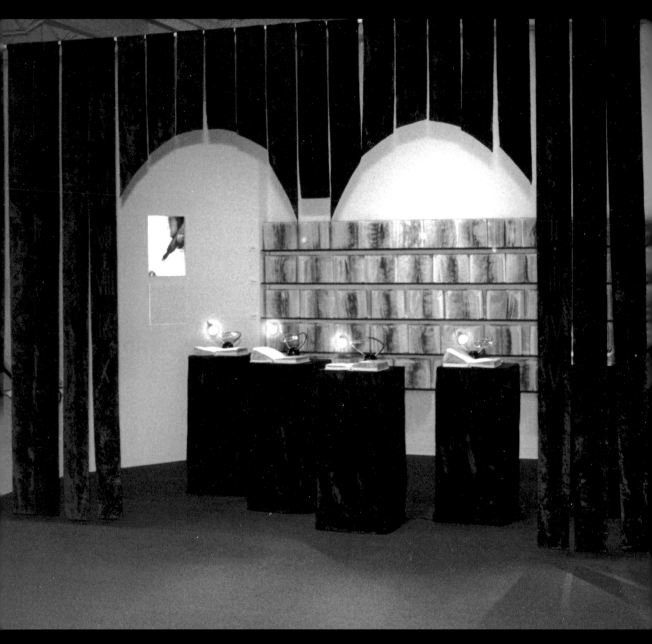

The Liberation of G–d, 1990–1996. Mixed media.

I BEGIN THE LIBERATION OF
G – D
SEARCHING IN THE FIVE BOOKS OF MOSES
FOR THE SECTIONS WHERE
G – D
HAS BEEN SPOKEN FOR.
I LOOK INTO THE PASSAGES
WHERE PATRIARCHAL ATTITUDES
HAVE BEEN PROJECTED ONTO
G – D
AS THOUGH MAN
HAS THE RIGHT TO HAVE
DOMINION
EVEN OVER
G – D
I GLUE TRANSPARENT PARCHMENT
ONTO EACH PAGE
SO THAT THE PARCHMENT BUCKLES
MAKING THE WORDS
CLOUD UP—THEN CLEAR
WHILE THE VIEWER
IS INCLINED TO PRESS THE PAGE DOWN
TO READ THE TEXT MORE EASILY
AS THE SOUND FROM THE PARCHMENT
CRACKLES.
I HIGHLIGHT ONTO THE PARCHMENT
THAT COVERS EACH PAGE:
BETWEEN WORDS IN THE EMPTY SPACES
WHERE A FEMALE PRESENCE
HAS BEEN OMITTED
WHERE ONLY THE FATHER'S NAME
IS RECORDED AS THE PARENT WHO
BEGOT THE OFFSPRING
AND I HIGHLIGHT OVER WORDS OF
VENGEANCE, DECEPTION, CRUELTY AND
MISOGYNY,
WORDS ATTRIBUTED TO
G – D
I DO NOT CHANGE THE TEXT
BUT MERELY LOOK AT THIS DILEMMA.
I ASK: WHEN WILL
G – D
BE RESCUED FROM
UNGODLY PROJECTIONS
IN ORDER TO BE
G – D
FOR SURELY
G – D
WOULD BE MORE CREATIVE
THAN TO RELY ON MILITARY CONQUEST
AND THE DEATH PENALTY
AS PRIMARY SOLUTIONS
INSISTING THAT MORTALS
CARRY OUT THESE SOLUTIONS
AS A SIGN OF OBEDIENCE.
SURELY THE CREATOR
WOULD BE SENSITIVE TO ALL OF CREATION
AND WOULD NOT DEMEAN ANY BEING
WITH THE EPITHET
ABOMINATION

NOR CONSIDER THE IMPAIRED
UNCLEAN
NOR MEASURE WOMAN
AS LESS VALUABLE THAN MAN
A GIRL CHILD
OF LESSER REGARD THAN A BOY CHILD.
G – D
WOULD NOT ALLOW ANIMALS CREATED TO DIE
FOR THE SINS OF HUMANS
WHILE INHALING THE SMELL
OF BURNING FLESH WITH PLEASURE.
G – D
WOULD NOT EMPHASIZE TEMPLE RITUALS
REPEATEDLY
WHILE STATING
THOU SHALL NOT KILL
ONLY IN THE TEN COMMANDMENTS
CONTRADICTING
THIS INJUNCTION THROUGHOUT THE TEXT.
I TREMBLE
WHEN I READ DEUTERONOMY XIII:
IF THERE ARISES IN THE MIDST OF YOU
A PROPHET OR A DREAMER OF DREAMS
AND HE GIVES YOU A SIGN OR A MANIFESTATION
. . .
YOU SHALL NOT LISTEN TO THE WORDS
OF THAT PROPHET
OR THAT DREAMER OF DREAMS
BUT YOU SHALL SURELY KILL HIM
YOUR HAND SHALL BE THE FIRST ON HIM
TO PUT HIM TO DEATH
AND THE HAND
OF ALL THE PEOPLE AFTER.

I FEAR IN THIS MOMENT OF TIME
THAT THIS PASSAGE
COULD HAVE BEEN INTERPRETED
AS A SANCTION
TO KILL YITZCHAK RABIN.

I SHRUGGED OFF THESE FEARS
THIRTY YEARS AGO
HOLDING ON TO THE WORD RUACH
NOT SEEING THE WORD SMITE.
I EVADED THIS TASK ANOTHER TWO DECADES;
I LOOKED INWARD TO KABBALA
I LOOKED OUTWARD FOR TIKKUN OLAM.
I CAME TO REALIZE
THE FIVE BOOKS OF MOSES
WERE THE FIVE BOOKS OF MOSES.
THEN I WAS OBLIGED TO DESIST NO LONGER
BUT TO LET IT BE KNOWN THAT
THE
LIBERATION
OF
G – D
IS THE TASK THAT IS LONG OVERDUE.

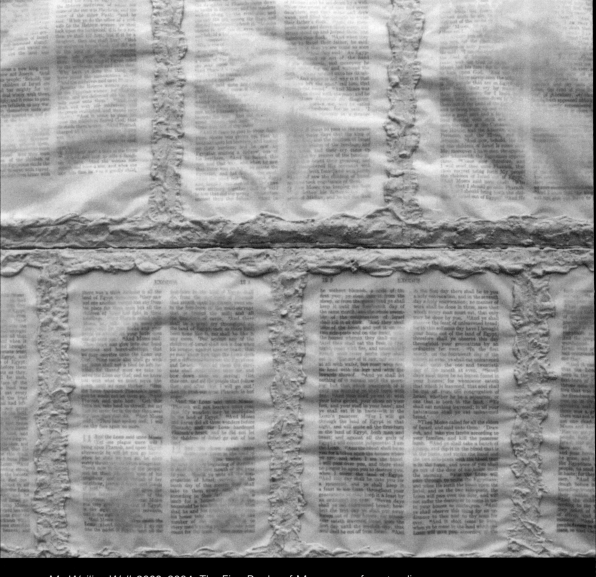

My Wailing Wall. 2002–2004. The Five Books of Moses on a freestanding
wall; Hebrew on one side, English on the other. Paper and cement.

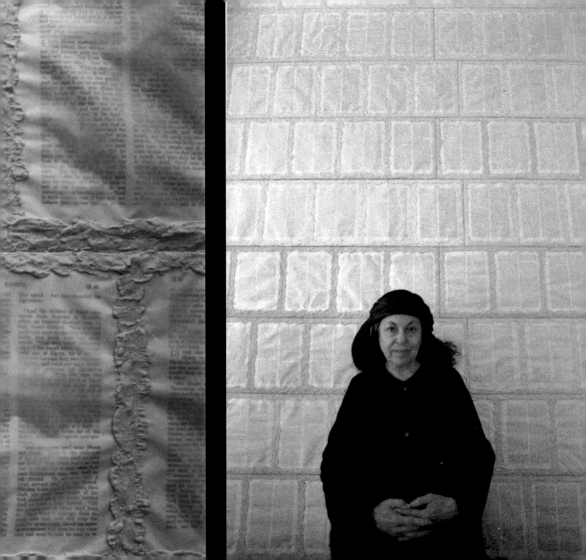

THE *MECHITZA* IS IN PLACE BUT THE SERVICE CAN'T BEGIN
NOT *SHACHARIT*—THE PRAYER WHEN THE EARLY SUN RISES AT AN ANGLE FROM AF
NOT *MUSAF*—THE PRAYER WHEN THE SUN RESTS IN THE CENTER OF THE SKY;
NOT *MAARIV*—THE PRAYER "BETWEEN THE SUNS" WHEN THE MOON AWAITS HER TU

THE PARTITION IS IN PLACE FOR THE WOMEN IN THEIR PLACE
BUT THE SERVICE CAN'T BEGIN BECAUSE THREE TIMES THREE IS NINE
AND A MINYAN CALLS FOR TEN FOR THE SERVICE TO BEGIN.
IT IS A GATHERING OF TEN MEN OR MORE FOR PRAYER.

THAT IS WHY, WHETHER IT'S *SHACHARIT, MUSAF* OR *MAARIV*
THE SERVICE CAN'T BEGIN IF THERE ARE ONLY NINE
THOUGH THE WOMEN ARE ALL THERE, WAITING IN THEIR PLACE
THOUGH THE WOMEN ARE ALL THERE, WAITING IN THEIR PLACE

Mechitza (divider), made of *tsitsit*, ritual fringes
worn by men under their clothing, 2002.

When I left my California studio in 1980, the land became an outdoor studio. I was looking toward the land for hints about ancient foremothers—a footstep in the sand, a bead, a remnant of a torn page. I was identifying the very body of woman in the body of the land, inserting my body into vast spaces so that I became a tiny presence enveloped in awe. I created a series of photographs of myself groveling in these landscapes, looking for the foremothers, as it were, the women whose names we never knew. I did not have ecofeminist artists Ana Mendieta's or Mary Beth Edelson's nerve to be seen up close, bare chested, nor did I want to greet my foremothers in this iconic sublime wearing jeans and a T-shirt. I draped myself in robes. I did not show these works until twenty-five years later, when I specifically named a foremother, Lot's Wife. I gave her a name: *Hashemshela*, which means "her name" in Hebrew. *Hashem* is a name for G–d. *Shela* means "belonging to her." Her name. It sounds musical in Hebrew.

I dedicated the Wrestlers series to Ana Mendieta, who had burned her own silhouette into the earth through fire. Like Lot's wife, the first battered woman, who turned around to look at the devastation after being forewarned not to look, Ana was unafraid to make her own rules. I also wanted to invoke Ana's name because of her incomprehensible violent death. In 1985 she allegedly fell out of a window in the thirty-fourth-floor Greenwich Village apartment that she shared with her husband, the artist Carl Andre. Andre was accused of pushing her, but was acquitted in the court trial that ensued and his career as the "father of minimalism" flourished. He was one of four male artists chosen for the opening of the new branch of the Guggenheim Museum in Soho. Although Ana had fallen to her death a few blocks from the museum, there was not even a pillar of salt to commemorate the spot where she fell.

Women protested in front of the Guggenheim Soho, decrying the lack of female artists and the very presence of Carl Andre. The Guggenheim conceded by adding Louise Bourgoise, but the protest did not end there. "Donde es Ana?" signs began appearing around the city. Long after others stopped plastering those signs, I kept going. Whenever Andre had a show, I would slip into the gallery and write "Donde es Ana?" in the visitor's comment book, then quickly leave, unnoticed.

I Balanced Above the Deep Pit, Wrestlers series, 1980–2005. Digital photography.

Top to bottom:
I Advanced to the Edge of Her Dwelling
I Wandered Near Echoing Caves
I Crawled Near Her Red-stained Pyramid

Top to bottom:
I Traced All Her Steps without Falling
I Groveled in Salt Lands of Yore
I Slid Down the Grooves of the Goddess

Wrestlers

So Jacob wrestled with God's angel about something

In a high place named Beit El, "House of God."

(There's a Midrash that no one since died in Beit El;

One had to leave it to die.)

I say that God's House is down below

And the first battered woman died there.

She was struck because she deigned to look back at

His devastation she was warned not to see.

When I yearn for a "House" it is not His hot furnace

Salted with rage against women.

I meander in dreams. I wake up with a start:

Dare I name "Lot's Wife" who is nameless?

I could name her "Hashem shela"—just a reminder,

Translated, "The Name of Hers."

(It almost sounds like God's name, "Hashem"

Translated, "The Name" I dare say.)

As for You, God,

You who are called "Melech Haolam"

Translated, "King of the Universe"

You are also "Melech Hamelach"

Translated, "King of The Salt."

Turnings

Once I looked for the footprints of Foremothers.

Now I walk through the grass at the crossroads.

When I reach the edge of the valley

They will know that a Foremother walked here.

In 1980 I strained to see footsteps

I strained to hear echoes of foremothers

In the silence;

I knew these foremothers

Wrestled to be heard.

In 2005, I gave a name to "Lot's Wife:"

I named her Hashem Shela—The Name of Hers.

I continue in the Garden while I look ahead

While I look behind until there is a turn—

My turn, when I become a Foremother.

Turnings

The year after my return to New York, 1983, in the Earth Ambulance, Betty Parsons died. As I walked down the steps of the Metropolitan Museum where Edward Albee had organized a memorial for Betty, I realized that I felt lost without her backing. There was no way I could explain myself to a new gallery owner even if one would deign to listen to my *gansa meisa* (whole story).

I sublet a studio in the artist Joyce Kozloff's building on Houston Street so I would have a place to show my work. I moved all the work out of storage, out of my apartment, playacting that I was moving into this airy studio for good. Tom Sokolovsky, then the director of NYU's Grey Gallery, was just across Houston Street, so I invited him to my studio. The first thing Tom noticed was the highlighted bible hiding in the corner. He called Norman Kleeblat, curator of the Jewish Museum, to have a look at it. Norman was fascinated with the premise of *The Liberation of G–d*, although he wasn't sure what form it could take as a work. What

was needed, he said, was "context" in a group exhibit. I patiently continued highlighting while I waited for Norman to figure it out.

FINALLY, in the 1990s, Norman called to say he had it: *The Liberation of G–d* would be in a group show he was planning, "Too Jewish?" He would show matzoh boxes in lieu of Campbell soup cans; Barbra Streisand instead of Jackie Onassis; and designer yalmukes from the artist who called himself Candyass.

I cringed. I told Norman that my work about G–d could not possibly be in this low down, smart-alecky show. But after two weeks it hit me that there really was something brilliant about the "Too Jewish?" idea after all. In truth there is a self-consciousness about being "too Jewish," unlike the electric attitude behind "Black is beautiful." I was comfortable with my identity as a process painter and an activist artist but not as a Jew. This show would be my "coming out" to the art world as a formerly Orthodox Jew.

Norman appointed Rabbi Burton Visotzky, from the Jewish Theological Seminary, as a co-curator explicitly for *The Liberation of G–d* installation. This was the first time a rabbi was asked to be a curator in the museum. But Norman

thought rabbinical backup was a must, especially for some of the museum's trustees who were a bit queasy about my premise of liberating G–d.

In the museum's signage, Visotzky referred to me as an "irritant." Quoting the late Shalom Spiegel (1899–1984), a leading expert in Medieval Hebrew literature, he wrote, "Just as a pearl results from a stimulus in the shell of a mollusk, so also a legend may arise from an irritant in Scripture." And, Visotzky claimed, if I had liberated G–d, I had liberated viewers too, to encounter G–d yet afresh.

But Rabbi Visotzky's seal of approval did not stop me from agonizing about anti-Semitism, heaven forbid, now that my attack on the Torah was going public.

Still, I swallowed hard and did not back down. The sound from the video of my turning the pages and pressing them down to see the words through the foggy transparent overlay soothed—much like the sound of logs crackling in a fireplace. When viewers of the books turned the pages, they added their own celestial murmur. Two ongoing videos of my hand highlighting in real time revealed where I slowed down and halted and hesitated to highlight, and where I went right to it. For example, when I came to the passage ordering that two men lying together shall be killed, I highlighted without hesitation; when I came to the fifth of the Ten Commandments, I was at a standstill. Honor thy father

and thy mother—but what if there were times you couldn't do that? What if the father abused the daughter?

Now that I had gone public as a Jewish feminist, I was often asked, "What makes someone Jewish?" The standard answer had always been circumcision. Feminist theologian Judith Plaskow noted that if that was the case, Jewish women aren't Jewish. I wondered if I should highlight circumcision. How come the world bought into circumcision in the first place?

In 1999, when my daughter Renée gave birth to twins—a girl, and ten minutes later, a boy—sure enough, the topic came up again.

"Did you highlight circumcision, Mom?"

"Yes, ultimately, I did. It's phallocentric."

"So I should not do the bris?"

"Of course you must do the bris. What a question. How could you not?!"

So baby Gavi (short for Gavriel, the biblical angel who said, "I have come to bring you wisdom") had a bris in Renée's sundrenched California home by the sea, and the chain of history was not broken. In fact, an ultra-kosher Orthodox bearded *moel* with *pais*, side burns, was brought in to do the job of correcting G–d's mistake. I had been through this with my three other grandbaby boys—by now, Mendy had two younger brothers, Benjy and Adam—

Renée with newborn Gavi (left) and Meléa, 1999.

and each time I heard that little cry of pain I shut my eyes tightly.

How different was the baby naming one month later of the girl twin, Meléa—the name in Hebrew means "fullness." A group of us sat in a circle in the sunny space and passed tiny Meléa around like a jewel to behold. I had no dread of hearing a newborn's cry piercing the calm as I had at her brother's bris. Renée held a large, handmade wooden bowl filled with water from the Pacific Bay below. Each of us held the little bundle with her precious tiny toes peeping out of the soft blanket, dunking the newborn's tiny feet into the seawater. This ceremony has a biblical derivation rooted in the story of Abraham's welcome to three strangers by offering them water to soak their feet after a long dusty voyage.

MOTHER INVITED the whole family to come to the opening of "Too Jewish?" as though it was my graduation. I was afraid she would bring cookies, as she did at my opening at the Max Hutchinson Gallery, twenty-six years before, so I connived to set up a special day for the "family opening" when none of the art world would be around.

As usual, mother repeated her usual refrain, "What do you need this for?" when she saw my installation. This

time I said, "Mom, there are thousands of comments in the viewers' book. Why don't you write your own comment?"

She agreed, always one to participate.

She looked at the installation with eyes clouded by macular degeneration. She opened the book of viewers' comments, and without hesitation, took a thick black marker from her old pocketbook to scrawl the following message across a whole page:

Dear Helen~

There are good teachings in the Torah. Why are they not acknowledged in your piece? I would have felt better if you did mention the greatness of the teachings

mom

From then on, mother's page seemed to pop up immediately for everyone who opened the viewers' comments book, like the raised hand of the smartest girl in the class.

No matter that I had been working as an artist for over two decades; I still felt like a schoolgirl trying to explain myself to Mother. Only now there was more, much more to explain, because I was not just explaining myself, but explaining myself in relation to the Jewish nation and in relation to the whole family, past and future, which was a small nation in itself. Mother was not sure if witnessing my highlighting at the museum was a celebration or an aggravation. But, she comforted herself, if the Jewish Museum was showing this work, it must be kosher.

To take her mind off my questionable contribution to Judaism, I wheeled Mother around the entire "Too Jewish?" group exhibit in a wheelchair provided by the museum and tried to explain the other artists' work. She liked the Debra Kass image of Barbra Streisand as Yentl because, as she explained, "that was positive." And Yentl took on the name Anshel, Daddy's name, when she posed as a boy in order to study in the yeshiva. Never mind that Yentl appeared in drag; she was carrying a *siddur*, a prayer book. She was not pointing a finger at the Torah, like me.

After years of my agonizing about Mother's agonizing about me and my work, I wanted to create an installation especially for her. It would show that I was at least preserving the Torah as a sacred object, that it was here to stay. I created *The Book that Will Not Close*. True, my *Book* also does not open, but I did not dwell on this.

The book was part of an installation that included a two-seater pew with brass nameplates: Mrs. Etta Scheinberg Greenfield Bodoff (her name in all its properness) to the right, and Ms. Helène Greenfield Fisch Aylon (my single name, my married name, and my made-up name) to the left. In front of the pew was a kind of horizontal stand that was made to hold prayer books. Here I placed two volumes of *The Book That Will Not Close*, their pages covered with the transparent overlay, making them very stiff and unable to open or close. Only *habracha* (The Blessing) in Deuteronomy, was highlighted in the book on the right; only *haklala* (The Curse) was highlighted in the book on the left. An audio recording of a two-hour conversation between my mother and me—a typical discussion between us—plays on a loop. You can hear me trying to convince her, with logic, with my guts. She cajoles, she taunts: "With your education, you could inspire others instead of taking this attitude." Shulamith again.

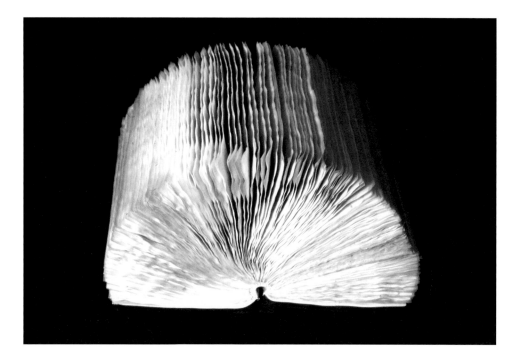

But maybe I like that she was never convinced. I called the installation *Epilogue: Alone with my Mother*, and dedicated it to "my mother who walked the straight and narrow while I walked around in circles." I saw *Epilogue* as conciliatory, both of us as we are, alone yet together. "Together is what counts," she always said. Yes, Mom, together is what counts, with me wanting her to be exactly as she was, and her accepting me for who I am, no matter that I never brought her that *Yiddische naches* (Jewish pride) she got from her other daughters.

The Book That Will Not Close from *Epilogue: Alone with My Mother*, 1999. Mixed media.

EPILOGUE: ALONE WITH MY MOTHER

dedicated to my mother
Etta Scheinberg Greenfield Bodoff

who steadily walked
the straight and narrow
while I went around in circles

Helène Aylon 1999

I SIT WITH MY MOTHER
FOR THE LAST HOUR, NEILA,
WHEN IT IS INSCRIBED
"WHO SHALL RISE AND WHO SHALL FALL
WHO SHALL LIVE AND WHO SHALL DIE."
I WAS BORN FROM THIS MOTHER
AND SHE, ETTA, WAS BORN FROM HINDA
AND HINDA HAS DIED AND ETTA'S TURN IS NEXT
(CAN I SAY THIS?)
AND MY TURN IS NEXT.
I MUST FACE THE CERTAINTIES.
THERE ARE ONLY TWO CERTAINTIES
SAYS A MIDRASH, ONLY TWO:
FROM A MOTHER, EM, WE BEGAN,
AS A DEAD PERSON, MET, WE WILL END.
THAT'S THE EMET, THAT'S THE TRUTH.
NOW I SIT ALIVE WITH MY MOTHER ALIVE
SHE IS 92 THIS YEAR AND WE SIT ALIVE
BEFORE THE GATES ARE SHUT.
I RETURNED FROM THE HEIGHTS OF THE VAST OUTSIDE
TO THE INSIDE WHERE AIR IS DISAPPEARED
SUCKED UP BY DAY-LONG SIGHS.
I LOOK TOWARD THE BENCH
WHERE AUNT TYBEE ONCE SAT
BEAMING AT ME WITH WATERY EYES
NO MATTER WHEN I CAME IN.
NOW STRANGERS ARE SITTING WHERE AUNT TYBEE ONCE SAT
WITH AUNT ELKA AND AUNT MOLLY.
MY MOTHER LOOKS FOR TORAH SCROLLS
COVERED IN VELVET FRINGED IN GOLD
TO BE DRESSED AND UNDRESSED
LIKE DOLLS HELD AND KISSED—
(LIKE IDOLS HELD AND KISSED, I DARE SAY.)
THE BOOKS THAT WILL NOT CLOSE
ARE THERE, I PUT THEM THERE.
THEY'RE COVERED AND BLUSHING PINK.
I SAY, "MOM, THE WORDS DO SHOW
THROUGH THE OVERLAY;
BUT TAKE THE LAST CHAPTERS,
THE BLESSING AND THE CURSE
YOU SEE THE BLESSING, AND I SEE—
CAN WE READ THIS SO I CAN EXPLAIN?"
TO MY QUERY SHE ANSWERS,
"HELENE, I'M A PLAIN PERSON."
(WOULD I WANT A DIFFERENT ANSWER?)
I LOOK OUT THE SEMICIRCULAR WINDOW
AS THE RAM'S WAIL TRAILS
THE LENGTH OF MY BREATH,
THEN, JOLTED BY SHOUTS—
THE LORD, HE IS GOD!
AGAIN, SIX MORE TIMES—
ADONAI HU H'ELOHIM!
I STAND ERECT. SHE BENDS TO ALL,
"A GUT YOR, IBER A YOR."
A GOOD YEAR, TO NEXT YEAR.
I WAIT MY TURN TO BE BLESSED.

f I felt angst about showing *The Liberation of G–d* in a venue like The Jewish Museum, I was sick with worry about the museum's plans to travel the piece to secular sites like the Los Angeles Hammer Museum. I feared this work would not be good for the Jews.

When Flora Biddle, granddaughter of Gertrude Vanderbilt Whitney, told me that *The Liberation of G–d* was meaningful to her, I did not think, how nice that someone from the Whitney likes the work. Instead I said, "Flora, you're lucky, you have Jesus whose words are much kinder than the words of Moses."

"But we also have the Father G–d!" Flora reminded me.

The museum viewer I most worried about was my grandson Mendy, who was then eight years old. He stood intently before the installation at the "family opening" while his parents and everyone else were looking over their shoulders to see who else from the family came. Mendy scrutinized the fifty-nine books, the proclamation, the video

of the highlighting, all of it. Finally he looked up at me and blurted out, "Moses wouldn't lie!"

Oy. Was I tarnishing this child's pure faith? I crouched down beside him and said, "Mendy, you have dreams, right?"

He nodded. "Sometimes you have scary dreams. Sometimes you have good dreams, and sometimes you have silly dreams, right?"

He nodded.

"Well, Mendy, so did Moses have these different kinds of dreams."

Mendy nodded once again. Whew! If these were the dreams of Moses, Moses was not responsible for saying that G–d spoke to him. It was just a dream—only Moses did not wake up from his dream.

I dedicated *The Liberation of G–d* to Yitzhak Rabin, the Israeli prime minister who was shot and killed in 1995. The passage in Deuteronomy 13 might have influenced the assassin, an Orthodox Jew. It reads:

> If there arises in the midst of you a prophet or a dreamer of dreams and he gives you a sign or a manifestation and the sign or the manifestation comes to pass . . . then shall you not listen to the

Leah Rabin with me at the *Liberation of G–d* installation in Baltimore, 1997.

words of that prophet or to that dreamer of dreams . . . your hand shall be the first on him to put him to death and the hand of all the people afterward.

To me, Yitzhak Rabin was a dreamer of dreams, ready to exchange land for peace. I wrote a letter to his widow, Leah Rabin, and since I didn't know her address, I simply wrote on the envelope, "Leah Rabin, Israel." Three weeks later, I nearly keeled over when I got a surprisingly folksy answer on her letterhead. She said she would be in Baltimore at the same time *The Liberation of G–d* was being shown there. I was to call for her at her hotel.

She came down to the lobby with a tall secret service agent, and we drove to the Jewish Museum of Baltimore. I was a bit anxious about the whole thing. I hadn't told her anything about the installation, just that it was dedicated to her husband. Sure enough, at the very entrance to *The Liberation of G–d*, Leah Rabin scoffed, "God does not need to be liberated!" She must have been expecting a marble bust of her husband. I told Ms. Rabin that I believed her husband's assassin had imagined he was doing what the Torah wanted. I talked about projections laid on G–d in every religion. She listened without interruption, and finally said,

"Ah, *Ha'aseemahn nafal.* "The token fell down," meaning what I was saying registered; it clicked.

It was the first time I'd heard this Hebrew expression. I stopped worrying whether liberating G–d was good for the Jews.

I INSISTED that each venue showing *The Liberation of G–d* include me in a rabbinic symposium. Mother was right about my fine education coming in handy when I showed off in debates with rabbis who thought they and *Moshe Rabeinu* (Moses our rabbi) knew best. The San Francisco Jewish Museum programmed "Four Rabbis and an Art-

ist: A Talmudic Debate," in which I took on an Orthodox, Conservative, Reform, and Reconstructionist rabbi. The National Museum of American Jewish History in Philadelphia had a similar program. The Los Angeles Armand Hammer Museum sent in a stream of rabbis one at a time as I sat on a bench waiting for them to confront me.

The Ackland Art Museum in North Carolina invited a young *Chabad* rabbi who had probably never set foot in the museum before. I was rather caustic with this young man. When I brought up the passage that stated that two men lying together must be killed, he hemmed and hawed. I said, "Tell me if you agree. Please say 'yes' or 'no.'" More mumbling. I repeated the question. "Yes, or No?"

The poor guy got up and left the room.

The next day, the young rabbi came back to the museum to visit me. He brought chocolates. I said, "I can't eat sugar." He said, "It's kosher. Don't worry." I explained that the issue was onset diabetes, not religious law. He looked at me and said that he wanted to bring something sweet because it was sweet to stay in the fold. He had come to personally ask me not to leave the fold. If I had questions, I could call him any time. I told him that no rabbi, however learned, could answer my questions.

Oh, but that dear young rabbi from *Chabad*. He reminded me of my grandnephew, Tuvia, who has that

same special v*ahrmkeit* (warmth). Beginning when he was 9 years old, Tuvia gave himself the job of calling me every Friday to inform me of the time to light candles. "We have *Shabbos* one minute later in Passaic than in New York, New York," he would tell me excitedly. "You *bench lecht* at 6:17 p.m. and 22 seconds. Have a great *Shabbos*!"

I know this boy will always have a great *Shabbos*. Once he and his ten siblings reach yeshiva age, they are invited by their Dad to take turns standing at a lectern set up at the head of their dining room table to give a *dvar* Torah (a "learning" from the Torah). There's a small stool for the younger children who can't reach over the top of the lectern, and even these little ones repeat what they learned in the yeshiva's kindergarten. This is how I could spend twenty years denouncing what's in the Torah, but still love the idea of Torah.

All Rise

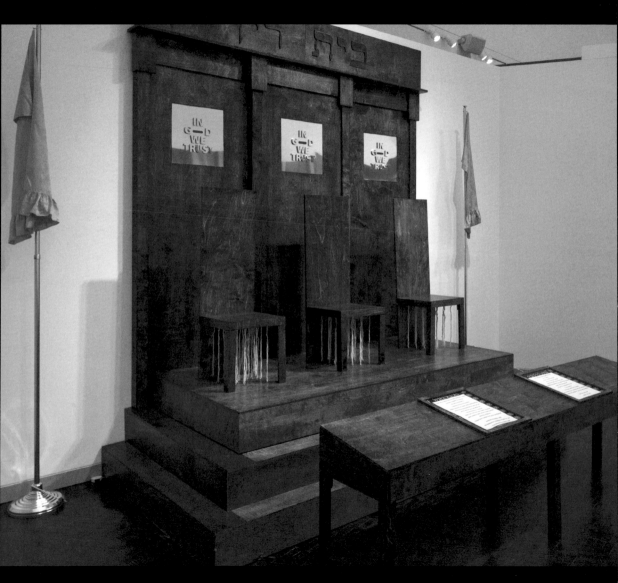

All Rise, 2010. Contemporary Jewish Museum, San Francisco. Mixed media including

WHEREAS

The Shulchan Aruch and Mishna Torah
forbid women to judge
or give evidence.
I respectfully examine
these edicts of karo and maimonides
for false representations of G-d
with words G-d did not say.
I respectfully submit
that G-d did not say that women
and minors and idiots and slaves
(among others)
could not judge nor give testimony.
Exhibit number one:
an imaginary female court of law
also known as a beit din.

PETITION

For an apology in abstentia
as it were
to all those judges
who could not judge
because they were not men
their judgments will never be known.
The final argument
is simply to be able to say
"your honor"
to judges who are women;
In so doing, all women will be honored
and the name of G-d will be honored.
In the year 5768
I rest my case.
Helene Aylon

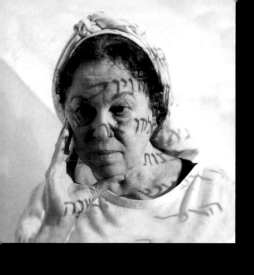
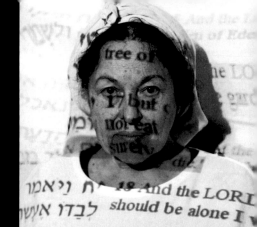
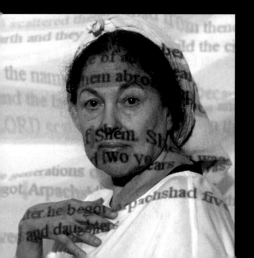
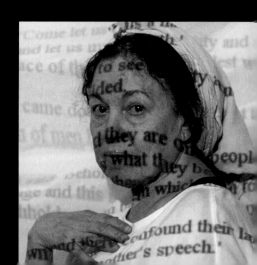

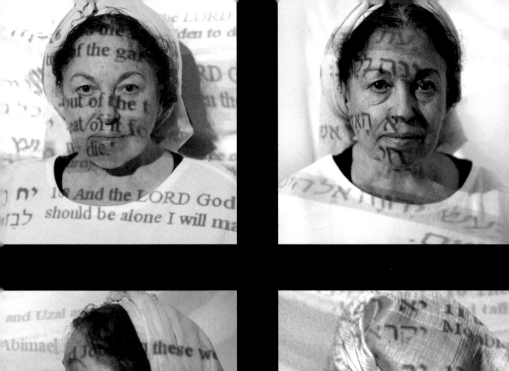

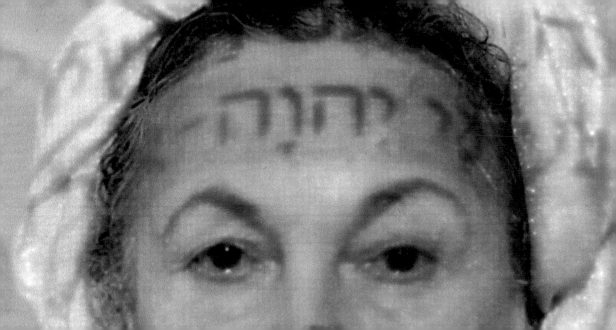

At age ninety-eight, my mother moved out of Boro Park, away from Forty-Seventh Street, away from the window that looked out on the solitary maple tree that turned a sunny green at the start of spring. She moved to North Hollywood, where she would sit under palm trees looking out on a backyard pool, at her youngest daughter's sprawling home. She packed her sturdy brass candlesticks and her graceful sterling silver candlesticks and the trays that held these glories. She left at 5:30 a.m. on Friday, August 5, 2006 so she would arrive at Linda's home hours before the start of *Shabbos.*

Four days later, on Nagasaki Day, I became gravely ill—by gravely, I mean ready for the grave. I'd gone to the hospital for a routine procedure that went terribly wrong when a vein was torn. I was bleeding to death and almost had a leg amputated. A vascular surgeon was called in, and I had to have forty-two blood transfusions and an emergency operation to put in new plastic veins—a procedure

called, oddly enough, a "fem-fem" bypass, which stands for femoro-femoral.

On top of this I had two heart attacks from the trauma. My children were called in and told I was not expected to survive the night. But Mother, safe in North Hollywood, was spared the news of my illness.

I woke from a twenty-day coma to the sight of my son and daughter and a small gathering of close friends surrounding my hospital bed, all of them nervously waiting to see if I would open my eyes, if I would be able to speak or if my brain had been damaged from the lack of oxygen. The Israeli poet Irit Katzir said sleep is but a dress rehearsal for the Great Sleep. I don't know if that makes me feel any better about death, but the truth is it wasn't that bad, being totally out of it for twenty days.

I tried to grunt "hi" through the pipes that were shoved down my throat, to breathe any utterance, any sound out of my larynx. For once I did not worry about whether this group was compatible or whether they had all met each other. The words that finally came out of my mouth were not *mechayeh ha'masim* (He brings the dead to life) or *baruch shepatrani* (blessed that I was spared). Nor did I offer up a *mi sheberach*, the prayer reserved for such a calamitous illness, a prayer to acknowledge that I was kept alive with

tubes down my throat and my hands tied to the bed so that I would not yank the tubes out. Nor did I say the thank you that I wanted to say to this devoted, loving group, the thank you that welled up inside me.

No, "café latte!" I rasped. While I had my audience's rapt attention I faced my son and made a cutting motion with my fingers as I mouthed the letters C-U-T, damn it, please cut the horrid straps attaching my arms to the bed. My son pretended not to understand, which was agitating for both of us, a possible last request from his claustrophobic mother that the doctors told him he had to ignore.

When the tubes were eventually pulled out by one of the circulating doctors, I had to answer a battery of questions: What is your name? Where are you? What year is it? Who is the president? What is the name of this hospital?

One doctor finished the questionnaire by asking: "Before you came here, did you work?"

"I liberated G–d," was my answer.

Luckily, Renée was there to assure the doctors that this was a good sign: I remembered who I was.

I spent the next weeks in intensive care, solitary confinement for severe illnesses. I could only move my head from side to side, one side toward the window with a view of the George Washington Bridge, a bridge that I have come to hate, and the other side toward the hallway where

overworked nurses scurried back and forth looking straight ahead, too busy to answer calls coming from the patients' rooms.

I would have wanted Mother's prayers, had she known about my illness, because I could not truly pray. Maybe this resistance to praying for my own life was a test to see what remnants of the *dvaikut*, the clinging devotion of my past years, remained those years when I had given my daughter as a middle name the Hebrew word for "faith," Emunah, and named my son in Hebrew "gift of G–d," Nesaniel.

When I got out of intensive care, where visitors had to don paper overcoats and present themselves one at a time, a line of people took turns standing at my bedside as if it was my memorial service.

Norman Kleeblat, the curator from the Jewish Museum, came on Rosh Hashanah, his way of doing a mitzvah on that significant day, as he later told me. Peter Samis, the curator from the San Francisco Museum of Art, was there, and for a second I thought I must be in California.

In fact, one day I heard the voice of my Berkeley friend, the poet Gloria Frym, reading to the group around my bed. I thought I heard my name in the poem, and the names of old lovers of mine, and I thought I heard her exclaim with her offbeat humor, "if she could live through the New York art world, she can endure anything." If the poem

is about me, it must be a eulogy, I thought, but a funny one. I thought I was witnessing the most original funeral there ever was. How bicoastal! How art worldy!

Perhaps it was a day, or twenty days after that "funeral," I woke up to a dazzling light. The light was a gigantic square, a diamond the size of the nave of the grand cathedrals of Rome. I imagined I saw the shadow of a young boy walking along a glass plank above. It was probably my daughter's then seven-year old son, Gavi. In the labyrinth of my drugged-out head I decided this meant my daughter was nearby. Which she was.

WHEN I WAS finally fully awake, when I could stand at last, after collapsing like a noodle at every try, and after a total of six months in various hospitals and rehabs, I cried inside for what I had been through and because I had been spared the jaws of death. I knew that I would have to express enormous, infinite gratitude. It would not do to simply mumble, "gee, thanks" to G–d upon my return to the living. Whichever G–d it was who had worked such a miracle in saving my life deserved the bursting fullness of a Hallelujah that would echo through all the forests and oceans and constellations of this planet. Hallelujah! Why should my Torah

ruminations about Moses interfere with my gratitude to the unknowable G–d?

A few weeks after I left the hospital I found myself heading to a small "post-Denominational" Shabbat service in a junior high school building on the Upper West Side. The small congregation seemed to be predominantly young secular Jews wanting to experience Judaism. It wasn't easy for me, with my cane, to enter a room of twenty-somethings who were eager for what they had never had, something that I once had to the fullest. I was not sure I could deal with their jovial ceremonies, their jumping up and down with the Torah—hugging it, passing it from one person to the next, kissing it. What was this, an idolatrous orgy? And for what?

But the leader of the service, a young rabbi, had named this makeshift congregation Romemu, from the root word, *l'harim* (to uplift); I got the feeling he was a searcher himself. My J-dar recognized his once-Orthodox background. After the group frenzy with the Torah, the service continued with many voices joining, some harmonizing. A guitar provided soft accompaniment. I wondered why musical instruments had been forbidden in the synagogue during my Orthodox childhood, as King David most likely had played the harp on *Shabbos*.

Listening to the ascending arpeggio of *Ashrei Ashrei Yoshvei Beitecha* . . . (Richly happy are those who dwell in your house), tears came to my eyes. I thought of Baba in our crowded bedroom murmuring the *Modeh Ani, she-hechezarta bi nishmati* (I acknowledge before You that You restored my soul). Baba had awakened each morning as though her sleep had been a coma, like mine, and she was resurrected at sunrise.

Had I not survived, I would have become an ancestor, like my *davinning* Baba, like the ancient, nameless "Lot's wife." Somehow, remembering the foremothers and designating myself as a future foremother consoled me. Not everything would evaporate. The Zohar says that when you come to the end of life, you bring your days: *Bah Bayamim*. The word *yamim* is also the word for oceans. It's plural, it could be more than one ocean, it could be ten oceans, or one hundred. It evokes a state of deathlessness. It's the breaking of the vessel, the surrender to restarting, the melodrama of looking forward and looking back simultaneously.

ONE THING IS clear: I cannot come to any conclusion. That is the way with my relationship to my upbringing, to my Paintings That Change, to my Judaism. I try to keep my balance, holding the paradoxes, waiting to see what will

happen as in the Paintings That Change. But the Judaism remains a constant. As I once told a reporter, "In order to save Judaism for myself, I had to turn to the *sod* (secret things), the *nistar* (hidden)."

I looked for what was absent in the Torah to find the *nistar*. The *nistar* that moved me most often came from the foremothers themselves.

The sacred lighting of the candles—nowhere in the Five Books of Moses is there a commandment for the woman to light candles. But it became a custom and this custom got passed down from mother to daughter, and I have passed it on to my daughter Renée who lights Mother's sterling candlesticks while I light Mother's brass candlesticks. And Renée is passing this tradition down to my granddaughter, Meléa.

I am sure it was a foremother who was the first to cover a mirror during mourning. I imagine in her grief she could not bear to look at herself. Nowhere in the Five Books of Moses is there a commandment to cover mirrors.

The *Tvila*, the prayer uttered by women while submerging in the waters of the *mikveh*, was surely written by a woman, especially as women were not commanded to bathe; in Leviticus, only a man was commanded to bathe if he has touched a *niddah*. When I immersed myself—one, two, three times—it was not like dunking myself in a pool at the gym. It was a gift from my foremothers to myself.

There is one word in the Torah that appears hundreds of times: *Yehova*, the holiest name for G–d. There's a silence around that word: one does not pronounce it, but instead substitutes another word, *Hashem* or the letters of the name, yud-kai-vav-kai, for that ultra-sacred word cannot be uttered. Rabbis have noted that the letters for *Yehova*, in different configurations, spell the words *hayah, hoveh, yehyeh*—past, present, future. However, Rabbis did not go a step further to notice that this name, so holy that it cannot be uttered, is the only name for G–d that has no gender. Eternity includes women.

THERE IS an eternal light in every synagogue and in many churches too. In Hebrew, it is called *ner tamid*. I created an eternal light for the installation of *The Liberation of G–d and the Unmentionable* in the Warhol museum in Pittsburgh, where I covered three small square windows in the museum's cathedral ceiling with shiny metal. A tiny block in the shape of a "G" was affixed to the first window on the left, and a "D" was attached to the third window on the right. In the covered center window, I cut out a horizontal "dash" to let the natural light shine through. I glued a pink transparent layer against the back of the cutout, so the light would filter in pink. When I looked up at this subtle glow, I

My Eternal Light:
The Illuminated Pink Dash

wanted to be bathed in its faint light. This delicate pink dash sums up my striving for the inclusion of women. It is what has been missing since Abraham discovered monotheism. I had inserted a feminine presence into the Godhead. If I had to summarize the essence of my twenty-year endeavor to liberate G–d, I could just point to that one small dash.

THE HOME I grew up in was sold by the landlord, who graciously waited until Mother was safely settled in North Hollywood. The last time I visited the old homestead, new housing was being built on the lot. I peeped through a hole in the fence erected on the site to see the construction. Where did my origins go? Even the gate in front of the house that I swung on until my teens was gone. The little stained glass sign above the door, emblazoned with the address, 1-2-5-1, was no longer there.

I wonder what happened to the mezuzah on the front doorpost that my mother touched with her hand upon entering her house or leaving her house for any reason, even for a walk to the corner mailbox to mail a birthday card to a great grandchild.

Mother never uttered the word die. When she spoke of her eventual death, she'd simply say, "When I close my eyes . . . " It happened the month of my seventy-eighth

birthday, when Mother was one hundred years and three quarters. She had called from California on the fourth day of February to sing "Happy Birthday" to me over the phone. I felt like I was nine years old. I tried to hurry her along, encouraging her to stop after the first line, but no, she sang the whole thing through, leisurely and loudly and deliberately, drawing it all out, ignoring my audible sighs.

I had spoken to Mother a few days earlier, in the last week of January. She had asked, "When are you coming, Helène?"

"The last day of February," I responded.

"But that's so long from now."

"That's just next month, Mom. Now it's January and then comes February," I told her.

ON FEBRUARY FIFTH, the day after my birthday, Mother took her afternoon nap and did not wake up until February 17, when she opened her eyes for a split second, sensed that all was good, and then closed her eyes forevermore. Indeed, she had been right; February 28 was too far into the future. A Yiddish expression comes to mind: *A mensch tracht en Gott lacht* (a human plans and G–d laughs).

Two years earlier, before setting out for California, Mother made sure she would eventually be brought back

to Boro Park, to be sent off by the Jeffers funeral parlor on Forty-Ninth Street. Between the time she made funeral arrangements and the time of her death, that funeral parlor moved to Forty-Sixth Street and renamed itself *Shomrei Hadat*, guardians of the faith. Mother would have thought that was an improvement on its former name. She had made plans to be buried near my father in the Young Israel plot of the King David cemetery. She had willingly made the voyage to California because she knew it would be an interim stopover; she would be coming back.

I sat shivah for the first five days with my sisters in the New York apartment my sister Sandy maintained, though she lived in Jerusalem. For the last two days, when Sandy went back to Jerusalem and Linda was planning to return to California, I knew I could not sit alone in my Westbeth studio. It seemed *traif*. Besides, I could not arrange a *minyan* (ten men to initiate the morning and evening prayers) twice a day. I did not have *shul menshen* (religious men) at my beck and call; my sisters could command parades of them. So I flew back with Linda to sit on the low wooden stools for shivah in her home. For you, Mother of mine, I mourned the full seven days of shivah and I accepted the premise that ten men whom I did not know would come for a *minyan*. The men came in the morning while I was still bleary-eyed, waking up to a day without you, and they

returned for *maariv* (the evening prayers). And hundreds who paid the shivah visit arrived without saying hello and left without saying goodbye as is the custom; the only salutation allowed was *"Hashem dayan emet"* ("G–d is the true judge"). No questions from me for once. I wanted to do it your way.

But first there had been the burial. If one could call a burial beautiful, Mother's was beautiful. The people formed two lines, two walls of humans, both lines facing the center. They all repeated the refrain, *"Hashem yinachem im cal avlei Yisrael"* ("G–d will comfort with all the mourners of Israel"). We three mourners, Linda, Sandy, and I, walked barefooted slowly between the two rows of people. As the oldest, I went first. The ground felt cold and pebbly, but the murmured prayers on both sides wrapped around me in protective layers. I looked straight ahead, not seeing the ones whose voices came to me from close up and from behind and from ahead. I walked between the sounds, between those mixed emanations.

NOW, I place her two tall, brass candlesticks on a corner of her brass tray. They stand guard as if the tray is their homeland. I stand, and they stand, by my window overlooking the Hudson River.

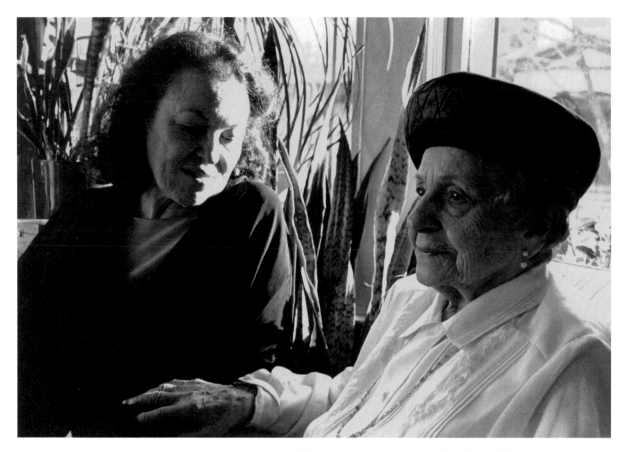

With Mother on her porch, Brooklyn, 1998.

284

I light the candles, and the flames are reflected on the windowpane and river. If I move slightly, the flames move to the edge of the sky. I walk away the length of the loft, and when I turn I see the lights have moved to the other side of the sky.

There's an icy veneer on the waters from the February frost, but the ice will thaw as though from the warmth of these flames.

Acknowledgments

To Dr. David Silberstein and Dr. Jerry Lax, my eternal gratitude. My thanks pour out to all those who, in 2006, stood with my family around my bedside waiting for me to wake up from my coma: Irene Hochstein, Sally Gottesman, Rachel Tiven, Jane deLynn, Tsippi Keller, Gloria Frym, Katt Lissard, Ilene Burack, Lenise Soren, Malka Frankel, Scott Haran, Helen Humphreys, Michelle Jaffe, Bruno Oriti, and Brenda Dixon Gottschild (who sang "We Shall Overcome" with Renée, which may well have awakened me). I'm also recalling Allen Wallach, Irwin Herschlag, Phyllis Rosenzweig, Gary Shiro, Valerie Merians and Dennis Johnson, Zoe Mullery, Yocheved Muffs, Catherine Hiller, Lisa Tillinghast, Flora Biddle, Magda Salvesen, Yvonne Puffer, Sean Elwood, Robert Berlind, Louis Solomon, Debra Nusbaum Cohen and her son Ari, and the late Leigh Davis.

I was able to write this memoir because the omniscient Gloria Jacobs, executive director of the Feminist Press, saw the potential even though it read like Judaism 101. Thank you to Theresa Noll, the tenacious editor from Kentucky who got it all. The Reuben/Rifkin Jewish Women Writers Series co-editors Elaine Reuben and Shulamith Reinharz

lent cascades of encouragement from Washington, DC and Massachusetts; I am grateful to be included in the series. Thank you to freelance editor Ruth Greenstein for her early guidance, and to Feminist Press managing editor Jeanann Pannasch for doing the hard stuff in her quiet way. And book designer Drew Stevens sorted out the black and white pages of my life.

There were those who jumpstarted my life as a feminist artist: Chrissy Iles programmed a video and performance of *The Breakings* at the Whitney, Livia Straus got *The Earth Ambulance* out of the garage to show it for four years at Hudson Valley Center for Contemporary Art in Peekskill, and Norman Kleeblat had the courage to take a chance and exhibit *The Liberation of G–d* in the Jewish Museum.

I thank all the women who participated in the ceremonials and activism over the decades.

Through all these phases, I acknowledge Maryel Norris, who gave me shelter from the storms.

Published in 2012 by the Feminist Press
at the City University of New York
The Graduate Center
365 Fifth Avenue, Suite 5406
New York, NY 10016

feministpress.org

First printing May 2012

Cover and text design by Drew Stevens

Library of Congress Cataloging-in-Publication Data

Aylon, Helène, 1931-
 Whatever is contained must be released : my Jewish orthodox girlhood, my
life as a feminist artist / Heléne Aylon.
 p. cm.
 ISBN 978-1-55861-768-1
1. Aylon, Heléne, 1931- 2. Jews—New York (State)—New York—Biography.
3. Jewish women—New York (State)—New York—Biography. 4. Painters—
New York (State)—New York—Biography. 5. Jewish painters—New York
(State)—New York—Biography. I. Title.
 F128.9.J5A95 2012
 759.13—dc23
 [B]
 2011043068